The Genius of Michelangelo
Part III

Professor William E. Wallace

THE TEACHING COMPANY ®

PUBLISHED BY:

THE TEACHING COMPANY
4151 Lafayette Center Drive, Suite 100
Chantilly, Virginia 20151-1232
1-800-TEACH-12
Fax—703-378-3819
www.teach12.com

ISBN 978-1-59803-337-3

William E. Wallace, Ph.D.
Barbara Murphy Bryant Distinguished Professor of Art History, Washington University in St. Louis

Professor William E. Wallace is an internationally recognized authority on the great Renaissance artist Michelangelo Buonarroti. He is one of a select group of scholars, curators, and conservators from around the world invited to the Vatican to confer about the conservation of Michelangelo's frescos in the Sistine Chapel. Dr. Wallace has published extensively on Renaissance art; in addition to more than 80 articles, book chapters, and essays (including two works of fiction), he is the author and editor of four books on Michelangelo, including *Michelangelo at San Lorenzo: The Genius as Entrepreneur* (Cambridge University Press, 1994); *Michelangelo: Selected Scholarship in English* (Garland, 1996); and *Michelangelo: The Complete Sculpture, Painting, Architecture* (Beaux Arts Editions, 1998), which was awarded the 1999 Umhoefer Prize for Achievement in Humanities in recognition of the book's outstanding merit. The professor also recently completed a biography of Michelangelo.

Dr. Wallace is the recipient of numerous awards and fellowships, including a year spent at Villa I Tatti, Harvard University's Center for Renaissance Studies in Florence (1986–1987), and a year at the American Academy in Rome (1996–1997). In 1999, he was the Robert Sterling Clark Distinguished Visiting Professor at Williams College, Williamstown, Massachusetts. In 2000, he appeared in a BBC film, *The Private Life of a Masterpiece: Michelangelo's David*, and in 2004, he was the principal consultant for a two-part BBC film, *The Divine Michelangelo*.

Dr. Wallace received his bachelor's degree in 1974 from Dickinson College in Carlisle, Pennsylvania; his master's degree in 1976 from the University of Illinois at Urbana-Champaign; and his doctorate in 1983 from Columbia University in New York. He joined the faculty of the Department of Art History and Archaeology of Washington University in St. Louis in 1983, and in 2000, he was named the Barbara Murphy Bryant Distinguished Professor of Art History.

Table of Contents
The Genius of Michelangelo
Part III

The Genius of Michelangelo

Scope:

Michelangelo Buonarroti is universally recognized to be among the greatest artists of all time. His career spanned the glories of Renaissance Florence and the discovery of a New World to the first stirrings of the Counter-Reformation. Living nearly 89 years, twice as long as most of his contemporaries, Michelangelo witnessed the pontificates of 13 popes and worked for nine of them. Although his art occasionally has been criticized (he was accused of impropriety in the *Last Judgment*), his stature and influence rarely have been questioned. Many of his works, including the *Pietà*, *David*, *Moses*, and the Sistine Chapel ceiling, are ubiquitous cultural icons. Despite the familiarity of Michelangelo's art and a large quantity of documentation, many aspects of his art and life remain open to interpretation. Only Shakespeare and Beethoven have inspired a comparable scholarly and popular literature.

Michelangelo is one of the most well-documented artists of all time. In addition to producing famous works in sculpture, painting, and architecture, he was an accomplished poet, draftsman, and correspondent. Still extant are some 300 poems and 600 drawings, nearly 1,400 letters to and from Michelangelo, more than 300 pages of his personal and professional records, and an extensive correspondence among members of his immediate family. We know a lot about the artist's life and loves, his family, friends, professional associates, and patrons.

This course, in addition to providing an overview of the man and his many accomplishments, offers a substantially new view of Michelangelo: he was both artist and aristocrat. He ardently believed that his family was of ancient and noble origins, descended from the medieval counts of Canossa. The belief in his patrician status fueled his lifelong ambition to improve his family's financial situation and to raise his social standing as an artist, from craftsman to genius, from artisan to gentleman. The life of such a fascinating individual is prey to embellishment, both by the artist and his contemporary biographers. Romantic interpretations of Michelangelo's art and life abound, and he continues to be a figure obscured by myth even in our rational age. This course explores his art through the prism of

truth and legend, each having contributed to a vivid portrait of a remarkable yet credible and deeply human individual.

The course is arranged as a chronological survey of Michelangelo's life, times, and work. Each lecture will take up a significant aspect of the artist, as well as a consideration of his many famous and some lesser-known masterworks.

Lecture Twenty-Five
Michelangelo's Drawings, 1520–40

Scope:

This lecture examines the period of Michelangelo's transition to Rome and his move there in 1534. Much of the lecture is devoted to the artist's friends, his great sense of humor, and the connection of both to his drawings at this time. At the end of 1532, Michelangelo met the Roman nobleman Tommaso de' Cavalieri. In the early stages of his newfound passion for this friend, the artist wrote poems and made a number of highly finished presentation drawings. This lecture then considers a remarkable series of drawings that Michelangelo made in the 1520s and 1530s, culminating in those he presented to Cavalieri. These drawings helped to revolutionize attitudes toward drawings: A medium that once was considered preparatory and discardable became something to collect and treasure. Then, we will introduce the next great work that would occupy Michelangelo for nearly six years between 1536 and 1541: *Last Judgment*.

Outline

I. Friends and laughter.

 A. Like many of his fellow Florentines, Michelangelo loved wit and aphorism. Although we often think of him as melancholic, his reply to Pope Clement VII's outlandish request for a marble monstrosity outside of San Lorenzo shows his humorous side, as well.

 B. Michelangelo loved bantering and exchanging letters with the Venetian painter Sebastiano del Piombo. One letter Michelangelo wrote was so hilarious that Sebastiano passed it around the Vatican for all to read. Referring to the letter, he said, "Nobody talks about anything else; it has made everybody laugh."

 C. According to Vasari, Michelangelo often "roared with laughter" at the stories of his "very agreeable" friend Menighella and enjoyed the company of Jacopo l'Indaco, a "gay and humorous" artist.

1. Likewise, Michelangelo took delight in the simplicity of his good friend Giuliano Bugiardini, who helped him on the Sistine ceiling, and the stone carver Topolino, whose mediocre efforts at marble carving caused Michelangelo to "nearly die of laughter."
2. Michelangelo was also a friend of the burlesque and satiric poet Francesco Berni, and the two exchanged humorous verses.

D. The artist's capacity for self-mockery is masterfully displayed when he writes of his aging body "packaged in here like the pulp in fruit compacted by its peel" and of his house, "a tomb where mad Arachne and her creepy crew keep jittering up and down, a spooky loom." A scatological poem about urination is also in this vein.

E. Although not generally recognized, humor is a prominent aspect of Michelangelo's personality: Wit, humor, and aphoristic wisdom are legion in his poetry, correspondence, and drawings, as well as in the many anecdotes related about his life. And, in curious fashion, his humor occasionally was translated into fine art.

II. From humor to art.

A. More than talent drew Michelangelo to his maladroit pupil Antonio Mini. The unequal companions scribbled and laughed together, indulging in bawdy jokes that were common in the Renaissance.

B. We see a design for a figural group from the Ashmolean Museum, probably for a sculpture that was never executed. On the front of this sheet, we note something of Michelangelo's humor in a grotesque face. On the back is an immense scrawl of squiggly and amusing drawings.
1. Some of these sketches are fairly well drawn, such as the skull in the middle, but others are incompetent.
2. On top of the sheet is an autographed sonnet absolutely attested to Michelangelo.
3. We can almost picture Mini and Michelangelo doodling and shoving this piece of paper back and forth to each other. Indeed, the paper may represent something of a drawing lesson for Mini. We see two drawings of the

Madonna and child by Michelangelo and Antonio's attempts to copy them.

4. At the bottom of the sheet, Michelangelo writes: "Draw, Antonio, draw, and don't lose more time."

C. Another drawing seems to show a similar lesson. A nice portrait has been drawn in the center, perhaps of Mini, but the attempts to copy it are inarticulate. Michelangelo's commentary on the sheet may be represented by the screaming head and the man defecating at the bottom.

1. The front of a sheet of drawings is called the *recto*, and the back is the *verso*. We almost always assign the recto to the most important drawing, and we assume that it is drawn first.

2. In this case, however, it's possible that Michelangelo and Mini were first doodling on one side of the sheet before Michelangelo turned the paper over and executed a truly beautiful drawing as an exemplar of fine draftsmanship.

3. We have about 600 drawings by Michelangelo, and we see many instances in which we might imagine similar circumstances. A drawing of Cleopatra, for example, may have begun with a pupil experimenting on one side of the sheet before Michelangelo turned it over and demonstrated his technique.

D. Even drawings that Michelangelo gave away as presents were sometimes used for multiple purposes. We see, for example, a drawing of Tityus on one side of a sheet transformed into a resurrected Christ on the other side.

III. The drawings for Tommaso de' Cavalieri.

A. *Ganymede* and *Punishment of Tityus* were among the first drawings made for Tommaso de' Cavalieri, a young Roman nobleman whom Michelangelo met at the end of 1532.

1. Ganymede is the cupbearer of Zeus, who is taken up to heaven because Zeus fell in love with the boy. Tityus, for his rape of Leto, was punished by having his liver eaten perpetually by a great eagle.

2. These two drawings are part of an outpouring of gifts that openly expressed Michelangelo's infatuation and admiration for Cavalieri. The young man reciprocated

the artist's feelings, serving as both inspiration and a willing pupil.

B. The early letters from Michelangelo to Tommaso de' Cavalieri are written in an overwrought, self-conscious prose, barely concealing the emotions that this older man felt toward the younger boy. Despite their difference in age and social station, Cavalieri responded positively to Michelangelo's halting overtures.

C. We know that together, Cavalieri and Michelangelo visited the church of Santa Maria in Aracoeli on the Capitoline Hill. There, they inspected a Roman sarcophagus bearing a representation of the fall of Phaethon.

D. Following this visit, Michelangelo created a magnificent drawing of the *Fall of Phaeton*.

 1. Phaeton is the young boy whose hubris leads him to ask Apollo, his father, to drive the chariot of the Sun. Phaeton drives wildly, and Zeus finally casts him down.

 2. Michelangelo sent what he considered to be a draft of the drawing to Cavalieri, promising to finish it if the young man was pleased. To our minds, this is a beautiful, fully finished drawing, but Michelangelo intended to make it even more spectacular.

E. Before Michelangelo could make the promised drawing, he was obliged to return to Florence and his obligations in San Lorenzo. However, he did send letters and poems to his young friend and, finally, in early September 1533, a finished drawing of Phaeton that caused a sensation.

 1. This is the same subject as the earlier drawing, except finely finished. Zeus is in the heavens, riding his eagle, while Phaeton is tumbling out of his chariot; the Earth gods are below.

 2. On receiving this drawing, Cavalieri, a bit bewildered, reported, "everyone in Rome wanted to see it." The young man didn't quite understand all the interest.

 3. The drawing is a miracle of the draftsman's art, a fully finished work, deliberately planned, perfectly composed, and beautifully executed. Its value has nothing to do with its humble materials but stems from its design by Michelangelo.

4. Almost immediately, cardinals and even the current pope came to see the drawing. It was copied into a rock crystal carving, such as the one we see here, and it was quickly engraved so that it could be reproduced for a widespread audience.

F. The same thing happened with some of the other Cavalieri drawings. The *Ganymede* was translated into paint and, subsequently, engraving. In this way, these private expressions of Michelangelo's love and admiration for Cavalieri entered the public realm.

G. Subsequent drawings Michelangelo presented to Cavalieri include the rather strange and enigmatic *Bacchanal of Children*. Scholars have searched for literary sources and precedents for this drawing for 500 years—to no avail. This undeniably peculiar drawing shifts the burden of interpretation to the recipient.

H. Michelangelo and Cavalieri declared their mutual admiration in an impassioned but socially acceptable correspondence and through the exchange of favors and gifts, including numerous drawings and a large body of love poetry. They remained friends for 30 years.

Works Discussed:

Santa Maria in Aracoeli, Rome, Italy.

Michelangelo:

Hercules and Antaeus and other Studies, red chalk on white paper, 11¼ × 16¾" (28.8 × 42.7 cm), The Ashmolean Museum of Art and Archaeology, Oxford, Great Britain.

Miscellaneous Sketches and a Poem, red chalk, pen and ink, 11¼ × 16¾" (28.8 × 42.7 cm), The Ashmolean Museum of Art and Archaeology, Oxford, Great Britain.

Madonna and Child, c. 1522–26, pen and brown ink, 15½ × 10⅝" (39.6 × 27 cm), British Museum London, Great Britain.

Heads and Figures, c. 1525–28, red chalk, 9¼ × 11¼" (23.5 × 28.7 cm), British Museum, London, Great Britain.

Ideal Head of a Woman, c. 1525–28, black chalk, 11¼ × 9¼" (28.7 × 23.5 cm), British Museum, London, Great Britain.

Drawing of Cleopatra, charcoal, 9⅛ × 7¼" (23.2 × 18.2 cm), Casa Buonarroti, Florence, Italy.

Punishment of Tityus, 1532, black chalk, 7½ × 13" (19 × 33 cm), The Royal Collection, London, Great Britain.

Ganymede, 1532, drawing, 14 × 10½" (36.1 × 27 cm), Fogg Art Museum, Harvard University Art Museums, Cambridge, Massachusetts.

Fall of Phaeton, 1533, black chalk, 12¼ × 8½" (31.1 × 21.6 cm), British Museum, London, Great Britain.

Fall of Phaeton, 1533, black chalk, 16¼ × 9¼" (41.3 × 23.4 cm), The Royal Collection, London, Great Britain.

Bacchanal of Children, 1533, red chalk, 10¾ × 15¼" (27.4 × 38.8 cm), The Royal Collection, London, Great Britain.

Artist Unknown:

Fall of Phaethon, ancient Roman sarcophagus, Galleria degli Uffizi, Florence, Italy.

Giovanni Bernardi da Castelbolognese:

Fall of Phaethon, 16th century, rock-crystal set in 19th century French frame, The Walters Art Museum, Baltimore, Maryland.

Alessandro Allori:

Rape of Ganymede (detail), 1562, oil on panel, 4' 6 ¾" × 7' 7¼" (139 × 232 cm), Museo Nazionale del Bargello, Florence, Italy.

Nicholas Beatrizet:

The Rape of Ganymede, 16th century, engraving, 16¼ × 10 ½" (41 × 26.3 cm), Fine Arts Museums of San Francisco, California.

Suggested Reading:

F. Hartt, *Michelangelo Drawings*.

M. Hirst, *Michelangelo and His Drawings*.

H. Chapman, *Michelangelo Drawings: Closer to the Master*.

W.E. Wallace, ed., *Michelangelo: Selected Readings*. See E. Panofsky, "The Neoplatonic Movement and Michelangelo."

R. S. Liebert, *Michelangelo: A Psychoanalytic Study of His Life and Images*.

Questions to Consider:

1. Were Michelangelo's friendships numerous? Were they healthy in character? Do you think that they were beneficial to him? How?

2. Drawings in the Renaissance were often discarded or burned. Why and how were Michelangelo's drawings for Cavalieri preserved?

Lecture Twenty-Five—Transcript
Michelangelo's Drawings, 1520-40

Hello. This lecture is about friends, laughing, and a remarkable series of drawings that Michelangelo made in the 1520s and 1530s, culminating really in those very, very special works that he presented to the Roman nobleman, his young friend, Tommaso de' Cavalieri. Now these small but precious creations helped to revolutionize attitudes towards drawings: a medium that once was considered preparatory and basically discardable became something suddenly worth collecting and treasuring.

But Cavalieri, the newest, is only one of many of Michelangelo's close friends, and as an introduction, sort of, to Michelangelo's many, many friendships, we should recognize that humor was an important ingredient of many of these relationships. Michelangelo was a Florentine and like many of his fellow Florentines, he loved wit and aphorism. We've already seen Michelangelo describing the colossus for Pope Clement VII's outlandish request for a marble monstrosity outside of San Lorenzo. And with his close friends—and there were a good number of them—Michelangelo exhibited a really genuine sense of humor, which is not what we generally think about this melancholic artist. But he could be both humorous and melancholic.

It's evident, for example, that Michelangelo thoroughly loved bantering with his friend, the Venetian painter, Sebastiano del Piombo. The two friends took huge delight in the fact that Sebastiano, an utterly unholy Venetian, was required to take holy orders prior to accepting the lucrative office of *Piombatore*—the keeper of the papal seal in the Vatican. Sebastiano joked to Michelangelo about his new appearance: "If you saw me you would surely laugh. I am the handsomest peacock in all of Rome." Sometimes, we can almost hear the two friends sort of chuckling, especially when reading one another's salty letters.

Once, Sebastiano wrote, "I know you will laugh at my chatter," and another time he amused Michelangelo when he told the Vatican, "Now wait a minute, it doesn't rain Michelangelos." But in turn, Michelangelo could also write highly amusing letters. One was so hilarious that Sebastiano passed it around the Vatican, and he wrote

to Michelangelo and said, "Nobody talks about anything else; it has made everybody laugh."

But Sebastiano was scarcely the only friend who amused Michelangelo. Giorgio Vasari reminds us that he often "roared with laughter" at the stories of his "very agreeable" friend Menighella, and one just doesn't imagine Michelangelo roaring with laughter. But he also enjoyed the company of Jacopo l'Indaco, a "gay and humorous" artist who seemed to amuse the master with jokes and mirthful chatter. Likewise, Michelangelo took delight in the simplicity of his good friend Giuliano Bugiardini, who actually helped him on the Sistine ceiling. He fondly dubbed Bugiardini "the beatified." And the stone carver Topolino, that assistant named the "Little Mouse," whose mediocre efforts at marble carving caused Michelangelo (quote from Vasari) to "nearly die from laughter."

So Michelangelo was also the friend of the burlesque and satiric poet, Francesco Berni, and the two of them exchanged humorous verses. When Berni wrote a poem praising the artist as *il divino*, Michelangelo responded facetiously, writing, "And good old Michelangelo, who still I think adores you, when he saw your screed just hit the roof with jubilance. What a thrill!" It's kind of nice to imagine Michelangelo hitting the roof with jubilance.

The artist's capacity for self-mockery is masterfully displayed when he wrote vividly of his aging body "packaged in here like the pulp in fruit compacted by its peel," and he wrote of his house as "a tomb where mad Arachne and her creepy crew keep jittering up and down, a spooky loom." This is just one of many sort of humorous poems Michelangelo wrote, and thanks to the wonderful translation by John Frederick Nims, this one gets even better, and I'd just like to read you a part:

> Urine! How well I know it—drippy duct compelling me awake too early, when dawn plays at peekaboo, then yonder—yuck!—dead cats, cesspool and privy slosh, pigpen guck—gifts for me, flung hit-or-miss? Can't trudge to a proper dunghill, gentlemen? Soul gets some help from body though in this: if guts, unclogged, could ventilate their smell no bread and cheese would keep it in duress, while round it now catarrh and mucus jell. Congestion blocks the postern

down in back. With all the phlegm, top exit's blocked as well.

And he goes on and continues. So although not generally recognized, humor is really a prominent aspect of Michelangelo's personality: wit, humor, aphoristic wisdom, they are legion in Michelangelo's poetry, correspondence, and drawings as well as in many anecdotes related about Michelangelo's life. And, in a curious fashion, humor occasionally was translated into fine art. And in this I'd like to consider the case of Michelangelo's pupil, Antonio Mini.

I'm showing you the drawing from the Ashmolean Museum that Michelangelo-like, what we're used to seeing, multitasked, doing a number of different things—working both small and large, designing a figural group of struggling figures, probably for a sculpture group for Piazza della Signoria that was never executed, a study of a leg—but already on the front of this sheet you begin to see something of Michelangelo's humor in this somewhat grotesque face.

But it's really the back that I'd like to direct our attention to on this sheet. Here you notice a kind of immense scrawl of squiggly and unimportant and sometimes amusing little drawings—a horse and rider here; a ladder; a giraffe very nicely drawn here with a rider on it; and then completely incompetently drawn over here, something that looks like it may have escaped from Jurassic Park. And there are a number of other totally incomprehensible drawings that are so poorly made that most people have not even thought to accept that this is Michelangelo's authorship.

But how do we explain then the other side of the sheet, absolutely securely Michelangelo's, with a bunch of drawings on the back? Some are drawn fairly well. The skull in the middle is certainly well drawn. And then there's this very curious little scatological drawing down here that's sometimes typical of Michelangelo's humor, rather scatological, what is in Italian called a *di rispetto* or disrespect.

And then over on top of all of it is an absolutely certain autographed sonnet written by Michelangelo on the left-hand side. So what I think we're seeing here is Antonio Mini and Michelangelo. We can almost picture them shoving this piece of paper back and forth across the kitchen table at one another. And some of them are Michelangelo's doodles and some are those of his pupil. But it wasn't just for humorous reasons.

Antonio Mini was an assistant to Michelangelo and was there largely to help him mostly as a secretary more than anything else. But in the course of assisting with Michelangelo's household chores, Antonio Mini also learned something of the proper manner to draw. And so we're looking at what is really a drawing lesson for Antonio Mini in this particular sheet. Michelangelo is drawing the Madonna and Child and is encouraging Mini to make a copy, which we see very, very lightly over on the right-hand side. Mini didn't get a very good start. He is not a very good draftsman. So Michelangelo reverses the sheet and tries to give the young man another try. He makes another drawing of the Madonna and Child and he encourages Mini once again to start drawing and make a copy. Rather incompetent.

And so finally Michelangelo at the bottom writes in his inscription, "*Disegni Antonio, disegni, e non perder il tempo.*" "Draw Antonio, draw, and don't lose more time." But I don't think any amount of time would turn Antonio Mini into a good draftsman. But it's a wonderful side of Michelangelo to sort of see this sort of infinite patience with incompetence, since Antonio Mini is really not there to learn to become a master artist, but is really helping the artist in many other capacities.

Let's take another example. Take a look at this sheet. Persons in the past have been inclined to reject it because not all these drawings are extremely competent. The one in the center is very interesting. The portrait here is very nice, but the copy of the portrait is utterly inarticulate, and what this seems to be is a drawing lesson again: a head drawn and redrawn over on the left-hand side, and actually in profile several times.

But how can we have this sort of combination of quality and less than quality? I think what we're looking at is another drawing lesson, in which Michelangelo has actually provided certain models. This very nice portrait—and this may even be a portrait of Antonio Mini—that he expects his assistant to try to copy. If we turn the sheet around, that screaming head is completely brilliant, and we might almost imagine it's Michelangelo's comment on this whole situation, like "Ahh, you must be able to draw better than that." There's another little comment here, too, as we see this man defecating here in the very bottom of the sheet.

We once again see a kind of very casual drawing lesson, drawing encounter between obviously more than just one individual: one very competent, one less competent. So does it surprise you that all of this sort of mess is on the back of this utterly exquisite head that has never been doubted as a Michelangelo? So how can we going about denying the back of the sheet to Michelangelo and yet accepting the front? We must imagine that someone at some point would have taken a Michelangelo drawing and drawn all these things on the back, including scatological drawings. It's really sort of impossible to imagine that anybody would deface the gorgeous work of art here in such a manner.

Much more likely would be just the opposite. A front of a sheet is called the *recto* and the back of a sheet of drawings is called the *verso*. We almost always assign the *recto* to the most important drawing. So this is called the *recto*, or the front, and so we assume that fronts of sheets are drawn first. But I'd like to suggest it might be just the opposite: that Michelangelo and Mini are drawing haphazardly a bunch of sort of silly drawings, and finally Michelangelo turns the sheet over, has a perfectly clean page and executes a truly beautiful drawing as a kind of exemplar of draftsmanship, of what was called *buon disegno* in the Renaissance.

And so we should not ever necessarily accept that the conventional front of a sheet is necessarily the first side that's actually drawn. And the more drawings of Michelangelo we look at, and we have nearly six hundred, we see many, many instances of this. So even on a beautiful sheet like the *Cleopatra* in the Casa Buonarroti, of course, this is called the *recto*. On the back is a much lesser drawing that's very hard to reproduce. But it's more likely that the back was sort of a first experiment, maybe possibly by the pupil, and then Michelangelo turns it over and in a way demonstrates if you want to draw Cleopatra, this is how she looks. And so a drawing lesson turns into a kind of work of art.

Even drawings that Michelangelo gave away as presents were sometimes used for multiple purposes. This is a drawing of Tityus that I'll come back to in just a second because it was given ultimately to Tommaso de' Cavalieri, but notice that before it left Michelangelo's possession, he drew the Tityus, and then turned the sheet over and he had drawn this figure darkly enough that he traced the outline of it on the back.

But then he also did a very characteristic thing. He transformed the mythological subject of Tityus into a resurrected Christ, so suddenly pagan mythology becomes a Christian subject. Now, he doesn't develop the drawing very much on the back, but he does, in fact, end up giving this sheet away. So Michelangelo is not at all averse to the idea that what he's really giving away is this very beautiful drawing on the front, and it's immaterial what's on the back.

This is the drawing of Ganymede and paired with it is the drawing of Tityus, as Michelangelo probably first intended it. Ganymede is the cupbearer of Zeus who is taken up to heaven because Zeus fell in love with the young beautiful boy. And Tityus, for his rape of Leto, was punished by having his liver eaten perpetually by a great eagle.

These are the first drawings that Michelangelo made or else gave to his Roman nobleman friend, Tommaso de' Cavalieri, shortly after meeting Cavalieri at the end of 1532. These two drawings are part of an outpouring of gifts in the form of poems and a number of highly finished drawings that openly expressed Michelangelo's infatuation and admiration for the youth. Indeed the choice of a subject like the *Ganymede* seems somewhat self-evident, that just as Michelangelo admires Tommaso de' Cavalieri, a young beautiful man, so does Zeus admire the young Ganymede. It's somewhat harder to explain the Tityus, but we'll hold that for a minute. Cavalieri reciprocated the artist's feelings, serving as both inspiration and a willing pupil, and indeed Michelangelo seems also to have done some drawing lessons for Cavalieri.

The early letters that Michelangelo wrote to Tommaso de' Cavalieri are in an overwrought, utterly self-conscious prose, and they barely conceal his surging of emotions that this much older man is feeling towards this younger boy. The numerous drafts and convoluted locution of the first letter amply attest to Michelangelo's awkwardness in sort of having the courage to take the initial step in cultivating a relationship with a much, much younger man. I'd like to read you part of this very first letter. This is how the letter begins:

> Inadvisably, Messer Tommao, [Tommao rather than Tommaso] my dearest lord, I was prompted to write your lordship, not in answer to any letter I had received from you, but being the first to move, thinking, as it were, to cross a little stream dry-shod, or rather what was apparently, from

its shallow water, a ford. But after I left the bank I found it was not a little stream but the ocean, with its overarching billows, that appeared before me; so much so that, had I been able, I would willingly have returned to the bank whence I came, to avoid being completely overwhelmed. But since I've got so far we'll take courage and go on.

It's almost impossible for the modern reader to understand what Michelangelo is really getting at. He's so falling over himself with graciousness. But despite their difference in age (more than 40 years) and their social station (Cavalieri is Roman nobility and Michelangelo comes from a much lower class of artist), Cavalieri nonetheless responded positively to Michelangelo's halting overture. He expressed surprise "that a man so excellent as you are [as he said] without peer on this earth, should wish to write to a young man like me hardly born into this world."

Michelangelo had sent Cavalieri two drawings (probably the *Tityus* and the *Ganymede*), which the young man in return promised to contemplate with pleasure for "at least two hours a day." Now, Cavalieri goes on and mentioned that although he was presently sick, he hoped that in just a few days he could call upon Michelangelo to pay his respects in person "if you are agreeable." Michelangelo was utterly elated and he immediately responded:

> Far from being a mere babe, as you say of yourself in your letter, you seem to me to have lived on earth a thousand times before. But I should deem myself unborn, or rather stillborn, and should confess myself disgraced before heaven and earth, if from your letter I had not seen and believed that your lordship would willingly accept some of my drawings. This has caused me much surprise and pleasure no less. And if you really esteem my works in your heart as you profess to do in your letter, I shall count that work more fortunate than excellent, should I happen, as I desire, to execute one that might please you.

So Michelangelo now is holding out the promise, not just of having sent a couple of drawings, perhaps things he had in the workshop left over to send to Cavalieri, to make something specifically to please the young man. Well, out of this rather halting beginning, the two, in fact, do develop a friendship. These kinds of sentiments don't sit well in the modern world, but I think we're far removed from the

kinds of sentiments that would have been common between people of such different age and different social station, and before we make judgments, let's reserve judgments and follow their friendship and how it develops, and see how then we can assess it.

Because shortly after, apparently, Tommaso de' Cavalieri did call upon Michelangelo, and together we know that they visited the church of Santa Maria in Aracoeli on the Capitoline Hill. It was about halfway between the two houses of de' Cavalieri and where Michelangelo was living in Rome. So from this very formal beginning, the friendship seemed to pass into its next phase, and within a few days the two visited this great church on the Capitoline Hill. Now inside this church, this great ancient Christian basilica, together they inspected a Roman sarcophagus that had a representation of the Fall of Phaethon.

So this is an older man, an artist, in a sense being a *cicerone* leading a younger around and showing him some of the ancient works of art, things that he admires. And apparently they admire this together, because following this visit Michelangelo created a magnificent drawing of the Fall of Phaeton, partly inspired by that ancient sarcophagus that they had looked at together. So it's in some way a kind of record of their visit and the next step in the way of their friendship.

It's a very beautiful drawing of the Fall of Phaeton. Phaeton is the young boy whose hubris leads him to ask Apollo, his father, to drive one day the chariot of the sun; and then he drives wildly, and Zeus finally casts him down, and we see Zeus sending a lightning bolt down and Phaeton being cast out of the chariot, the horses tumbling out of the sky and down into the river.

At the bottom of this drawing Michelangelo has added an inscription, "Messer Tommaso, if this sketch does not please you, tell [my servant] Urbino since I will have time to make another by tomorrow, as I promised; and if it pleases you and you would like me to finish it, send it back to me." Of course this is in Italian that he's writing this—Michelangelo has made the drawing of the Fall of Phaeton, given it to his servant, who has delivered it to the nobleman's house, and Michelangelo is essentially asking, "Do you like it and would you like me to really draw it?" So even though this is a beautiful, to our minds, fully finished drawing, Michelangelo intended to make an

even more spectacular object for the young man as a kind of record and as a work of art, as a gift.

Cavalieri was indeed pleased, but before Michelangelo could make the promised drawing he (the artist) was obliged to return to Florence. He was still engaged in the Medici Chapel and he has obligations in Florence, and cannot spend all his time in Rome. This enforced an unwelcome separation, however, prompting Cavalieri to write a friendly if facetious letter in which he wondered whether Michelangelo had forgotten him. Such gentle raillery elicited an extravagant response from Michelangelo. It's not that Michelangelo forgot Tommaso de' Cavalieri, maybe a week or two weeks had gone by and Michelangelo is enormously busy, but just that little sort of gentle raillery, "Have you perhaps forgotten me?" prompted Michelangelo to write back:

> I could [as soon] forget your name as forget the food on which I live—nay, I could sooner forget the food on which I live, which unhappily nourishes my own body, than to forget your name, which nourishes body and soul, filling both with such delight that I am insensible to sorrow or fear of death, while my memory of you endures.

Cavalieri then had to admit to having teased Michelangelo but only with friendly intentions. What he most desired was Michelangelo's return to Rome, where they could pick up their friendship. But Michelangelo could not return because of his obligations in San Lorenzo; but he did send letters and poems to his young friend and then, finally, in early September 1533, he sent a sonnet and this very finished drawing of Phaeton, which is in Windsor Castle. This drawing caused an utter sensation in Rome.

We see the same subject as in the British Museum drawing, except finely finished as if it's some kind of wrought jewel. We see Zeus in the heavens riding his eagle, Phaeton being tumbled out of his chariot, and the earth gods down below. Cavalieri reported on receiving this drawing that "everyone in Rome wanted to see it." He was a little bit overawed by all of the attention. He didn't quite understand. What did everybody want? But we're at a moment when Michelangelo is an enormously successful and internationally recognized artist. And suddenly people are realizing that Tommaso de' Cavalieri is getting these really rather special drawings. Cavalieri

was, nonetheless, very grateful for Michelangelo's intimacy and the two remained friends for 30 years.

This is really a miracle of the draftsman's art. It's a fully finished work of art deliberately planned, perfectly composed, beautifully executed. It's of utterly humble materials. It's a sheet of paper in black chalk. Its value has nothing to do with its materials; its value has to do with it's a design by Michelangelo. So we've inverted, in a sense, the whole scale of judging art from the earlier Renaissance, where the cost of materials really did matter. Now we're just seeing the idea of Michelangelo being realized in front of us.

Well, Rome went crazy. They just loved this, and almost instantly cardinals and even the current pope came to see this drawing. And it was almost immediately copied into a rock crystal carving. And rock crystal is a semi-precious medium. It's a unique object, nothing else like it in the world, and this particular one is in the Walters Gallery in Baltimore. It was probably carved for that admiring cardinal, but notice what's happened here. A rather inexpensive drawing has been turned into a rather expensive gem, a jewel. So the worth now is being added to it. It's not only a Michelangelo; it's also now translated into a precious medium. But it's not only the unique object of the crystal; it was very quickly also engraved, Michelangelo's drawing for Cavalieri. And engraving, of course, is a reproducible medium, and caused this drawing to have a widespread audience, and become, in a way, a widespread phenomenon.

The same happened for some of the other of the Cavalieri drawings. The *Ganymede* was almost immediately translated into paint and then subsequently into engraving, which means that many people could purchase or own such an object for a fairly inexpensive price. And recall the technique of engraving tends to, in this case, reproduce the image in reverse.

So suddenly these private expressions of love and friendship and admiration enter the public realm, and shortly thereafter in a subsequent moment Michelangelo also presented other drawings to Cavalieri, including this rather strange and enigmatic *Bacchanal of Children*. This is undeniably peculiar, but what it does is shift the burden of interpretation to the recipient. Michelangelo's not only taking, generally in his art, old subjects and reinterpreting them in new styles. Now he's inventing perhaps altogether new subjects.

People have been looking for literary sources and precedents for this drawing for five hundred years, and they never came up with any satisfying explanation about what this crowd of young babies is doing. People argue about whether this is a deer or some kind of other animal. They seem to be carrying it to a vat, and there are all kinds of other things strangely going on in this.

But the whole point is this is a private object. This is not a public thing to be understood by everybody in the world. Instead, it's something to be enjoyed by a connoisseur who, in conversation maybe with a few others, is going to enjoy them as something that is precious, something that causes us to imagine: What is the meaning of such an object?

Now, whatever we make of this drawing, and whatever we think we might make of their relationship, between Michelangelo and Cavalieri, it was not done in secret or in private. It was largely pursued in public. Throughout their long acquaintance, Cavalieri always acted with propriety and remained genuinely appreciative of the artist's friendship. The effusive, revelatory letter and the florid love sonnet, declaring passionate and intimate feelings, were perfectly acceptable genres of self-expression, whether it was written by the scholarly Erasmus or the less restrained Shakespeare. Michelangelo and Cavalieri declared their mutual admiration in an impassioned but socially acceptable correspondence, and through the exchange of favors and gifts, which included numerous drawings and a large body of love poetry.

Cavalieri went on to get married. Just once, many years later, Michelangelo took offense at some imagined slight, which prompted Cavalieri to reaffirm his friendship. He wrote: "I promise you, if you don't want me for a friend, you can say so, but you will never prevent me from being a friend of yours or from seeking to serve you." And this is precisely what Cavalieri did. He remained a faithful friend to the very end of Michelangelo's life.

Lecture Twenty-Six
The *Last Judgment*

Scope:

This lecture begins by focusing on a few more of Michelangelo's finished drawings, among his most admired works of art. We then turn to his first great work for Pope Paul, the fresco of the *Last Judgment* in the Sistine Chapel. More than 20 years after completing the ceiling of the same chapel, Michelangelo once again found himself painting a monumental work at the very heart of Christendom and papal authority, an eschatological vision of enormous scale and power. This lecture discusses the historical background and artistic precedents of this fresco, before undertaking an examination of the work's central and most important figures. As we are now aware from our familiarity with Michelangelo's art, bodily position and gesture, although sometimes ambiguous, are always highly significant.

Outline

I. Michelangelo's drawings, continued.

 A. Some scholars attribute fewer than 100 drawings to Michelangelo, while others believe that 600 is closer to the correct number. He made many more drawings but was known to have destroyed some at the end of his life.

 B. We begin with a drawing called *Three Labors of Hercules*. In his work, Michelangelo almost always began to the left of center; thus, we are fairly certain that the first group drawn was Hercules lifting Antaeus. The artist continues the drawing on the right, and then adds a third group in the constricted space on the left.

 C. Unlike the *Labors of Hercules*, no one has ever definitively identified the subject of the so-called *Archers*. A group of young men and one female are ostensibly shooting arrows at a herm (a kind of stone boundary marker), although none of them has bows, and they're all dancing, some even flying, in the nude.

1. Starting left of center, we can imagine that Michelangelo drew a fully articulated figure. He then adds figures, including the small group of boys blowing on a flame on the lower part of the sheet.
2. The artist may not have started this drawing with any particular subject in mind. He drew a beautiful, flying, dancing nude youth, then got caught up in his own imagination in adding to the picture. The result is puzzling but attractive.

D. *The Dream of Human Life* is another subject that has confounded scholars. Most people assume that the drawing was a gift for Tommaso de' Cavalieri, but that gives us little idea about its meaning or sources.

1. This kind of image shifts the burden of interpretation to the viewer. Instead of Michelangelo telling us what he has in mind, he gives us the opportunity to engage in discussion about the drawing's intent.
2. This, in turn, raises drawing from a discardable medium to high art. With Michelangelo, drawings become rare and precious, something worth collecting and treasuring.

II. Historical situation.

A. Michelangelo's transfer of his home base from Florence to Rome in 1534 was the most significant geographical and psychological shift in the artist's life. But before that move, he still had multiple obligations following the collapse of the Florentine Republic.

B. The last vestige of an independent government in Florence was stamped out when Alessandro de' Medici was declared duke in 1532. Florence was now ruled by an irrational and despotic Medici prince, who offered little safety and no peace for Michelangelo.

C. Alessandro tested the artist's loyalty to his family by asking him to design a new Fortezza del Basso in Florence. Michelangelo, loyal to the idea of an independent republic, could not stomach this imperialistic project or its patron.

D. When he received news of Pope Clement's fatal illness on September 20, 1534, Michelangelo slipped out of Florence, never to return.

1. The Medici Chapel was far from finished; indeed, many years later, its unfinished state was considered a disgrace.
2. Nonetheless, the chapel is still a noble and satisfying ensemble that eloquently celebrates the Medici family and moves us to reflect on the transience of earthly life and fame.

E. In 1534, with the election of Pope Paul III whom we see in a portrait by Titian, Michelangelo's professional life once again gained a measure of stability and security.
 1. The two men enjoyed a relationship of trust and mutual respect, based partly on the fact that they were both nearing 60 years of age.
 2. Both Paul and Michelangelo were also profoundly Christian men, committed to religious reform and to supporting the Catholic Church in the face of the Lutheran Reformation.
 3. Shortly after his election, Pope Paul saw to the renegotiation of Michelangelo's contract for the Julius tomb. He then employed the artist, first in painting the *Last Judgment*, then in decorating the eponymous Pauline Chapel.

F. Pope Paul's long pontificate (r. 1534–1549) was a glorious time for Michelangelo. He was at the apex of his fame, surrounded by friends and admirers, and working for a discerning patron.
 1. Paul entrusted the artist with projects that challenged him, helping him to become more than just a painter and sculptor. Michelangelo turned increasingly to architecture and helped transform the dilapidated ancient city of Rome into a modern Christian capital.
 2. We'll look at some of Michelangelo's contributions to the city of Rome in future lectures, including the Campidoglio, the Farnese Palace, the Sforza Chapel, and of course, St. Peter's.

III. The *Last Judgment*.
 A. The *Last Judgment*, painted on the altar wall of the Sistine Chapel, was begun in 1536 and completed six years later. In painting this fresco, Michelangelo was faced with the task of

complementing his earlier work on the ceiling. Although the two projects are dramatically different in style and subject matter, they are closely related as part of a larger Christian message.

B. Just as the ceiling, in a sense, represents the beginning of time, so the *Last Judgment* represents the end of Christian history. This is the culminating decoration for the Sistine Chapel—an eschatological vision of the end of time and the second coming of Christ.

C. We can get an idea of Michelangelo's approach to the *Last Judgment* by first looking at previous examples of Last Judgments, such as Giotto's in the Arena Chapel.

 1. The comparison reveals what would have been expected in a Last Judgment and how very different Michelangelo's version is. Because the subject is of such dogmatic importance, Giotto's composition is extremely clear and organized.

 2. In Giotto's fresco, Christ is high in the center, and the remainder of the fresco is composed in rigidly hierarchical registers. The composition is bisected by the central axis, dominated by Christ, who saves with his right hand and condemns with his left.

 3. Michelangelo follows a similar formula, although much more loosely. In his composition, we are confronted by a vast sea of humanity, seeming to rise and sink on either side of the central figure of Christ. As in the Giotto, Christ dominates the central axis, which bisects the fresco, leaving the saved on the left and the damned on the right.

D. A preparatory drawing for Michelangelo's *Last Judgment* allows us to witness the evolution of his thinking.

 1. In the middle of the central group is an idea that will be preserved in the final fresco: In the midst of this melee, an angel struggles against a figure attempting to mount to heaven.

 2. From the very beginning, Michelangelo designed a *Last Judgment* in which the question of who will be saved and who will be damned is not yet determined. There is still a struggle between the angels and the demons, and

both salvation and damnation remain possible. The idea that things are still in the balance and unfolding before our eyes is remarkably innovative.

E. Many other novelties become apparent as we examine some of the individual figures in this fresco.

 1. We all carry our own hopes and fears in looking at the *Last Judgment.* Those free of sin and guaranteed of heaven will see this as a happy moment, but most of us aren't in that category and might interpret the fresco quite differently.

 2. We may also be misled somewhat by Vasari's eloquent description of the fresco: "Christ is seated and turned with a terrible expression towards the damned, to curse them, while the Virgin, in great fear, shrinks into her mantle and hears and sees the ruin."

 3. We should keep in mind, however, that Michelangelo is always more ambiguous than he is polemical, and he allows for a range of emotions. We don't know, for example, whether Christ is seated, as Vasari states, or whether he is rising. The purposeful ambiguity of his action permits us to read it either way.

 4. The Virgin may be "fearful," as Vasari states, but her pose and gentle countenance may be read in just the opposite way, as an expression of humility. She huddles close to her son in a manner that prefigures the near fusion of the two that Michelangelo will explore in the Crucifixion drawings and two later *Pietà* sculptures.

 5. Some viewers, following Vasari, interpret the raised right arm of Christ as a vengeful gesture. But one does not damn with the right hand. Moreover, we might see the raised arm as setting in motion the Resurrection.

 6. Christ's powerful, muscular frame may lead us to sympathize with Vasari's reading, but his beardless Apollonian face suggests otherwise. His is not a "terrible expression," as Vasari said, but a face full of compassion, gentle rather than violent.

 7. Moreover, it's significant that Christ looks to the side of the damned, for those are the souls who still need salvation.

F. Let's look at some details of other figures and groups.

1. Peter is the large figure to the right of Christ, returning the keys of heaven. This is the second coming of Christ, when he alone judges the quick and the dead. Peter's services as protector of the gates of heaven are no longer required.

2. Andrew sets down his cross because he and all the martyrs have already accomplished their work of sacrifice. They are free of suffering and have earned their salvation and glory.

3. Sebastian, Catherine, and Blaise each hold the instruments of their martyrdom. Michelangelo initially painted the latter two figures nude, like almost all the other figures in the *Last Judgment*. This particular group, however, was singled out for criticism and later provided with clothing. We will consider some of these issues and other details of the *Last Judgment* in our next lecture.

Works Discussed:

Michelangelo:

Three Labors of Hercules, c. 1530, red chalk, 10 ¾ × 16½ " (27.2 × 42.2 cm), The Royal Collection, London, Great Britain.

Archers, c. 1530, red chalk, 8½× 12¾ " (21.9 × 32.3 cm), The Royal Collection, London, Great Britain.

The Dream of Human Life, c. 1533, black chalk, 15½× 11" (39.6 × 27.8 cm), Courtauld Institute of Art, London, Great Britain.

Last Judgment, 1536–41, 48 × 44', fresco, Sistine Chapel, Vatican Palace, Vatican City, Rome.

Last Judgment, 1536–41, black chalk, 15¼× 10" (38.5 × 25.3 cm), British Museum, London, Great Britain.

Titian:

Portrait of Pope Paul III (Pope from 1534–49), 1543, oil on canvas, 46 × 27¼" (117 × 69 cm), Museo Nazionale di Capodimonte, Naples, Italy.

Giotto di Bondone:

Last Judgment, c. 1305, Arena (Scrovegni) Chapel, Padua, Italy.

Suggested Reading:

H. Hibbard, *Michelangelo*.

C. de Tolnay, *Michelangelo: The Final Period.*

W. E. Wallace, *Michelangelo: The Complete Sculpture, Painting, Architecture.*

B. Barnes, *Michelangelo's Last Judgment: The Renaissance Response.*

W. E. Wallace, ed., *Michelangelo: Selected Readings.* See M. B. Hall, "Resurrection of the Body and Predestination."

M. B. Hall, ed., *Michelangelo's Last Judgment.*

Questions to Consider:

1. How does our knowledge of how Michelangelo approached the task of drawing help us to interpret some of the results?

2. Michelangelo often uses the whole body as "gesture" to communicate meaning. Yet, how we interpret gestures often depends on personal disposition and cultural context. A simple question is to ask whether Christ is sitting or standing. A more difficult question is how to "read" the gestures of Christ and his mother.

Lecture Twenty-Six—Transcript
The *Last Judgment*

In our last lecture we talked about some of the most beautiful drawings Michelangelo made for his friend Tommaso de' Cavalieri. Before moving on to our next major topic, the *Last Judgment*, I'd like to say another word about the character of Michelangelo's drawings, largely because they are such an important part of this production and yet not everyone is that familiar with what Michelangelo did for drawing and how many he made. There's a lot of argument in terms of the attributions of drawings. Some—most—restrictive scholars think as little as one hundred, but few think that, and probably many more think that six hundred is closer—but somewhere between that large range, in the hundreds—and these are just the ones that survived. He made many, many, many more, but at the end of his life also was known to destroy some.

It's also an extremely important part of Michelangelo's production because they were always admired. Not everything that we'll look at, including the *Last Judgment*, always maintained a high regard in people's eyes, but everybody thought that Michelangelo's drawings were an essential part of his contribution to the history of art, and perhaps in some ways we might consider them the most influential of the things he made.

So let's take a look at this example of the drawing from Windsor Castle, the so-called *Three Labors of Hercules*. Of course, there are 12 labors of Hercules, but let's, in fact, sort of watch how Michelangelo draws, because we too often take a drawing as if it's a complete thing planned out ahead of time. But in fact, Michelangelo works in a fairly consistent way, and if we take a sheet, he almost always works to the left of center of the sheet, and so we can be absolutely certain that this is the first group drawn here of Hercules lifting Antaeus.

And then after having drawn that group, the large part of the sheet still available to make a drawing on is over to the right, and this is clearly his second drawing on the sheet. And by now, he's interested in this project and draws a third in a rather constricted space over on the left-hand side. You notice how he's had to make the figure actually fit and bend right here in order not to overlap or interfere with the foot of the previous drawing.

So this gives us a kind of very, very basic guideline for realizing that drawings, of course, are sequentially made, and they're very rarely planned out ahead of time except in very unusual cases like the one we saw of the *Fall of Phaeton,* which actually had its own preparatory drawing. Let's take this drawing as another good example, also in the royal collection at Windsor Castle, the so-called *Archers.* But unlike the *Labors of Hercules,* nobody has ever really figured out exactly what this subject is—a bunch of nude youths and even one female are ostensibly shooting arrows at a herm, although none of them have bows and they're all dancing, some even flying, in the nude.

So let's think about rather how Michelangelo actually created this sheet, because what we end with is not necessarily what he was thinking of from the beginning. If we take our rule of thumb that Michelangelo works to the upper left of center, it becomes pretty evident from this redrawing of the sheet that this figure in the foreground was the first drawn on the sheet. It's in Michelangelo's preferred location. It's towards the foreground and it's a fully articulated figure. And then he likes the idea, and so he draws another figure just behind it, somewhat overlapped by the first, and then continues to draw in the available space a third figure in the foreground. And then finally, when most of the sheet is now filled, he draws a small group of young boys blowing on a flame at the lower part of the sheet and then gradually adds subsequent figures.

The point here is I'm not sure Michelangelo actually started drawing with any particular subject in mind. He drew a beautiful, flying, dancing, nude youth, and gradually added to it and added to it, and then gets caught up in his own imagination I think, and then creates an object that puzzles us, but is also enormously attractive.

So that leads me to ask, for example, in *The Dream of Human Life,* what exactly this is. This is another subject that has confounded most scholars. It's a drawing of uncertain purpose, and like each of these three I've just shown you, these are drawings of uncertain destination. We don't really know whether they were intended to do anything and whether or not they were intended as gifts for somebody.

This is the most finished of them all, and one does suspect that perhaps it was a gift drawing, and most people assume it might have

been a gift for Tommaso de' Cavalieri. We're not absolutely certain about that. And alternately we're basically struck with having very little idea about what this is really about, although multiple meanings have been suggested and multiple sources offered.

But what I think is significant here is that the image is shifting the burden of interpretation to the viewer; that instead of Michelangelo necessarily telling us what exactly he has in mind, he's giving us the opportunity to engage in learned discussion and a kind of connoisseurship for whatever lucky recipient was the receiver of this particular sheet.

What's really important here is that drawing has been raised to a high art. What has been traditionally a preparatory medium suddenly has become something that people would like—to have a drawing by Michelangelo. In fact, from about this moment on (1530) everybody wanted to have something from Michelangelo's hand, whether it was a sculpture, a painting, which they were very unlikely to get, but perhaps you might be lucky enough to be given a drawing such as this.

So normally drawing up to this moment, really, in Renaissance history was a discardable medium. It was nothing but preparatory, and once you made use of it, you could throw it away. But instead, Michelangelo is making drawings that are rare and precious, something that's worth collecting and treasuring.

So these are really rare examples of Michelangelo's art, and they were kept, admired, and copied as precious and valuable objects. Indeed, these are some of the very first drawings in the history of art ever to be considered as collectors' items.

Now let's turn to the next major episode in Michelangelo's life, but let's review our historical situation because we are at a point in our course, it is a very significant break—the transfer from Florence to Rome. This is the most significant geographical and probably the most significant psychological shift in Michelangelo's life. Although he never knew that he was going to spend the rest of his life in Rome, this is the moment when he makes that transfer to a familiar city, but never would he return to home again.

But before that happens in 1534, he has multiple obligations still following the collapse of the Florentine Republic. Michelangelo has spent increasing amounts of time in Rome during this period after

1530, partly because he was unhappy and uncomfortable in a defeated and humiliated Florence, and now partly because he was so much happier in Rome, in large measure because of a newfound friendship with Tommaso de' Cavalieri. So despite promises to concentrate on completing the Medici Chapel, Michelangelo made actually three different, and increasingly longer, sojourns to Rome between the years 1532 and 1534.

The last vestige of an independent government in Florence was stamped out when Alessandro de' Medici (who was a bastard son of Pope Clement VII) was declared duke in 1532. This was the first duke that Florence ever had, and from this moment on it would be a dukedom. Florence was now ruled by an irrational and despotic Medici prince, who offered little safety and no peace for Michelangelo.

Alessandro, knowing that Michelangelo had worked for many years for his family, displayed open animosity towards the artist, and tested his loyalty by asking him to design a new Fortezza del Basso in Florence. But Michelangelo, loyal to the idea of an independent republic, could not stomach this imperialistic project nor the patron. So like other sympathizers and supporters of the republic, Michelangelo began to fear for his life, and he longed to find an excuse to escape Florence.

So virtually the moment he received news of Pope Clement's fatal illness on September 20, 1534, Michelangelo prepared and slipped out of Florence the following day, never to return. Michelangelo the Florentine would never see Florence again.

The Medici Chapel was far from finished; indeed, many years later, its unfinished state was considered a disgrace. Michelangelo had placed the two statues of the dukes in their niches, but the four allegories were still on the ground, and the floor itself was not laid for more than two decades. The tomb of Giuliano was patched together rather hastily and the double tomb of the Magnifici, the very centerpiece of the entire chapel, was never even begun.

The *Madonna* that we discussed that now adorns the unarticulated wall recess was still in Michelangelo's studio in 1549, fifteen years after Michelangelo's hasty departure from Florence. So really, despite its unfinished state, I would say the chapel is still a noble and satisfying ensemble that eloquently celebrates the Medici family and

moves us to reflect on the transience of earthly life and fame. So even in its truncated or torso-like state, the chapel is still what Michelangelo seems to have conceived it as, and it works very effectively as such.

But now Rome, where Michelangelo would spend the remaining 30 years of his long life: He first came to Rome in 1496 as a 21-year-old youth; he was lured again in 1505 with the prospect of working on the tomb of Julius II; and then he was summoned by that same pope in 1508 to decorate the Sistine Chapel.

So by 1534, Michelangelo had spent virtually a dozen years in the city, and it had become something of a second home. He had a number of close friends and numerous ties, especially in the large community of Florentine expatriates, people who had fled Florence, including Donato Giannotti, Niccolò Ridolfi, Bindo Altoviti, and Roberto Strozzi. All of these are now exiles from a hostile Florence. Now Michelangelo was always somewhat timid as a political figure, and for political reasons, he was cautious about these associations; however, these are the persons who will repeatedly appear in Michelangelo's life during the next 30 years.

With the election of Alessandro Farnese as Pope Paul III—shown here in a portrait by Titian—when he was elected in October of 1534, Michelangelo's professional life once again gained a measure of stability and security. Of course, Michelangelo lost a great patron and an acquaintance of more than 40 years when Pope Clement VII died; but with the elevation of Pope Paul III, I think he gained an even greater patron, a greater friend and protector.

There was a trust and a mutual respect between these two men, based in no small measure on the fact that they were old, and virtual contemporaries. At the time of Paul's election, both Paul and Michelangelo were nearing 60 years of age, two profoundly Christian men committed to religious reform, and to supporting the Roman Catholic Church, especially in the face of the Lutheran Reformation.

So despite the better-known relationship with Pope Julius II, and the very long acquaintance that Michelangelo enjoyed with Pope Clement VII, I would actually argue that Paul was probably Michelangelo's greatest patron of all.

Vasari relates the wonderful story that shortly after his election, Paul summoned Michelangelo, and after paying him some compliments and making him various offers tried to persuade him to enter his service and remain near him. Michelangelo refused, saying that he was bound under contract to the duke of Urbino for the tomb of Julius II. But then the pope got rather angry and said, "I have nursed the ambition to employ you for 30 years, and now that I'm pope I am going to be satisfied. I'll tear the contract up," he implied. "I'm determined," he said, "to have you in my service, no matter what."

Now of course, the angry pope did not tear up the Julius II contract, but what he did do is help facilitate its renegotiation, and then he subsequently employed Michelangelo, first on the *Last Judgment*, then in decorating the eponymous Pauline Chapel, as well as numerous architectural projects.

Genuinely interested in the artist's creations, Paul once asked Michelangelo if he would kindly receive him in the Sistine Chapel and to show him the progress on the *Last Judgment*. It's a delightful glimpse of an unusual friendship—the artist giving a tour to a knowledgeable connoisseur.

Vasari was perhaps exaggerating when he wrote that "Paul felt for Michelangelo such reverence and love that he always went out of his way to please him." On the other hand, Vasari actually knew this relationship rather closely, and at Vasari's age, he knew it first hand, and Michelangelo's own words and behavior tend to support Vasari's characterization.

When his nephew, for example, regularly sent Tuscan wines and fruits to Rome (Michelangelo always missed some of those Tuscan products), Michelangelo frequently would share them with the pope. One year he gave him ten flasks of Trebbiano wine. The next year it was 33 Tuscan pears.

Pope Paul's very, very long pontificate, from 1534 to 1549, were really glorious years for Michelangelo. He was at the very apex of his fame, surrounded by friends and admirers, and working for one of the most discerning patrons of all time. Paul entrusted Michelangelo with projects that challenged him, and so Michelangelo became more than just a painter/sculptor. Michelangelo turned increasingly to architecture and helped transform a dilapidated ancient city into a modern Christian capital.

Michelangelo's contribution to the future of Rome lay in the sort of scale and the audacity of the vast number of projects he undertook. Think of them all: the Campidoglio, the Farnese Palace, San Giovanni dei Fiorentini, Santa Maria degli Angeli, Porta Pia, the Sforza Chapel, and, of course, Saint Peter's. All of these will be subjects of future lectures.

But the first project for Pope Paul was the *Last Judgment*, painted on the altar wall in the Sistine Chapel. Giorgio Vasari, especially in his first edition, considered the *Last Judgment* the culminating work of Michelangelo's career, what he called "the great exemplar of the Grand Manner of painting." And so it remained, really, until the end of the 18th century. Begun in 1536 and completed six years later.

But please attempt to imagine the unusual circumstances that Michelangelo was facing in creating the *Last Judgment*. Few artists are ever forced to confront their earlier work and, in a sense, faced with the task of "complementing it." But this was the case when Michelangelo received the commission to paint the *Last Judgment*, 24 years after completing the ceiling in the very same chapel.

While the two projects are dramatically different in style and subject matter, they are also closely related—physically and as part of a larger Christian message. Think about it. Every day that Michelangelo mounted the scaffold to paint the *Last Judgment* he confronted and pondered his earlier masterpiece. Beginning at the top of the wall, as is the typical manner in fresco painting, his new work directly abutted and partly obliterated the old. So what thoughts passed through his mind, now painting in the midst of the Catholic Reformation, four popes and nearly a quarter century after the Sistine Chapel?

As the ceiling, in a sense, represents the beginning of time, so the complementary *Last Judgment* represents the end of Christian history. This is the culminating decoration for the entire Sistine Chapel—an eschatological vision of the end of time and the Second Coming of Christ.

In November of 1536, Pope Paul released Michelangelo from the Julius tomb in order to work exclusively on the *Last Judgment*, thereby relieving the artist of his most chronic anxiety. After the clamor and distraction of the previous few years—much disruptive—Michelangelo could now turn his full attention to the giant fresco.

This was the first project he carried out for Pope Paul, and he threw himself into it with characteristic intensity.

Let's get an idea of what Michelangelo conceives and how he works on the *Last Judgment* by first looking at the previous examples of Last Judgments, but I'll choose only one. Let's use Giotto's in the Arena Chapel. Many artists before Michelangelo had painted the subject; notably, the example by Giotto may even have been known to Michelangelo.

The comparison is illuminating. It partly reveals what would have been expected in a Last Judgment and it shows how very, very different Michelangelo's is. Because the subject is of such dogmatic importance, the composition, especially as we see in Giotto's, is arranged in an extremely clear, highly organized fashion.

Christ is high in the center surrounded by a circular, mandorla-like halo, and the remainder of the fresco is composed in rigidly hierarchical registers, from the lower earthly to the higher heavenly realm. So it's a kind of layer cake of figures. The composition is bisected by the central axis dominated by Christ, with an importance accorded to the left and right: Christ saves with his right hand and condemns with his left—which is just the reverse of left and right as we view the fresco. But from now on in our discussion I'm going to use left and right as we're looking at the picture, only when I talk about particular gestures of Christ. It doesn't really matter that we get our left and right exactly right.

Now let's turn and look at Michelangelo's version of this. He follows essentially the same formula, although much more loosely. The composition is much less rigidly organized in registers. Rather we are confronted by a vast sea of humanity, on one side seemingly to rise, and on the other to sink around the central figure of Christ. Similar to Giotto, Christ does dominate the central axis, which bisects the fresco into left and right halves, the saved on our left and the damned on the right. So it's not unlike the formula of Last Judgments, but it's nonetheless, as everything with Michelangelo, somewhat different.

We can follow in a way how he came about this, in looking at some of the preparatory drawings. We'll just look at one. This one in the British Museum permits us to witness Michelangelo's evolving evolution of creation. We see really here characteristically that he's

working on both large and small scale, as we oftentimes see, working at details of individual figures at the same time he's making studies for larger groups.

So there's a great interest in evolving a sort of dynamic central group here, and if we note at the center of it is an idea that will be preserved in the final fresco. In the midst of this melee we'll see an angel struggling against a figure attempting to mount to heaven. This idea will be preserved in the final fresco, but it also raises a more interesting and important issue.

Michelangelo from the very beginning is designing a *Last Judgment* in which it is not yet certainly determined who will be saved and who will be damned. There is still a struggle between the angels and the demons, and salvation remains possible. Damnation still remains possible. The whole idea that things are still in the balance and unfolding before our eyes is a key notion that's preserved in the final fresco, but it's also remarkably innovative. It's less dogmatic than it is compelling.

Many other novelties about this fresco will become apparent as we examine some of the individual figures, but let's begin with the two most important: Christ and his mother. First and foremost, we should note the important role accorded to the Virgin Mary, as remember, the Sistine Chapel is dedicated to her. Nonetheless, it's very uncommon in the Last Judgment to have Mary playing such a prominent role. What exactly is she doing? And what exactly is Christ doing? These would seem to be key elements we must really understand to understand the *deus ex machina* that's unleashing all that we're seeing.

I actually think we all bring our own hopes and fears when we look at the *Last Judgment*. Those free of sin and guaranteed of heaven will see this as a happy moment, but the majority of people aren't like that. Those who feel their sins weighing on their conscience could potentially interpret Michelangelo's fresco very, very differently.

And I also think we've been misled somewhat by Vasari's very eloquent description of the fresco. Vasari wrote that, "Christ is seated and turned with a terrible expression towards the damned, to curse them, while the Virgin in great fear shrinks into her mantle and hears and sees the ruin."

I'd really like to take issue with this description, and propose a fundamentally different interpretation of what we're looking at. First and foremost, I would insist that Michelangelo is always more ambiguous than he is polemical, and he allows for a range of diverse and sometimes contradictory emotions. Similarly, his art allows for a range of dissimilar and sometimes ambiguous interpretations. We shouldn't be insistent in anything we say about the *Last Judgment,* including anything that I say to you.

The ambiguity begins with the very pose of Christ: Is he seated, as Vasari states, or is he rising? The purposeful ambiguity of the action permits us to read it actually either way, and different people will say different things. And so in doing so, we invest Christ with movement. We saw this as early on as the *Doni Tondo,* the uncertainty and the ambiguity of movement lending a kind of activation to the whole composition.

How about the Virgin? The Virgin may be "fearful" as Vasari states, but I'd suggest that her pose and gentle countenance may be read just the opposite, as expressing extreme humility. She huddles close to her son in a manner that recalls the near fusion of mother and son that Michelangelo will further explore in late Crucifixion drawings and finally in the two late sculptures of the *Pietà* that he carves.

Some viewers, following Vasari and reading the gesture of the raised right arm of Christ, interpret him as vengeful, about to cast the damned into hell. But one does not damn with the right hand. Moreover, we might see the raised arm as setting in motion the Resurrection. He's bringing them to heaven. He's helping them rise.

Christ's powerful, muscular frame may lead us to sympathize with Vasari's reading, but if we take a closer look at his face, he's beardless, he's Apollonian in his beauty—these suggest otherwise. This, I would say, is not a "terrible expression," as Vasari said, but a face full of compassion, gentle rather than violent. Moreover, it's significant that Christ looks to the side of the damned, for those are the souls who need salvation. The Lord looks with gentle countenance, as if hoping to save one more soul before the damned disappear into hell's maw. The saved are already saved, and he leaves them in the care of his mother.

Let's take a look at some details of the individual figures and groups.

We can start with Peter, the large figure to the right of Christ, who returns the keys of heaven; for this is the Second Coming of Christ, when He alone shall judge the quick and the dead. Peter's service as protector of the gates of heaven is no longer required.

Andrew sets down his cross because he and all the martyrs have already accomplished their work of sacrifice. They are free of suffering and have earned their salvation and glory.

In this group of Sebastian, Catherine, and Blaise, Sebastian kneels in the pose of an archer and holds a clutch of arrows with which he was tormented. We see Catherine holding a portion of the spiked wheel on which she was tortured. And behind her is Saint Blaise, who holds the combs that were the instruments of his particularly gruesome martyrdom.

Michelangelo initially painted these latter two figures nude, like most all of the other figures on the ceiling and in the *Last Judgment*. They were, however, singled out for special criticism—an instance of contemporary censorship and controversy that I will consider in a subsequent lecture. The result was that they were provided with clothes, and many other nudes were swathed with somewhat illogical loincloths. But many of these issues and some of the other details of the *Last Judgment* we will consider in our subsequent lecture.

Lecture Twenty-Seven
The *Last Judgment*, Part 2

Scope:

In this lecture, we continue our examination of the *Last Judgment*, the work that served as the culmination of the first edition of Giorgio Vasari's *Lives*. In particular, we will look at individual figures and details, both to demonstrate Michelangelo's inventive capacity and to reveal the unconventional nature and multiple meanings of the gigantic fresco. We will conclude with a discussion of the reception of the fresco, which was not always positive. There was, in Michelangelo's own lifetime, a sharp controversy regarding the nudes, an issue that has reverberated down to our own time.

Outline

I. Artistic absorption.

A. Michelangelo was completely absorbed in his work on the *Last Judgment* between 1536 and 1541, and we catch only occasional glimpses of the artist in the historical record.

B. Every day that he was in the Sistine Chapel, Michelangelo worked in the shadow of his own earlier masterpiece. And he was now working in a dramatically changed world: The once universal Catholic Church was now confronted by the Protestant Reformation.

II. Returning to the fresco.

A. The figures on the central axis below Christ in the *Last Judgment* are the seven trumpeting angels described in the book of Revelation. They are a clarion call to us, and we are meant to hear their trumpet blast.

1. Two of the angels hold books, a large book for the names of the damned and a small one for those who are saved.

2. In the lower left of the vast fresco, we see the dead issuing forth from their graves. The skeleton that is about to rejoin its envelope of reawakened flesh is a powerful visualization of the Catholic belief in the

resurrection of the body.

B. In the lower left corner, we see the reborn bodies physically assisted in their ascent to heaven by angels. In one instance, an angel drags a soul up to heaven by a set of rosary beads. In the lowermost corner are two figures crawling from what appears to be a primitive rock tomb or cave. They may be Adam and Eve, the first people on Earth and the first to be released from purgatory.

C. A monk in the lower left corner blesses and assists the saved and reminds us of the important role of the Catholic Church—its priests and rituals—as intermediaries between God and man.

 1. In contrast, the Protestant Reformation asserted the belief in a direct relationship between humanity and God.

 2. The detail of the monk, along with the angels, the rosary beads, and Mary and the saints, serves to remind us that our only hope for salvation rests with the Catholic Church.

III. The damned.

A. In contrast to the side of salvation, there is little hope for the damned on the opposite side of the fresco. While the angels help the saved on the left side, they assist in violently thrusting the damned into hell on the right. Notice the angel physically knocking a soul into hell; around this figure's neck is a moneybag, also dragging him down.

B. Michelangelo's hell is a fascinating compilation of torment. We see, for example, Charon wielding his oar, driving a torrent of doomed souls from his boat and into the lowest depths of a flaming hell.

 1. Charon, of course, is a figure from Greek mythology who ferries souls across the rivers of Hades.

 2. The damned tumble from Charon's boat and, disconcertingly for the viewer, seem to spill into our space.

 3. This fearsome vision of the future is painted very close to eye level, meant to inspire terror in viewers.

C. One figure makes an indelible impression—the very image of hopeless damnation. As he is dragged down by demons, he looks directly at the spectator, the only living figure in the entire fresco to do so.

 1. This figure is situated along the line of Christ's sight, approximately halfway between Christ and eternal damnation. Perhaps there is still time to make an appeal to Christ's mercy.

 2. The fact that his fate may still hang in the balance reminds us that ours does, as well. Contrary to the teachings of Martin Luther, our destiny is yet to be determined. Before such an image, we are made aware of our sins but also reminded that salvation and resurrection of the body are still attainable with the second coming of Christ.

D. In the lowermost corner of hell, ass-eared Minos is tormented by a serpent that circles his fleshy body and bites his genitals. Minos is another figure from Greek mythology, the exemplar of the bad judge, who won his ears for preferring Marsyas over the god Apollo in a musical contest.

 1. According to Vasari, Michelangelo's Minos is a portrait of Biagio da Cesena, a church official who asserted that the nude figures in the *Last Judgment* were inappropriate for a papal chapel.

 2. When Biagio pleaded with the pope to have the unflattering portrait removed, Pope Paul declared that while he had some influence with heaven, he had no such authority over hell.

E. Close to Christ is the figure of Bartholomew, who holds the signs of his horrific torture, a knife and his flayed skin.

 1. Some people have recognized Michelangelo's own distorted features in the limp folds of Bartholomew's epidermis.

 2. Perhaps conscious of the excessive hubris of imagining and representing a future event such as the Last Judgment, Michelangelo has portrayed himself as a discardable bit of human flesh, held tenuously over hell.

IV. A sacred topography.

A. Looking up to the fresco from the vantage point of the floor, we see the Lord, surrounded on either side by the Virgin Mary and a legion of apostles and saints, who intercede on our behalf.

 1. These figures are proportionally much larger than many others in the lower registers of the fresco, partly to correct for the great distance from which they are seen and partly because they are larger than life; they are the blessed who populate heaven.

 2. Departing from the convention of representing the apostles and saints as complacent beings enthroned on either side of Christ, these are soldiers of Christ who are still laboring to save sinners.

B. To a greater extent than might generally be recognized, a number of Michelangelo's commissions, including the *Last Judgment*, are related to the Catholic veneration of saints and relics.

 1. Some of the earliest works of the artist were made to adorn the tomb of St. Dominic in Bologna; more significantly, the Rome *Pietà* and the *Risen Christ* have strong topographic associations, recalling important sites and relics in early Christian Rome.

 2. Shortly before beginning the *Last Judgment*, Michelangelo also designed the reliquary tribune in San Lorenzo for the storage and display of the Medici collection of relics.

 3. These examples serve to remind us of the central importance of relics for Michelangelo and for the Renaissance in general, both as objects of devotion and as creative inspiration.

C. As the recent experience of the Holy Year 2000 testified, Christian pilgrimage is still very much alive.

 1. In the Renaissance, Rome was one of the primary destinations of pilgrims, where they could visit an astonishing number of shrines, relics, and places associated with the saints and the apostles, including the tomb of the apostle Peter.

 2. Rome has more than 1,000 churches, but among these, seven have been granted special privileges and constitute

obligatory stops on a pilgrim's itinerary. Five of these churches are the patriarchal basilicas, which enshrine some of the most important relics of the Christian faith.

3. The five holy figures—Peter and Paul, John, Lawrence, and Mary—clustered around Christ in the *Last Judgment* recall the names of the five patriarchal basilicas.

4. Further, these figures, unlike most of the hundreds of others in the fresco, all bear attributes and are, thus, readily identifiable.

D. After visiting the shrines of Rome, to stand before Michelangelo's *Last Judgment* is to stand in the presence of Christ and the saints.

1. In the mind of the devout, especially one fresh from the experience of pilgrimage, the painting might have stimulated recollection of the pilgrim's actual experience of Rome.

2. In a sense, then, artistic composition becomes a kind of geography: The wall is a visual topography of the most important Christian sites. Looking becomes an analogue to pilgrimage, a sort of retracing of the pilgrim's itinerary.

3. This observation arises from personal experience. Not Catholic, nor even especially pious, I saw this aspect of Michelangelo's *Last Judgment* following a visit—in one day and by foot—to the seven pilgrimage churches during Holy Year 2000.

V. Nudity in the *Last Judgment*.

A. Even before the fresco was completed, complaints were lodged about the inappropriateness of the large number of nudes in the papal chapel. In the face of this controversy, El Greco, who was then resident in Rome, even offered to repaint the fresco.

B. In Michelangelo's own lifetime, his friend and pupil Daniele da Volterra was commissioned to cover some of the most egregious nudes with drapery. Among other changes, Daniele covered the breasts of St. Catherine and changed the direction of Blaise's look to obviate the suggestion of sodomy.

C. In 1990, before the conservation campaign, there was much discussion about whether or not to remove the draperies. The final decision was to remove later additions but retain the Daniele interventions.

VI. The impact of the fresco.

A. In describing the *Last Judgment*, Vasari invoked Dante, the poet of damnation and salvation so admired by Michelangelo. Like Dante, Michelangelo has created an unforgettable vision of heaven and hell.

B. At the time of the unveiling of the *Last Judgment* in 1541, Pope Paul had already determined that the artist's next project would be the newly completed Pauline Chapel, the subject of our next lecture.

Works Discussed:

Michelangelo:

Last Judgment, 1536–41, fresco, Sistine Chapel, Vatican Palace, Vatican City, Rome.

Suggested Reading:

H. Hibbard, *Michelangelo*.

C. de Tolnay, *Michelangelo: The Final Period*.

W. E. Wallace, *Michelangelo: The Complete Sculpture, Painting, Architecture*.

B. Barnes, *Michelangelo's Last Judgment: The Renaissance Response*.

W. E. Wallace, ed., *Michelangelo: Selected Readings.* See M. B. Hall, "Resurrection of the Body and Predestination."

M. B. Hall, ed., *Michelangelo's Last Judgment*.

L. Partridge, et al., *Michelangelo, The Last Judgment: A Glorious Restoration*.

Questions to Consider:

1. Is the nudity of the *Last Judgment* bothersome to you? Is it appropriate for its time and place? Is it appropriate now? Had you been part of the Vatican team of conservators would you have removed or preserved the draperies not painted by

Michelangelo?

2. Do the *Last Judgment* and the Sistine Chapel vault work together as a coherent artistic ensemble? How is that possible, given the first was painted with no foreknowledge that the *Last Judgment* would come later?

Lecture Twenty-Seven—Transcript
The *Last Judgment,* Part 2

This is the second of two lectures on Michelangelo's *Last Judgment*, the great fresco that adorns and dominates the altar wall in the Sistine Chapel. But before continuing our discussion, I'd like to provide some biographical context for what we are seeing during the six years that Michelangelo worked on this fresco.

There are less than 40 letters to and from Michelangelo during the almost six years that he worked on the *Last Judgment*, between 1536 and 1541. In contrast, there are more than four times as many letters from the previous five years. Now this may be a fault of loss, but it also, I think, reflects the artist's total absorption in his work. He was so busy that when his nephew expressed a desire to come visit in Rome, along with his brother-in-law, Michelangelo wrote and put them off, saying, "to have to do the cooking would be too much; it would be the last straw."

And we catch only occasional glimpses of the artist at work, as when at one point he stormed out of the Vatican ("*con gran furia*"), he writes, because his beautiful figures would be damaged if the chapel were not immediately repaired. We don't know exactly what the matter was—was the roof leaking or was the wall excessively damp? We're uncertain. And then, just shortly before he completed the *Last Judgment*, he actually fell from the scaffolding and injured his leg.

But except for these very isolated glimpses, the documentary record, which is so rich in the details of Michelangelo's life just prior to his work on the *Last Judgment*, is comparatively silent for nearly the entire time he's working on the great fresco. So what thoughts passed through the mind of the artist, painting his first fresco in nearly 25 years? Every day that he worked in the Sistine Chapel, he worked in the shadow of his own earlier masterpiece, the great ceiling. And he was now working in a dramatically changed world: The once universal Catholic Church was now confronted by the Protestant Reformation.

Here, we see the only other group of figures on the central axis below Christ, the seven trumpeting angels that are described in St. John's book of Revelation. They are a clarion call to us, and we are meant to hear their trumpet blast. They call forth the dead. And we see two of the angels actually holding a large book and small book,

open for us to peruse the inscribed names, suggesting, as this angel faces the damned, that many are damned, and this, the smaller book, that only a few are saved. In the very lower left of this vast fresco, we see the dead literally issuing forth from their graves. The skeleton that is about to rejoin its envelope of reawakened flesh is a powerful visualization of the Catholic belief in the resurrection of the body. Thus is affirmed, more convincingly than in reams of written dogma, a fundamental Catholic belief that there *is* life after death and that one's soul will be reunited with one's earthly body and will rise to heaven intact.

In the lower left corner of the fresco, we see the reborn bodies physically assisted in their ascent to heaven by angels. In one instance, we see an angel here actually dragging a soul up to heaven by a set of rosary beads, or prayer beads, used in the Catholic faith. In the lowermost corner are two figures crawling from what appears to be a primitive rock tomb or a cave, suggesting a time far removed from the present. I wonder if these are not Adam and Eve, the first persons on Earth and the first to be released from purgatory.

Also in this area of the fresco is this detail of a monk. It's possibly a portrait. He blesses and assists the saved and reminds us of the important role of the Catholic Church, of its priests and its rituals, as intermediaries between God and man. This is especially important in the face of the contemporaneous Protestant Reformation, which taught man to believe in the direct relationship between humanity and God. Such a detail as this monk, along with the angels, the rosary beads, as well as the prominence of Mary and the saints, all serve to remind of us of the important role of the Catholic Church, its priests, its rituals, and its symbols. Our hope for salvation, the *Last Judgment* strongly affirms, rests within the bosom of the church.

In contrast to the side of salvation, there is little hope for the damned on the opposite side of the fresco. While the angels assist the saved on the left side, so do they assist in violently thrusting the damned into hell on the right. Here we see an angel physically thrusting, knocking a soul into hell. And notice how the heavy moneybag, golden-colored, around this figure's neck helps to drag the sinner down. Of course, remember we pay in hell for our sins on Earth, so clearly, this was a moneylender or a miser.

Partly inspired by Dante and medieval representations of damnation, Michelangelo is equally imaginative about the fallen state of humanity, and so hell is a fascinating compilation of torment. Here, we see Charon wielding his oar. He drives a torrent of souls from the boat and into the lowest depths of a flaming hell. Charon, of course, is a figure from Greek mythology who ferries souls across the rivers of Hades. So this is another case, among many that we have seen in this course, of Michelangelo reconciling the worlds of Classical learning and Christian theology. Note the protuberant eyes on the figure of Charon and the fear on the faces of the damned, who cannot bear the torment of sound. The damned tumble from the boat, and disconcertingly for the viewer, they seem to spill into our space. Note the figure that's dragging one of the damned from the boat, here in the lower part, and then behind, another who voluntarily climbs out of the boat, as if already resigned to his fate. The details are numerous; it's a fearsome vision of our future, all very close to our own eye level, these figures. They're meant to inspire terror in sinners and in the viewers of the fresco.

This damned soul is dragged downwards by devils. He makes an indelible impression, as he is the very image of hopeless damnation. This is the only living figure in the entire fresco to look directly at the spectator, and thus, it is a person with whom we inevitably identify. He seems to appeal to us, but what can we do? He is actually situated on the line of Christ's sight, approximately halfway between Christ and the eternal damnation of hell. Perhaps there is some hope, still in the balance; is there time to make one last appeal to Christ's mercy? The very fact that his fate may still hang in the balance reminds us, of course, that ours does, as well. In contrast to what Martin Luther was currently preaching, our destiny is yet to be determined. Before such an image, we are made painfully aware of our sins but also reminded that salvation and resurrection of the body are still attainable with the second coming of Christ. Therefore, we must hope, as I suggested in our last lecture, that Christ is looking towards the seemingly damned soul and, at the same time, looking towards us. And we had better hope that he is looking with a face of compassion and not a face of anger and damnation.

But in all the seriousness, there are some moments of levity in Michelangelo's fresco. In the lowermost corner of hell, ass-eared Minos is tormented by a serpent that circles his fleshy body and bites his genitals, a provocative nude just above the heads of the spectator

and above the door as we exit the chapel. Now, Minos is a figure from Greek mythology. He's the very exemplar of the bad judge, having preferred Marsyas over the god Apollo and, thus, winning himself the ears and the reputation of being an ass—another instance when Michelangelo reconciled Christianity and pagan antiquity. This marvelous invention reveals Michelangelo's mordant sense of humor, and I'd like to read a passage from Giorgio Vasari about it.

> Michelangelo had already finished more than three-fourths of the work when Pope Paul went to see it. On this occasion, Biagio da Cesena, the master of ceremonies and a very high-minded person, happened to be with the pope in the chapel and was asked what he thought of the painting. He answered that it was most disgraceful that in so sacred a place there should have been depicted all those nude figures, exposing themselves so shamefully, and that it was no work for a papal chapel but rather for the public baths and the taverns. Angered by this comment, Michelangelo determined that he would have his revenge, and as soon as Biagio had left, he drew his portrait from memory in the figure of Minos, shown with a great serpent curled around his legs, among a heap of devils in hell. Nor for all his pleading with the pope and Michelangelo could Biagio have the figure removed, and it was left to record the incident as it is today.

In fact, the story goes on that Biagio complained to the pope, and Pope Paul cleverly declared that while he had some influence in heaven, he had no such authority over hell. And so just like Dante, Michelangelo has exacted revenge on one of his officious contemporaries.

Now very close to Christ is the figure of Bartholomew, who holds the signs of his horrific torture, a knife and his flayed skin. It's a strange form of signature, because people have recognized that Michelangelo has represented his own distorted features in the limp folds of Bartholomew's epidermis. Perhaps conscious of the incredible hubris, that is, excessive pride, in imagining and representing a future event such as the Last Judgment, Michelangelo has portrayed himself very humbly as a discardable bit of human flesh. It's held over hell in a tenuous manner. How different this form of signature is from that earlier, very proud one that he inscribed on the chest of the Rome *Pietá*, where he wrote

"Michelangelo, Florentine, made this." Now Michelangelo, humbled many, many years later in his life, infinitely more aware of his sins, portrays himself as a discardable bit of flesh. During these years of poetic fecundity, Michelangelo frequently alludes to a desire to achieve spiritual grace by sloughing off his earthly skin. So, like hundreds of figures represented by Michelangelo, we are rendered naked before our creator.

But now, to look up and back to the whole fresco from the lowly vantage point of a person standing before this very large wall, once again, we look up to the forgiving face of our Lord. On either side he is surrounded by the Virgin Mary and a legion of apostles and saints, who intercede on our behalf. These figures are proportionally much larger than many others in the lower registers of the fresco, partly to correct for seeing them from a great distance down below, but also because they are larger than life; they are the blessed who populate heaven. And so, departing from the convention of representing the apostles and saints as enthroned, as so often in the past, as complacent beings flanked on either side of Christ, these are soldiers of Christ who are still laboring to save sinners.

I'd like to pause and suggest a larger idea about the *Last Judgment*, what I will call a sacred topography of this fresco. Now to a greater extent than might generally be recognized, a number of Michelangelo's commissions, including the *Last Judgment*, are related to the Catholic veneration of saints and relics—relics, that is, the material yet holy remains of saints. Some of the earliest works of the artist were made to adorn the tomb of St. Dominic in Bologna. And more significantly, the Rome *Pietà* and the *Risen Christ* have strong topographic associations, eliciting memory of important sites and relics in early Christian Rome. And then just shortly before embarking on the *Last Judgment*, Michelangelo designed the reliquary tribune in San Lorenzo for the safe storage and the ceremonial display of the Medici collection of relics. These examples—and there are many, many more—serve to remind us of the central importance of relics for Michelangelo and for the Renaissance in general, both as objects of devotion and as creative inspiration. So we would be wrong to think that relics are something of the Middle Ages. They're not a phenomena confined to a dark time, a previous time; they've been a continuous part of Christian practice from antiquity even to the present.

As the recent experience of the Holy Year 2000 testified, Christian pilgrimage is very much alive. In the Renaissance, Rome was one of the primary destinations of holy pilgrims, largely because distant sites of the Holy Land were occupied by infidels. In Rome, pilgrims could visit an astonishing number of shrines, relics, and places associated with the saints and the apostles, including the most important holy site in all of Western Christendom, the tomb of the apostle Peter. Indeed, the veneration of relics and the many abuses associated with their collection and authenticity were among the very practices that Martin Luther found most abhorrent when he visited Rome. In contrast, Michelangelo, in the *Last Judgment*, insists upon the importance of relics.

Now there are more than 1,000 churches in Rome, but among these, seven have been granted special privileges, and these constitute the obligatory stops on a pilgrim's itinerary. They are St. Peter's, San Paolo fuori le Mura, San Giovanni Laterano, San Lorenzo fuori le Mura, Santa Maria Maggiore, San Sebastiano, and Santa Croce in Gerusalemme. The first five of these seven churches are the so-called patriarchal basilicas, which are among the oldest foundations in the city, and all of them, except Santa Maria Maggiore, were founded by Constantine the Great, the first pagan Roman emperor to convert to the Christian faith. These churches, these five, enshrine some of the most important relics of the Christian faith.

So I'd like to ask, is it a coincidence that we find these five holy figures—Peter and Paul, John, Lawrence, and Mary—clustered around Christ in the *Last Judgment*? These five saints recall the names of the so-called patriarchal basilicas. It is also notable that among the hundreds of figures in the *Last Judgment*—most of which do not have attributes of any kind and are not, therefore, specifically identified with this or that saint—these major figures, all close to Christ, do bear attributes and all, therefore, are readily identifiable. For example, St. Lawrence holds the grill on which he was roasted, and he [represents] one of those five patriarchal basilicas.

After visiting the shrines of Rome, replete with relics of the faith, to stand before Michelangelo's *Last Judgment* is to stand in the presence of Christ and the saints. In the mind of the devout, especially one fresh from the experience of pilgrimage, the painting might have stimulated recollection of the pilgrim's actual experience of Rome. In a sense, artistic composition is a kind of geography; the

wall is a visual topography of the most important Christian sites. Looking becomes something like an analogue to pilgrimage, a sort of retracing of the pilgrim's itinerary.

This observation arises from personal experience. During the Holy Year 2000, all the churches of Rome stayed open throughout the day and well into the evening. Now, as is expected of a holy pilgrim, I actually visited all seven of those pilgrimage churches in a single day. And I did it walking, in the old-fashioned way, not on a bus like many of the pilgrims around me were doing. I'm not even Catholic, nor especially pious, but the experience permitted me to see Michelangelo's *Last Judgment* entirely afresh, as a visual suggestion of Rome's sacred topography and my personal pilgrimage. The fresco helped to remind me of what I had just accomplished, of where I had just been. It allowed me to catalogue and recapitulate the experience of all those sacred places I had visited. In recognizing various saints in the fresco, it was easy to picture his or her church, where I had gazed upon the relics, some of which Michelangelo shows us as being held by his living saints. And vice versa—I expect the next time I visit one of those churches, I will recall Michelangelo's *Last Judgment* in the place of the church, in the hierarchy of heaven.

I'd like to say a word about the nudity in the *Last Judgment*, as well. Even before the fresco was completed, there were complaints about the inappropriateness of the large number of nudes in the papal chapel. One eloquent objection was voiced by Michelangelo's contemporary, the Venetian writer Pietro Aretino, so-called the "scourge of princes" because of his acid tongue and his writings. Aretino likened the fresco to a decoration appropriate to a brothel. This sounds something like Biagio da Cesena's objection to Michelangelo's nudes in the *Last Judgment*, as well. Now in the face of a growing controversy about the nudes, the painter El Greco, who was then resident in Rome, actually offered to repaint the entire fresco for free, which apparently won him absolutely no friends whatsoever in Rome and probably the invitation to go off and become a famous artist in Spain, which is what he did.

At various times in history, to blunt this criticism, some of the nudes were given loincloths. Even within Michelangelo's own lifetime, his friend and pupil Daniele da Volterra was commissioned to cover some of the most egregious nudes with drapery, thereby earning the

man the unhappy epithet, "*il Braghettone*," or "the pants painter." In one of the more significant of these interventions, for Catherine and Blaise, Daniele covered the pendulous breasts of St. Catherine and changed the direction of Blaise's look to look upward back towards Christ, so as to obviate the suggestion of a sodomitic pose, since Blaise originally had been bending over Catherine's backside in a pose that seemed far too suggestive.

In 1990, prior to the conservation campaign on the fresco, there was much discussion about whether or not to remove the draperies. I recall the historian Romeo de Maio making an impassioned plea for preserving the subsequent interventions, arguing that they were part of the living and ongoing history of the fresco. Who were we to decide to reverse or, worse, to eradicate history? The Vatican decided to take a middle road, removing later additions but largely keeping the Daniele interventions, since he had actually replaced portions of the fresco with new plaster and there was nothing to do; so, for example, the Blaise and the Catherine are the way that Daniele corrected [them].

And when we were discussing the Sistine Chapel ceiling, I mentioned the experience of hearing the Sistine choir singing in the chapel at that time; looking up towards the ceiling was [like] looking and feeling a sense of poetry. Looking towards the *Last Judgment*, I was filled with feelings of the sublime. Like Dante, Michelangelo has created an unforgettable, grand vision of heaven and hell, a vision of damnation and salvation. In describing the fresco, Vasari invoked Dante, the poet of damnation and salvation so admired by Michelangelo. Vasari wrote, "The dead are dead, the living truly live…." The fresco, he declared, is "the great exemplar of the grand manner of painting" in which "we are shown the misery of the damned and the joy of the blessed." Before the *Last Judgment*, we're made painfully aware of our sins and also reminded that salvation and the resurrection of the body are still attainable with the second coming of Christ.

Now Michelangelo's *Last Judgment* was ceremoniously unveiled on All Saint's Eve, October 31, 1541. The first letter Michelangelo wrote after completing the painting was to his nephew Leonardo in Florence, nearly three months later, and I'd like to read you that letter. Michelangelo informed Leonardo that he had been meaning to

write, but "I hadn't time and also because writing is a bother to me." He continued:

> I'm sending you 50 scudi in gold and instructions as to what you are to do with the money if you want to come to Rome. … And if you decide to come, let me know first, as I'll arrange with some honest muleteer here for you to come with him.

There is absolutely no mention of the *Last Judgment*, the work that had been occupying Michelangelo for more than five years previously. A letter full of just money and mules, family, farms, and fretting—this is the usual business of Michelangelo's life in letters. But let's recall that Michelangelo wrote letters for the conduct of business, whether familial or professional. Few of his letters we can characterize as friendly, and rarely does he ever write about art, except to complain about being busy. He generally wrote to air grievances and to, in some way, resolve problems; [he wrote] infrequently when he was really working hard, as during this five to six years painting the *Last Judgment*, and never merely to chat or express contentment. Thus, we really should not be surprised that Michelangelo shares little of what he has just accomplished or what he was now in engaged in with his nephew.

When he again wrote to Leonardo two weeks later, Michelangelo appeared solely occupied with money matters, and he concluded his letter, as he often times did, "*Altro non accade*": "Nothing else happening." But, in fact, much else was happening, since Pope Paul had already determined, rather than completing the tomb of Pope Julius, Michelangelo would paint frescos in the newly completed Pauline Chapel. This is the subject of our next lecture.

And then, of course, there is always, still, St. Peter's.

Lecture Twenty-Eight
The Pauline Chapel

Scope:

This lecture focuses on the *Conversion of Saul* and the *Crucifixion of Peter*, two frescos in the Pauline Chapel that Michelangelo began for Pope Paul III directly after completing the *Last Judgment*. These works, the last paintings ever made by Michelangelo, introduce the final phase of the artist's life, during which, as he grew older, he became increasingly preoccupied with his Christian faith and its translation into sublime works of art. We will first consider the position and significance of the Pauline Chapel in the Vatican complex; then, we will turn our attention to an examination of the two facing frescos. We will give particular consideration to how the decorations work in situ, as a dynamic ensemble that unfolds in film-like fashion before the moving spectator. Finally, we will briefly consider the *fortuna critica*, the "critical fortunes," of these frescos, especially as they were reprised in the art of Caravaggio nearly 100 years later.

Outline

I. The Pauline Chapel.

 A. The Pauline Chapel is a tiny structure in the Vatican complex, tucked behind the front façade of St. Peter's. We see it from both an aerial view and a ground plan of the complex.

 B. Michelangelo began preparing the chapel to paint the *Conversion of Saul* and *Crucifixion of Peter* frescos soon after he completed the *Last Judgment* in 1541. The frescos took him nearly eight years to complete.

 C. Pope Paul III viewed the Pauline Chapel shortly before he died in November 1549, and Michelangelo finally finished the chapel that same year. The chapel is now one of the innermost sanctuaries of the Vatican, where the pope prays privately.

 D. As we see in a photograph, the chapel is a tall, narrow space,

with the frescos on either side wall facing each other. The frescos rise off walls that are well above our heads; thus, we always see these scenes in fragments and almost always at an oblique angle.

E. As we've seen a number of times, first and foremost with the *Pietà*, Michelangelo had a longstanding interest in the natural conditions for viewing sculpture. The same is true of paintings: Natural light and the angle of viewing are absolutely critical.

II. Viewing the frescos.

A. The Pauline frescos have been considered among Michelangelo's least successful works for a number of reasons: The paintings seem to disobey the rules of Renaissance composition; ground planes appear oddly tilted; there are unexpected shifts in scale; figures are cut off abruptly or exhibit peculiar proportions; and there's a disparity between the proportions of the figures in different parts of the frescos.

B. Many of these so-called problems are actually the fault of photographic reproduction.

 1. The oddities of scale and composition are greatly exaggerated when the frescos are seen in the frontal view of most photographs.

 2. This view, however, is impossible. We never see the frescos as a single image all at once, straight on, and from an elevated position.

 3. Two photographs I've taken in the chapel give some idea of the experience of the frescos in situ. Notice, for example, the view of the *Crucifixion of St. Peter* as we enter the chapel. One gigantic figure seems out of scale to all the other figures, but if we move past the fresco and look back, other figures and other parts of the fresco become much more prominent.

C. Michelangelo seems to have adjusted the arrangement and proportions of his figures so that they would appear correct as successive parts of an unfolding narrative from a number of different viewpoints.

III. The *Conversion of Saul*.

A. The *Conversion of Saul* is on the left-hand side as we enter the chapel. Saul was a Roman soldier and persecutor of the followers of Christ. When he was on the road to Damascus, he was struck from his horse by a bolt of lightning, resulting in his temporary blindness and eventual conversion to Christianity.

B. As we've now come to expect, Michelangelo took advantage of the natural light conditions in the chapel, locating this subject that revolves around light and vision, both real and spiritual, on the well-lit left wall.

C. Contrary to the norms of most Renaissance painting, which favored balanced and symmetrical compositions arranged around the center of a compositional field, Michelangelo has placed his protagonists along a vertical shifted far to the left. Thus, the two protagonists are closest to us, because we enter the chapel from the left side of the painting.

D. The real light in the chapel and the painted bolt of lightning help to illuminate the scene of Saul's conversion, permitting us to witness this miracle.

E. After Saul, we become aware of the bolting horse. The horse began its flight in the foreground, but as we move through the chapel, Saul falls to the ground and the horse runs into the background, splitting the composition in two. This is one of those compositional peculiarities that has been pointed out about the fresco, but in reality, Michelangelo is showing successive moments in a narrative drama.

F. Christ in heaven initiates the action; after knocking Saul from his horse, he directs Saul and us to Damascus in the far right background, where Saul will regain his sight and begin his Christian ministry as St. Paul. Thus, Christ unleashes the opening moments of the narrative, then encourages us to recall later moments of that same history.

G. In the course of walking past the fresco, we seem to be following, physically and vicariously, the two pilgrims who are climbing the hill. As we progress toward the altar, we notice the secondary figures on the right in various states of confusion and disarray. They are the aftermath of the disrupting bolt of light that opened the scene.

H. Only a few of Saul's now-scattered entourage look to heaven, and we take our cue from these brave souls. From this vantage point, we see Christ's left arm much more prominently directing us to Damascus.

I. At the center of the burst of light and the symmetrically disposed angels, Christ is the first and last figure we see, the alpha and omega of Michelangelo's pictorial narrative.

IV. The *Crucifixion of St. Peter*.

 A. Not only is the *Crucifixion of St. Peter* on the darker wall of the chapel, but the scene also takes place at sunset, a time often associated with death. An atmosphere of foreboding and tragedy, heightened by the semi-darkness, enshrouds the slow-moving and ponderous figures.

 B. Our inclination is to approach closer to the fresco because we can't see it all at once.

 1. As we do, we see a giant figure, sometimes identified as a self-portrait of Michelangelo, who appears literally to stride into our space. The conventional boundary between a work of art in a frame and our world is broken down.

 2. It's easy to see the unusual proportions of this figure that have been noted as one of the oddities of Michelangelo's composition, but its size depends on our proximity to the scene and the angle from which we view it.

 C. Again, as we get closer to the wall, we discover a group of huddled women mourners, cut off by the lower edge of the fresco, two of whom stare back at us. In the words of Kenneth Clark, "They are like a Greek chorus, intermediaries between us and the tragedy."

 1. One of the women directs our attention to Peter and the tragedy unfolding before us, and Peter, in turn, directs his unflinching glare back at us.

 2. No matter where we are in the chapel, Peter is always looking at us. His look is an admonition: As he followed Christ, so should we.

 D. Recall that Peter requested to be crucified upside down so that he wouldn't directly imitate his Lord; note also the turning of the cross in space as it is erected. This movement

describes a cylinder in space and would remind viewers of the cylindrical Tempietto designed by Bramante that marks the spot of Peter's crucifixion in Rome. The figure digging a hole replicates the action of pilgrims taking away sand from that site.

- **E.** Only in walking past the crucifixion do we become aware of the soldiers who are mounting steps on the left-hand side of the fresco. These are the actual steps by which we would climb up the Janiculum Hill to visit the site of Peter's crucifixion, San Pietro Montorio.

 - **1.** Our tendency is to vicariously follow the soldiers, again, dissolving the boundary between art and life.
 - **2.** One of the few surviving cartoons of Michelangelo is a full-size cartoon for these figures, a small indication of the amount of labor that went into the design and execution of these frescos.
 - **3.** The commanding officer of the soldiers again directs our attention to Peter. We are either complicit in his death or Christian witnesses called upon to act on our faith, as Peter did.

- **V.** The two frescos together.

 - **A.** The view from the altar, which is the view of the pope, is the most important in the chapel, but it's almost impossible to replicate in photographs.

 - **1.** The figures that we saw first upon entering the chapel are scarcely visible. Most of the figures that are physically closest to us have their backs turned toward us; thus, we look beyond them.
 - **2.** The complex narrative compositions are now simplified to their essential elements: Saul and Peter, both of whom are thrust in our direction.

 - **B.** The two frescos are a contrasting pair. The *Conversion of Saul* unfolded before the spectator as a rapid series of vignettes; the *Crucifixion of St. Peter* transpires with greater solemnity. Saul was converted instantly by a dramatic external intervention; crucifixion, on the other hand, is a slow and agonizing death.

 - **C.** Michelangelo has taken advantage of the natural light and

enforced viewing conditions in the chapel to enhance our viewing experience. In both cases, but in different ways, he has convincingly and forcefully included us in the drama, guiding our perception and our understanding of the events before us.

D. The narratives unfold in a cinematic fashion to the left and right as the spectator walks down the central aisle of the chapel. The multiple sequential scenes culminate at the altar, the view of the pope. The multi-figure compositions and separate narrative vignettes from this vantage point are distilled to their essential elements.

E. Of all the sights in the chapel, it is Peter's gaze that makes the most powerful impression. For the pope and the cardinals who gathered in this chapel, Peter's look is an admonition and a dispensation, bestowing a burden and a blessing: Sacrifice is our Christian duty, yet it is through such devotion to Christ that we gain eternal life.

F. Seen in the failing light of day, the frescos make a profound impact on the spectator. They extend and dominate the space in the chapel and populate it with real figures as large as life. We, in turn, become participants in the events of Christian history.

VI. Reassessing the frescos.

A. Rather than revealing evidence of Michelangelo's declining abilities, the Pauline frescos evince his prodigious inventiveness and his sensitivity as a painter of Christian history.

B. The effectiveness of the frescos is lost when they are seen in engravings. No wonder Michelangelo's last masterpieces of painting—better known from such reproductions than from firsthand viewing—were considered failures.

C. The 17th-century artist Caravaggio painted the same two subjects as Michelangelo in the Cerasi Chapel in Santa Maria del Popolo, again, facing each other in a narrow chapel space. Although Caravaggio's pictures are much smaller and painted in oil rather than fresco, they narrate the same events and take full advantage of the limited light in the chapel and the enforced oblique viewing angle.

D. With the completion of the Pauline Chapel virtually coinciding with the death of his great patron Paul III, Michelangelo was finally free to turn his attention once again to the tomb of Pope Julius II, the subject of our next lecture.

Works Discussed:

St. Peter's Basilica, Vatican City, Rome.

Pauline Chapel, Vatican Palace, Vatican City, Rome.

Michelangelo:

Pietà, 1498–99, marble, 5' 8½" H (173.9 cm H), Basilica of St. Peter's, Vatican City, Rome.

Crucifixion of St. Peter and *Conversion of St. Paul*, fresco, 20' 6"× 21' 8" (6.25× 6.6 m), Pauline Chapel, Vatican Palace, Vatican City, Rome.

Three Soldiers, c. 1536, black chalk cartoon, 8' 7½"× 5' 1½" (2.63 × 1.56 m), Museo Nazionale di Capodimonte, Naples, Italy.

Donato Bramante:

Tempietto, c. 1502, San Pietro in Montorio, Rome, Italy.

Giovanni Battista de Cavalieri:

Martyrdom of St. Peter, after Michelangelo, 16th century, engraving, 16¼× 21⅜" (41.4× 54.2 cm), Fine Arts Museums of San Francisco, California.

Caravaggio:

Crucifixion of Saint Peter and *Conversion of Saint Paul*, 1600–01, oil on canvas, 7'6½"× 5' 9" (230× 175 cm), Santa Maria del Popolo, Rome, Italy.

Suggested Reading:

H. Hibbard, *Michelangelo*.

C. de Tolnay, *Michelangelo: The Final Period*.

W. E. Wallace, *Michelangelo: The Complete Sculpture, Painting, Architecture*.

L. Steinberg, *Michelangelo's Last Paintings*.

W. E. Wallace, ed., *Michelangelo: Selected Readings*. See P. Fehl, "Michelangelo's Crucifixion of Peter: Notes on the Locale of the

Action," and W. E. Wallace, "Narrative and Religious Expression in Michelangelo's Pauline Chapel."

Questions to Consider:

1. How has Michelangelo employed the natural light of the chapel to artistic and expressive effect?

2. Are these frescos, painted in Michelangelo's old age, evidence of the artist's decline or continuing vitality?

Lecture Twenty-Eight—Transcript
The Pauline Chapel

This lecture will focus on the two frescos the *Conversion of Saul* and the *Crucifixion of Peter* in the so-called Pauline Chapel. Michelangelo painted the two frescos for Pope Paul III directly after completing the *Last Judgment*, and hence the name of the chapel, the Pauline Chapel, for Paul. These works, the last paintings ever made by Michelangelo, introduce the final phase of the artist's life, in which, as he grew older, he became increasingly preoccupied with his Christian faith and its translation into sublime works of art and poetry.

We'll first consider the position and significance of the Pauline Chapel in the Vatican complex, and then we'll turn our attention to an examination of the two facing frescos. We'll give particular consideration to how the works "work" in situ, especially as they function as a dynamic ensemble that unfolds in cinematic fashion before a moving spectator. Let's take a look at where the Pauline Chapel is in the Vatican complex.

It's a rather tiny structure. It's practically invisible in this aerial view, tucked behind the front façade of St. Peter's. On our ground plan here, what we see is the Scala regia that leads up to the Sala regia, which is probably the main audience hall where the pope did much of his personal business. And the Sala regia was directly off the large papal palace complex. Also off of the Sala regia is our Sistine Chapel, and then at the other end of the Sala regia is the so-called Pauline Chapel, and as you can see, it's a much smaller space than the larger Sistine Chapel, which we considered in an earlier lecture.

Michelangelo began preparing the chapel to paint these frescos immediately after he completed the *Last Judgment* in 1541. It took him nearly eight years to complete these frescos, not only because they're large—they're, in fact, much more monumental than is apparent from reproduction—but also I think the length of time was due to numerous interruptions, not least of which was finally completing and installing the tomb of Pope Julius II, which will be the subject of our next lecture.

Pope Paul III viewed the Pauline Chapel shortly before he died in November 1549. After eight years of intermittent work on this

project, Michelangelo finally finished the chapel that same year, with the death of his patron freshly in his mind. The Pauline Chapel serves a dual function as the Chapel of the Sacrament and the Chapel of the Conclave. This is where the popes were originally elected. This is now done in the Sistine Chapel as the College of Cardinals has grown in size, but here in the Pauline Chapel, popes began their mission as Peter's successors.

Where once the College of Cardinals deliberated, the current pope now quietly prays. This is one of the innermost sanctuaries of the Christian religion. Given the importance of the place, it is inconceivable that Michelangelo would not have tried his very best to create masterpieces. And yet the Pauline Chapel frescos have rarely been viewed as such.

Now let's take a look at the smallest chapel. It's hard to get a sense of the scale and space from photographs, but the frescos are on either side wall facing one another, the *Crucifixion of Peter* on the right, the *Conversion of Saul* on the left. As you note from this photograph, it's a tall, narrow space, and as you can see from the scale of the benches, the frescos actually rise off walls that are well above our heads, and so we always are seeing these frescos in pieces, as fragments, in this very tall, narrow space. Almost always are we looking at the frescos in some kind of oblique, angled vision. But now Michelangelo is going to consider this angle of vision and, of course, natural light as the givens for painting a fresco inside a chapel any time.

I'd like to remind you that we've discussed this a number of times in this course, and first and foremost with the *Pietà*. Recall that Michelangelo had a longstanding interest in the natural conditions of viewing sculpture. The same is absolutely true of paintings. Natural light and the angle of viewing of them are going to be absolutely critical, and it would be natural for Michelangelo to take these into consideration. If we recall the *Pietà*, how important it was to see the *Pietà* under natural light and from certain angles and how radically it changes sculpture. We rarely think the same is true of paintings, but I'd like to try and demonstrate that that is, in fact, the case with the Pauline Chapel, as well.

So the conventional, straight-on views that we've seen in most photographic reproductions are highly misleading and, I think, have resulted in much misunderstanding. Despite the importance of the

chapel and its patron, the Pauline frescos have been considered among Michelangelo's least successful works—products sometimes explained as the decline of Michelangelo's old age. Among the various reasons cited for the failure of these frescos are these: the paintings seem to disobey the conventional rules of Renaissance composition; ground planes appear oddly tilted; there are unexpected shifts in scale; figures are cut off abruptly, especially along the lower edge of the fresco; many exhibit peculiar proportions; and there's a tremendous disparity between the proportions of the figures in one part and the other part of the fresco.

So how do we explain these various peculiarities? By Michelangelo's old age, by his declining abilities, by his senility? I think none of these can explain something of the radical innovations that Michelangelo undertakes in these frescos. For one, I would say that many of these so-called problems that have been pointed out are the fault of photographic reproduction. In contrast to the well-known Sistine Chapel, the nearby Pauline Chapel is relatively inaccessible and is better known through photographs than firsthand experience. It's very hard to get permission to visit the Pauline Chapel, as it is the private place for the pope to pray.

Michelangelo's frescos have been very ill-served by photographic reproduction. They are best experienced in situ, as decorations flanking the long, narrow, tall space of the chapel. The often-remarked oddities of scale and composition are greatly exaggerated when the frescos are seen in this manner, in the so-called "ideal" frontal view of most photographs. But such views are manifestly impossible. We never see the frescos in this manner—as a single image all at once, straight on, and from the elevated position of 15 feet in the air. Rather, we see the frescos something like this—two photographs I've taken in the chapel myself. They're imperfect, but they'll at least give you some idea. Notice how, for example, that this is how we see the *Crucifixion of Peter* as we enter the chapel. This large and gigantic figure seems way out of scale to all the other figures. Parts of the fresco are virtually invisible from this view.

However, if we then move into the chapel and pass the fresco and look back, do you notice that that figure on the right-hand side that we first saw now has diminished radically in proportion and is virtually invisible? And, instead, other parts of the fresco have become much more prominent.

So this is my primary thesis—that Michelangelo adjusted the arrangement and proportions of his figures so that they would appear correct as successive parts of an unfolding narrative from a number of different viewpoints, almost all of which were oblique—a succession of oblique viewpoints.

In addition, he was extremely sensitive to the natural light conditions in the chapel, and he exploited them to intelligent ends. For example, in this case, he located the "dark" subject of crucifixion on the dark wall with little light. This is the only wall that has a window. If you notice the window above the fresco of Peter, it allows in an enormous amount of light to the opposite wall, leaving this wall with the *Crucifixion of Peter* in darkness. It's a dark scene of crucifixion. In comparison, he has located the conversion scene, a conversion facilitated by a bolt of descending light, flooded by direct sunlight.

So recognizing that it is artificial to consider these frescos all at once and in such a perfectly photographed manner, nonetheless, we'll consider one scene and then the other, although our tendency is to see them much more discontinuously.

Let's begin by considering the *Conversion of Saul* on the left-hand side as we enter the chapel. Saul is a Roman soldier and a famous persecutor of the followers of Christ. When he was on the road to Damascus, he was struck from his horse by a bolt of lightning descending from heaven, and this resulted in his temporary blindness and eventual conversion to Christianity. So Saul the Roman soldier became St. Paul.

As we've now come to expect, Michelangelo took advantage of the natural light conditions in the chapel, locating this subject that revolves around light and vision, both real and spiritual, on the well-lit left wall. Also, completely contrary to the norms of most Renaissance painting, which tends to favor balanced and symmetrical compositions arranged around the center of a compositional field, Michelangelo has placed his protagonists along an emphatic vertical shifted far to the left—Saul and Christ linked by this bolt of heaven. And so the two protagonists are shifted way to the left of the compositional field but closest to us because we enter the chapel from this side of the painting, from the left.

The flash of light that links heaven and Earth knocks Saul from his horse and temporarily blinds him, but at the same time, the real light

in the chapel and the painted bolt of lightning help to illuminate the scene for us, permitting us to witness the miracle of conversion. And note that despite [the fact that] there's a crowd of figures around Saul, he's actually the closest figure to us physically. As we enter the chapel, two figures we see are running into the distance, but Saul is closest to us.

After Saul, we note the bolting horse. Now, of course, the horse began its flight in the foreground close to Saul. Saul was riding the horse, but all of a sudden, Saul has already fallen on the ground, and as a consequence, the horse has run into the background. It suggests a sequence of action that's unfolding before us. And notice how it splits the composition in two. It's actually the horse that's at the center of the compositional field, which would be most unusual, especially seeing it from the rear. It's one of those compositional peculiarities that has often been pointed out about Michelangelo's fresco. But what he's doing—Michelangelo is showing successive moments in a dramatical and rapidly unfolding narrative drama. They were both in the foreground just a minute ago. Saul was falling to the earth. The horse bolts into the background.

Christ in heaven initiates the action, and after having knocked Saul from his horse, he directs Saul and us to Damascus in the far right background. From the chapel entrance, Damascus is virtually invisible. When we're on this side of the fresco, even though Christ is pointing to the background, Damascus is way over on the right-hand side in the background and virtually invisible to us. It's an important but secondary detail and only a subsequent stage in the unfolding narrative, because it's in Damascus that Saul will regain his sight and begin his Christian ministry as St. Paul. Thus, Christ unleashes the dramatic opening moments of the narrative and then, through this secondary gesture of his left arm, encourages us to recall the later moments of that same history.

In the course of looking, we've been walking into the chapel and past the fresco, and as we walk and look, we seem suddenly to be following, physically and vicariously, the two pilgrims here who are climbing the hill. Only from this new vantage point further into the chapel do we see the fleeing horse, now looking back at us. And as we progress towards the altar, we notice these secondary figures over on the right-hand side in various states of confusion and disarray. They are the aftermath of the disrupting opening bolt of light.

Only a few of Saul's now-scattered entourage look to heaven. Like them, we've been too distracted by the various events on Earth. We, too, find ourselves in confusion, uncertain where to look and how to proceed. Finally, we take a cue from the few brave souls who are looking heavenward for some kind of explanation. We, therefore, following them, look up to heaven and see Christ, and from this vantage point, we now see Christ's left arm much more prominently, directing us, as well as Saul, to Damascus, reminding him and us of our Christian duties.

At the center of the burst of light and the symmetrically disposed angels, Christ is the first and last figure we see, the alpha and omega of Michelangelo's pictorial narrative. So those two figures at the bottom that are cut off serve to remind us that they're not unlike us. We follow them up into the fresco.

Let's now turn to the opposite wall. The dark subject—death and crucifixion—is located on the opposite, the dark wall that never receives any direct sunlight. It's completely artificial to analyze these frescos in such a sequential order since, naturally, we tend to see them either simultaneously or much more discontinuously. As we walk through the chapel, we're looking to the left and to the right, and I think that disrupted viewing actually contributes to the sort of cinematic continuity of these frescos. By looking from one and into the other, we pick up different scenes as we move through the chapel. Our restless looking helps facilitate and animate both scenes simultaneously. They move and they unfold over time as we move through space. It's really a radically new way to think about looking at art. Instead of seeing it all at once, it's unfolding over a period of time.

Now it's a much darker wall, the *Crucifixion of Peter*, but also note the time of day that Michelangelo has chosen to paint the scene. It's sunset, often times associated with death, and we see the declining light in the background. An atmosphere of foreboding and tragedy, heightened by the semi-darkness, enshrouds the slow-moving and ponderous figures. It is a disturbing subject that, without the aid of modern electric lights, is difficult to see and nearly impossible to grasp in its entirety.

So our inclination is to approach closer to the fresco because we can't see it all at once, and we get closer. As we do, what we see is this giant figure, sometimes identified as a self-portrait of

Michelangelo, that looms above us and appears literally to stride into our space. Suddenly, the conventional boundary between a work of art in a frame and our world is broken down. Rather, what we see is a living, brooding figure striding into our world, so art and life have become mixed.

Now it's easy to see the unusual proportions of this figure that have been frequently remarked upon as one of those oddities of Michelangelo's composition, but its size is dependent on our proximity to the scene and to the angle from which we view it, as we already saw in those black-and-white photos. It's big when we see it from the right and much, much smaller when it's seen from the left.

In our further efforts to penetrate the gloom of this fresco, we approach closer to the wall, passing by that striding figure, and encounter—what? And we look and discover, somewhat disconcertingly, a group of huddled women, again cut off by the lower edge of the fresco—women mourners, two of whom unremittingly stare back at us. In the words of Kenneth Clark, he says: "They are like a Greek chorus, intermediaries between us and the tragedy." I would add that they are something like an unfolding accordion of glances.

The woman on the right looks at us. The next to the left—the next looks back to us. And the last looks finally towards Peter, directing our attention to the tragedy unfolding before us. They move us along inexorably towards the left, and thus, our attention then ultimately is directed to Peter, towards the center of this whole compositional field. And Peter, in turn, directs an unflinching glare back at us.

This is one of those *trompe l'oeil* , or "tricks of the eye"; from no matter where we are in the chapel, Peter constantly looks at us. He never wavers in his gaze. Throughout the entire progress from entrance to altar, his eyes encounter ours whenever we are brave enough to look at him and from wherever we stand in the chapel. His look is an admonition. As he followed Christ, so should we. Peter, remember, was so humbled by Christ's example, he didn't wish to directly imitate his lord, and so he requested that he be crucified upside down, and that's what we see.

Notice how the cross turns in space. This figure is bringing the cross on this way, and this figure is bringing the cross on that way. It's moving the cross in a circular pattern that actually mimics our very

movement past the chapel, past this fresco, past this detail. Note also the figure digging a hole. This is a naturalistic detail. This is the hole where the cross will eventually be placed as it's rotated up and then put into position, but it's also something more that I would like to suggest.

If this wall that we're looking at right now with Michelangelo's fresco of the *Crucifixion of Peter* were suddenly to dissolve, we would be looking directly toward the very site that is represented in Michelangelo's fresco in the very place where this action took place, that is, San Pietro in Montorio on the Janiculum Hill, overlooking the city of Rome. This is where Peter was crucified, on Mont Orio (the Mount of Gold), and therefore, notice Michelangelo painting the mountain on which Peter was crucified as golden. Here and in the sunset once again, we encounter Michelangelo, understated, but a very sensitive landscape painter.

Now come back to that turning of the cross. Think of it, that turning of the cross in space helps to describe a cylinder. It traces the outline of a cylindrical building like the one designed by Donato Bramante that marks the actual spot of Peter's crucifixion. So Michelangelo's fresco prompts us to think of that very building that was built over that very sacred site.

And so now we can come back to the man digging a hole. That naturalistic action also replicates the action of pilgrims who climb to Mont Orio, to San Pietro Montorio, to visit the site of Peter's crucifixion and Bramante's Tempietto, which is built over a hollow hole. And a pilgrim would arrive and reach into the ground, take some of the golden sand, and take it away as a relic of the pilgrimage to that spot. Again, I think this is Michelangelo as a very sensitive, very intelligent landscape artist, suggesting precisely the kinds of pilgrimage activities we are going to pursue in Rome represented in this fresco.

Now just as in the fresco opposite, only in walking past the crucifixion do we begin to note the group of soldiers who are mounting a series of steps on the left-hand side of the fresco. These are the actual steps by which we would climb up to the Janiculum Hill to visit the site of Peter's crucifixion, San Pietro Montorio. Those steps are still there. So just as in the opposite fresco, we see soldiers from behind, and our tendency is to vicariously follow them. Again, the boundary between art and life has been dissolved. We are

invited in a sense to visually join, to enter this scene, to climb the hill following along with these soldiers from behind.

One of the few surviving cartoons of Michelangelo is this full-size cartoon for these very figures. It's in the Capodimonte Museum in Naples. It's a very large cartoon for just a very few figures in this fresco, but it's a small indication of the amount of labor that went into the design and the execution of these frescos, a small indication of how important these figures and this whole composition was for Michelangelo and how much he labored on it.

Encouraged to enter the fresco, following the soldiers, climbing the hilltop, we're then directed as we mount the hill by our commanding officer to once again look towards Peter, who continues all this time to be staring at us. We are, thus, either like Roman soldiers complicit in his death or, if we so choose, Christian witnesses who are called upon to act on our faith, as Peter did.

Now the view from the altar, which is the view of the pope, is certainly the most important in all the chapel, but it's almost impossible to replicate in photographs. What happens is the figures that we saw first upon entering the chapel have become scarcely visible. The figures physically closest to us—the mass of soldiers on the left-hand side of Peter and these soldiers here—for the most part, have their backs turned toward us, and thus, we look beyond them. The complex narrative compositions are now simplified to their essential elements: Saul and Peter, both of whom are thrust in our direction.

The two frescos are a contrasting pair. The *Conversion of Saul* dramatically unfolded before the spectator as a rapid series of vignettes; the *Crucifixion of Peter* transpires with a greater solemnity. Saul was converted instantly by a dramatic external intervention; crucifixion, on the other hand, is a slow and agonizing death. The magnitude of Peter's act is comprehended as slowly as it takes us to view it.

Michelangelo has intelligently taken advantage of the natural light and enforced viewing conditions in the chapel to enhance our viewing experience. Somewhat anachronistically, I describe this as cinematic, but at the same time, Michelangelo ensures that these extended and dispersed narratives are distilled to their essential meaning—messages of Christian duty and sacrifice. In both cases but

in significantly different ways, Michelangelo has convincingly and forcefully included us in the drama, guiding our perception, as well as our understanding, of the events before us.

The narratives unfold in a cinematic fashion to the left and to the right as the spectator walks down the central aisle of the chapel. The multiple sequential scenes culminate at the altar, the view of the pope. The multi-figure compositions and separate narrative vignettes, from this vantage point, are distilled to their essential elements. From all the confusion of the crowds, we mainly distinguish the newly converted Saul and the crucified Peter.

Of all the things in the chapel, it is Peter's gaze that makes the single most powerful and long-lasting impression. For the pope and the cardinals who used to gather in this chapel, Peter's look is an admonition and a dispensation, bestowing a burden and a blessing. It would have reminded them, as it does us, that sacrifice is our Christian duty, and yet it is through such devotion to Christ that we gain eternal life.

Seen in the failing light of day, the frescos make a profound impact on the spectator. They extend and dominate the space in the chapel and populate it with real figures as large as life. We become more than mere spectators of the events of Christian history. We're made responsible participants. The pope at the altar is encouraged to reflect on his forbearers and his mission as Christ's vicar. As Christian pilgrims, we are made witnesses to Saul's dramatic conversion and Peter's heroic martyrdom. And as art historians, we're reminded that art is not well served by reproduction.

Rather than revealing evidence of Michelangelo's declining abilities, the Pauline frescos evince his prodigious inventiveness and his sensitivity as a painter of Christian history.

Now given that the effectiveness of the frescos depends on seeing them in situ and in motion, then imagine their effect when they are seen in engravings, such as this—as small, complete compositions and *reversed*! No wonder Michelangelo's last masterpieces of painting—better known from such reproductions than from the actual experience of seeing the frescos in the private papal chapel—were considered failures, rather than among the most sophisticated and moving Christian narrative paintings ever created.

The 17th-century artist Caravaggio, whose first name was Michelangelo, was one artist who completely understood Michelangelo's accomplishment. The same two subjects were painted by Caravaggio in the Cerasi Chapel in Santa Maria del Popolo. They face one another in a narrow chapel space with the angle of the viewer taken fully into consideration. Therefore, if we have some difficulty fully appreciating Michelangelo's final masterpiece as a painting, then we need only turn to the great master Caravaggio, who fully comprehended and celebrated Michelangelo's genius.

Although Caravaggio's pictures are much smaller, and they are painted in oil rather than fresco, they, too, narrate the same compelling events, taking full advantage of the limited light in the chapel and the enforced oblique viewing angle of the spectator. These two Michelangelos, Michelangelo Buonarroti and Michelangelo Merisi da Caravaggio, prove to have been among the greatest artists of Christian narrative history. Caravaggio has clearly taken his deserved place as a sensitive portrayer of sacred mysteries, but I think it's time that Michelangelo was accorded the same approbation and recognized for having provided inspiration to so many who followed in his giant footsteps.

With the completion of the Pauline Chapel virtually coinciding with the death of his great patron Paul III, Michelangelo was finally free to turn his attention once again to the tomb of Pope Julius II, and that will be the subject of our next lecture.

Lecture Twenty-Nine
The Completion of the Julius Tomb; Poetry

Scope:

This lecture brings to a close the long, convoluted history of the Julius tomb, a compromised but still magnificent monument. We will consider why the work was completed in 1545, after 40 years of delays and renegotiated contracts, and why Michelangelo once again made so many seemingly radical changes. The two newly carved works, the *Rachel* and *Leah*, are examined for their significance and relationship to the earlier tomb elements, notably the *Moses*. Finally, we will consider Michelangelo's contemporaneous friendship with Vittoria Colonna, to whom the artist presented some exquisite drawings and many poems.

Outline

I. The history of the Julius tomb.

 A. As you recall, the tomb project began in 1505, when Julius promised to pay Michelangelo the enormous sum of 10,000 ducats (enough to build a small church) to create a huge tomb, approximately 23×36 feet, decorated with 40 life-size or larger-than-life-size marble statues.

 B. Forty years later, the tomb, much reduced but still grand, was finally installed, not in St. Peter's but in the church of San Pietro in Vincoli. During this history, Michelangelo designed at least six monuments, signed four contracts, and changed his mind many more times.

 C. A key moment in the history of the tomb was the death in 1538 of Pope Julius's heir, Francesco della Rovere, who was no friend to Michelangelo. The new executor of the pope's estate was Francesco's son, Guidobaldo della Rovere, with whom Michelangelo shared a relationship of mutual respect.

 D. After the unveiling of the *Last Judgment* in 1541, Guidobaldo hoped that Michelangelo would return to the tomb project, but he graciously acceded to the wish of Pope Paul for Michelangelo to decorate the Pauline Chapel. Guidobaldo suggested that he would be content with just

©2007 The Teaching Company.

three statues for the tomb, including the already carved *Moses*.

E. In contrast to the many della Rovere heirs that had pestered Michelangelo about the tomb over the years, Guidobaldo exercised patience and tact in dealing with the artist, and perhaps as a result, the tomb was completed during his watch.

 1. At this point in his career, Michelangelo generally worked only for people whom he esteemed and who, in return, displayed deference to the artist.

 2. Guidobaldo, therefore, deserves credit for the tomb's completion, just as his predecessors must share the blame for its delay.

II. The Julius tomb.

A. Knowing something of this history prods many viewers to feel a vague sense of disappointment when they see the tomb that Michelangelo ultimately left us. But that is the key point: This *is* the tomb that Michelangelo left us. After delaying and procrastinating for nearly 40 years, Michelangelo did *not* just throw something together: It satisfied him and it satisfied his very demanding patrons.

B. The surest sign of Michelangelo's interest in this final product is the fact that he elected to carve two wholly new figures—*Rachel* and *Leah*—which flank the *Moses*. Many critics have suggested that these sculptures are mediocre knockoffs executed in a hurried attempt to complete the tomb, but they truly are great works of art.

C. As in the Bible, *Rachel* and *Leah* make a contrasting pair. *Rachel*, in the left niche, is lithe, her form rising and twisting, her ecstatic visage turned in fervent prayer. *Leah*, in the right niche, is stately, composed, and contemplative. The two females represent allegories of faith and good works, respectively, or as they were commonly designated, allegories of the contemplative life and the active life.

D. In substituting these two female figures for the earlier nude slaves, Michelangelo has turned from a language of exaggerated physicality to one of spiritual yearning, from pagan to Christian allegory expressed in the comely form of

draped females.

III. *Rachel* and *Leah*.

A. In robes that suggest a nun's habit, Rachel clasps her hands and submits her appeal to heaven. The drapery modestly covers yet reveals the subtle and multiple turns of her elongated, asymmetrically disposed body. Her form rises ethereal and flame-like; she bends toward the natural light, a metaphor for the presence of God. She directly contrasts with the solid, matronly aspect of her sister, Leah.

B. Leah's voluminous drapery and *contrapposto* stance give her the appearance of a Classical goddess. Indeed, it is likely that Michelangelo was inspired by a famous antiquity that he well knew, the *Cesi Juno*. But comparisons with the supposed model merely reveal the innovation in Michelangelo's conception.

C. The youthful Leah glances wistfully toward the mirror she holds in her right hand. The Bible (Genesis 30) informs us that "Leah's eyes were weak." Her limp left arm holds a garland. Her symmetrically parted and braided hair is bound up to create a natural diadem, the effect of which is heightened by the shell niche that enframes and accentuates her head. One thick tress of hair falls over her right shoulder and trails to her waist, where it mingles with the tress-like folds of her drapery.

D. Leah's long, flowing garment sports an unusual ornamented bodice and a collar. A tightly wrapped horizontal band accentuates her smallish breasts, and loose folds of drapery loop down below her waist. The swirling knot of drapery in front of her womb evokes her fertility, prompting us to recall the six sons that she bore Jacob.

E. According to the Bible, Leah was not as comely as her sister, but she was favored by God. As though to express the beauty of her inner spirit, Michelangelo has created a majestic and supremely lovely creature.

F. With plenty of marble on hand, Michelangelo could have created any figures, on any scale. The size, gender, and restrained movements of these two sisters, therefore, must be purposeful. They are in marked contrast to the earlier

Captives, whose titanic forms appear to burst from the confines of their blocks. This restraint is a notable achievement of the artist, who is otherwise known and celebrated for just the opposite.

1. Michelangelo observed a decorum of size and finish in these two sculptures to ensure that they would not compete with *Moses*.

2. Like the understated second movement of a symphony, they are quiet, subtle, and sublime.

G. In expressing the inner spirits of Rachel and Leah through bodily form, Michelangelo carved two exquisitely beautiful females. To characterize them as "bland" fails to recognize the artist's growth over the course of his long career and the history of the tomb.

1. Michelangelo has fashioned a new vocabulary of the human body, a new vocabulary of Christian art. As in his late drawings and poetry, the carnal body has become ethereal, pared to essentials. Michelangelo is interested in the body only as it represents beauty.

2. The artist—whether with chisel, chalk, or rhyme—seeks to express inward spirit, something abstract, Christian truths, and a profound but abstract yearning.

IV. The *Moses*.

A. The *Moses* was probably begun in 1505 or 1513 and worked on periodically for the next 30 years. The sculpture sat on Michelangelo's workshop floor, watching as the artist changed his ideas, grew old, and carved *Rachel* and *Leah*. Michelangelo lived with *Moses* and looked into the prophet's face almost every day for nearly three decades.

B. The powerful gaze of *Moses* is directed upward—a face that beholds divinity. If *Moses* were to stand, he would be nearly twice as tall as an average person, but his size is the least important measure of this figure's awesome power. *Terribilità*—"terribleness"—a word that is sometimes used to describe Michelangelo himself, aptly describes the fearsome aspect of Moses.

V. Reassessing the tomb.

A. In relating the tortuous history of the Julius monument,

Condivi termed it a "tragedy." Surely, his view reflected some of Michelangelo's frustrations and the fact that the tomb is merely a fragment of its original grand conception. But to imagine what the tomb might have been is to blind ourselves to what it is. Michelangelo devoted enormous energy to create this grand and noble funerary ensemble.

B. Condivi may have called the tomb a tragedy, but he also concluded by writing: "The tomb, just as it is, botched and rebuilt, is yet the most impressive to be found in Rome and perhaps anywhere else." This statement is confirmed daily by the number of people who flock to visit San Pietro in Vincoli.

VI. Vittoria Colonna (1490–1547).

A. We see here a portrait of Vittoria Colonna by an unknown artist. She was a member of a large circle of friends and acquaintances that Michelangelo cultivated in Rome, particularly among those of high social station. Colonna was the daughter of a noble Roman family and an accomplished poetess. For her, the artist made some exceptionally fine drawings and wrote some of his most fervent religious poetry.

B. Probably the first drawing Michelangelo made for Vittoria Colonna was the exquisitely wrought masterpiece of the *Crucifixion* that we see here.

 1. Note the upturned face and open-mouth appeal of Christ, which forcefully suggests his anguished cry on the cross—"My God, my God, why hast thou forsaken me?"

 2. Rarely has the world seen such a concentration of artistic excellence and religious fervor in such a small and vulnerable object.

C. As with the many drawings that Michelangelo presented to his friend Tommaso de Cavalieri, the drawings he made for Vittoria Colonna achieved instant fame. Rarely could one get an original drawing from Michelangelo himself, but painted versions could be commissioned, such as the example we see, probably painted by Michelangelo's friend and professional associate Marcello Venusti.

D. Multiple replications have also been made of the Gardner

Pietà, so-called because it is in the Isabella Stewart Gardner Museum in Boston. This drawing combines the artist's recurring interest in the theme of the *pietà* with his profound attachment to the poet Dante.

1. Here, we see Christ, removed from the cross, slumping downward and forward as if toward his grave. His weight is barely supported by two children, presumably angels but wingless. They are holding Christ's arms in a position that recalls the recent crucifixion.

2. Mary raises her arms in appeal or supplication, to us and to heaven. And although art is always mute, we again hear a plaintive cry in this drawing. In this case, Michelangelo has written on the cross above Mary's head an inscription, as if it's issuing from her.

3. The words from her mouth are from Dante's *Paradise*: "No one thinks how much blood it costs," spoken by Beatrice. In many ways, Vittoria Colonna was Michelangelo's Beatrice: a trusted spiritual guide in Christian matters.

4. Ultimately, this drawing was widely disseminated in various media. We see a painted example by Marcello Venusti.

E. Colonna's death in 1547 came as a serious blow to Michelangelo. We see the scene of the artist's last visit to his friend in a 19th-century anecdotal painting by Francesco Jacovacci.

F. Michelangelo found solace in words, those written himself and those by Colonna. In one verse, he mentions "her charming poems, sweet and pure," referring to a book he kept of her poetry. Colonna may have encouraged Michelangelo in his desire to publish his poetry, but her death seems to have ended his enthusiasm for that project.

G. The death of such a friend increased Michelangelo's melancholy tendencies. He unburdened himself to his friend Giovan Francesco Fattucci in an emotional letter, in which he enclosed four poems. The letter and poems paint a vivid picture of a man distracted by his grief.

H. Increasingly in the next few years, Michelangelo will be burdened with thoughts of death, and such thoughts creep

into his poetry. Nonetheless, there are still many things he will accomplish.

Works Discussed:

Michelangelo:

Tomb of Julius II, completed 1545, marble, San Pietro in Vincoli, Rome, Italy.

Moses, 1505–45, marble, 7' 8" H (2.33 m H), San Pietro in Vincoli, Rome, Italy.

Rachel, 1542–55, marble, 6' 7½" H, Tomb of Julius II, San Pietro in Vincoli, Rome, Italy.

Leah, 1542–55, marble, 6' 10" H, Tomb of Julius II, San Pietro in Vincoli, Rome, Italy.

Crucifixion, c. 1538–41, black chalk, 14½ × 10½" (37 × 27 cm), British Museum, London, Great Britain.

Pietà, c. 1540, black chalk, 11⅝ × 7⅝" (29.5 × 19.5 cm), Isabella Stewart Gardner Museum, Boston, Massachusetts.

Artist Unknown:

Portrait of Vittoria Colonna, undated, oil on panel, 24½ × 17¾" (62 × 45 cm), Casa Buonarroti, Florence, Italy.

Marcello Venusti:

Crucifixion, undated, oil on panel, 20 × 13" (51 × 33 cm), Galleria Doria Pamphili, Rome, Italy.

Pietà, 1546, oil on panel, 22 × 15¾" (56 × 40 cm), Galleria Borghese, Rome, Italy.

Francesco Jacovacci:

Michelangelo and Vittoria Colonna, undated, oil on canvas, 47¾ × 79" (121.3 × 200.7 cm), Museo Nazionale di Capodimonte, Naples, Italy.

Suggested Reading:

H. Hibbard, *Michelangelo*.

C. de Tolnay, *Michelangelo: The Tomb of Julius II*.

W. E. Wallace, *Michelangelo: The Complete Sculpture, Painting, Architecture*.

M. Buonarroti, *The Poetry of Michelangelo: An Annotated Translation*, J. Saslow, ed.

M. Buonarroti, *The Complete Poems of Michelangelo*, J. F. Nims, trans.

V. Colonna, *Sonnets for Michelangelo: A Bilingual Edition*, A. Brundin, ed.

W. E. Wallace, ed., *Michelangelo: Selected Readings*. See W. Pater, "The Poetry of Michelangelo."

A. Nagel, *Michelangelo and the Reform of Art*.

S. Ferino-Pagden, ed., *Vittoria Colonna: Dichterin und Muse Michelangelos*.

Questions to Consider:

1. Why were so many previously carved elements—the *Rebellious Slave* and *Dying Slave*, the four *Slaves* in the Accademia, and possibly, the *Victory*—not used in creating the final tomb of Julius II?

2. What were some of the facets of Michelangelo's friendship with Vittoria Colonna? Is "friendship" adequate to describe the relationship?

Lecture Twenty-Nine—Transcript
The Completion of the Julius Tomb; Poetry

This lecture brings to a close the long, convoluted history of the compromised but still magnificent tomb monument of Pope Julius II. I'll consider first why the work was completed *now* (1545), after 40 years of delays and renegotiated contracts, and why Michelangelo once again made so many seemingly radical changes. The two newly carved figures of *Rachel* and *Leah* are examined for their significance and their relationship to the earlier tomb elements, notably the *Moses*. And, finally, we'll consider Michelangelo's contemporaneous friendship with Vittoria Colonna, to whom the artist presented some exquisite drawings and many, many poems.

But first I'd like to recapitulate something of the long history of this commission that proved to be Michelangelo's albatross. It's also equally problematic for the artist's biographer. But it all began auspiciously enough, in 1505, when Julius promised to pay Michelangelo the enormous sum of 10,000 ducats (enough to build a small church) to create a huge tomb, something like 23 by 36 feet, decorated with 40 life-size or larger-than-life-size marble statues.

Forty years later, the tomb, much reduced but still grand, was finally installed, not in St. Peter's (its original intended location), but in the titular church of Pope Julius, the church of San Pietro in Vincoli (St. Peter in Chains). During this long, drawn-out history, Michelangelo designed at least six different monuments, signed no less than four contracts, and changed his mind many more times.

But a key moment in this prolonged history was the death in 1538 of Pope Julius's heir, Francesco della Rovere, who really was no friend to Michelangelo. Thankfully, the new executor of the pope's estate was Francesco's son, Guidobaldo della Rovere. And Guidobaldo was a very different person from his father. Guidobaldo was a person whom Michelangelo evidently liked and respected, and in turn, Guidobaldo showed the greatest respect for Michelangelo.

Following the unveiling of the *Last Judgment* in 1541, Guidobaldo hoped that this was a moment that Michelangelo could turn his attention once again to completing the tomb. But soon after, he learned that Pope Paul had other ideas and wished Michelangelo to decorate the Pauline Chapel, which we discussed in our last lecture. Now, Guidobaldo was enormously gracious in acknowledging this

preemptive obligation, and he suggested that he would be content with just three statues from Michelangelo's hand, including the already carved *Moses*. Guidobaldo was willing to offer the artist a highly favorable new contract. This is the fourth and final contract that Michelangelo ever signed, in August 1542.

In contrast to the many della Rovere heirs that had pestered Michelangelo about the tomb over all these years, Guidobaldo della Rovere exercised patience and tact in dealing with the artist, and perhaps as a result, the tomb was completed during his watch. It had already been more than three decades in the making, and Michelangelo was just as busy now as ever. He had, as always, any number of excuses, especially now that Pope Paul wanted him to decorate the Pauline Chapel.

At this moment in his career, Michelangelo generally worked only for persons whom he esteemed and who, in return, displayed deference to the artist. Everyone else was either refused—usually with claims of old age or prior obligation—or had to be satisfied with some kind of vague promise. Guidobaldo, therefore, deserves some credit for the tomb's completion, just as his predecessors must, in part, be culpable for its delay.

Now knowing something of this long, drawn-out history prompts many viewers to feel a vague sense of disappointment when they actually see the tomb that Michelangelo ultimately left us. But that is the key point: This *is* the tomb that Michelangelo left us. After delaying and procrastinating for nearly 40 years, Michelangelo did *not* just throw something together. It satisfied him and it satisfied his very demanding patrons.

The surest sign of Michelangelo's interest in this final product is the fact that he elected to carve two wholly new figures—the *Rachel* and the *Leah*. They flank *Moses* on either side of the niches. So in the comparatively short span of two years (between 1543 and 1545, when it was all complete), Michelangelo carved two new marble sculptures, which is impressive given that he was approaching 70 years of age, was desperately ill in mid-1544, and was still working on the Pauline Chapel. And contrary to popular judgment, I find these sculptures, *Rachel* and *Leah*, to be great works of art, not as many critics have suggested, mediocre knockoffs executed in a hurried attempt to complete the tomb.

As in the Bible, *Rachel* and *Leah* are a contrasting pair. *Rachel*, in the left niche, is lithe, her form rising and twisting; her ecstatic visage is turned in fervent prayer. *Leah*, in the niche to the right of *Moses*, is stately, composed, and contemplative. The demure females flank and complement the prophet Moses and represent allegories of faith and good works, respectively, or as they were commonly designated, allegories of the contemplative and active life.

Now, in substituting these two female figures for the earlier nude slaves (Michelangelo's earlier idea for the tomb), Michelangelo has turned from a language of exaggerated physicality to one of spiritual yearning, from pagan to Christian allegory expressed in the comely form of draped females.

Let's first look at Rachel. In robes that suggest a nun's habit, Rachel clasps her hands and submits her appeal to heaven. The drapery modestly clads yet reveals the subtle and multiple turns of the elongated, asymmetrically disposed body. Her form rises ethereal and flame-like; she bends towards the natural light, a metaphor for the presence of God. She directly contrasts with the solid, matronly aspect of her sister, Leah.

Leah's voluminous drapery and *contrapposto* stance give her the appearance of a Classical goddess. She's something like a Greek *kore*, or a caryatid figure—one of those sculpted Greek maidens who help support, with effortless grace, a temple structure. Indeed, it is likely that Michelangelo was inspired by a famous antiquity that he well knew, the so-called *Cesi Juno*. But comparisons with the supposed model merely reveal how modern Michelangelo's conception is.

The youthful maiden glances wistfully and unspecifically towards the mirror that she holds in her right hand. The Bible (Genesis 30) informs us that "Leah's eyes were weak." Her limp left arm holds a garland. Her symmetrically parted and braided hair is bound up to create a sort of natural diadem, the effect of which is heightened by the shell niche that enframes and accentuates, radiant-like, her beautiful head. One thick tress of hair falls over her right shoulder and trails all the way to her waist, there to be, in a way, confused with the tress-like behavior of her drapery folds.

Her long, flowing garment sports an unusual ornamented bodice and a collar. A tightly wrapped horizontal band accentuates her smallish

breasts, and loose folds of drapery loop down below her waist. Note the swirling knot of drapery right in front of her womb. I think this evokes her fertility and prompts us to recall the six sons that she bore Jacob. If you recall back to our lecture on the *Bruges Madonna*, drapery was used by Michelangelo to evoke the internal movements of the mind and body. In that case, a drapery flourished by the head of Christ; here, by the womb, it suggests and draws attention to Leah's very fertile womb.

According to the Bible, Leah is not as pretty or as comely as her sister, but she was favored by God. And as though to express the beauty of her inner spirit, Michelangelo has created one of the most majestic and supremely lovely creatures of his entire oeuvre. It's another case where I think we've lost a certain amount of sensitivity to Michelangelo's ability to show the beauty of females.

With plenty of marble on hand, Michelangelo could have created any figures and on any scale. Michelangelo elected to carve the *Rachel* and *Leah* and to carve them at an obviously different scale from the central figure of *Moses*. Their size, their gender, and their restrained movements are purposeful. They're in marked contrast with the earlier slaves whose titanic forms appear to burst from the confines of their blocks. It's a notable achievement of restraint from an artist generally known and celebrated for just the opposite. The modesty of their size and their expression and the lesser degree of surface polish, I think, were purposeful decisions. Michelangelo observed what I would call a decorum of size and finish. Thus, the *Rachel* and *Leah* do not compete with *Moses*; rather, they're like a chorus, a foil and a counterpoint. Or, like the understated second movement of a symphony, they are quiet, subtle, and sublime.

In expressing their inner spirits through bodily form, Michelangelo carved two exquisitely beautiful females. They are highly original creations, and they're unjustly overshadowed by the *Moses* and Michelangelo's many other heroic nude figures. To see them as "bland," as some commentators have done, is to fail to recognize Michelangelo's achievement. It fails to recognize that the artist has grown and he's matured, and he's radically changed his mind over the course of his long career, over the course of 40 years of carving this tomb.

He has fashioned a new vocabulary of the human body, a new vocabulary of Christian art. Kind of like his late drawings and his poetry, the carnal body has become ethereal, pared to essentials. Michelangelo is less interested in the carnal body except as it represents spirit. The artist—whether with chisel, chalk, or rhyme—is seeking to express inward spirit, something abstract, Christian truths, and a profound but abstract yearning.

Now the *Moses*, in contrast, reflects an earlier Michelangelo. It was probably begun in 1505 or 1513 and worked on periodically for the next 30 years, so dating it seems almost artificial. The *Moses* sat on Michelangelo's workshop floor, watching as the artist changed his ideas, grew old, and carved the *Rachel* and *Leah*. Michelangelo lived with *Moses* and looked into the prophet's face every day he entered his house for nearly three decades.

The powerful gaze of *Moses* is directed upwards, as though towards his Lord—a face that beholds divinity. If *Moses* were to stand, he would be nearly twice as tall as an average person, but his size is the least important measure of this figure's awesome power. *Terribilità*—"terribleness"—a word that's sometimes used to describe Michelangelo himself, really very aptly describes Moses' fearsome aspect: *terribilità*.

Vasari actually tells us that every Sabbath, the Jews, like starlings, flocked to see the prophet, which is really a remarkable testament to the power of art to attract the faithful of whatever religious persuasion. Rarely has a disregard of the Second Commandment, that Second Commandment which states not to make graven images, resulted in such a powerful figuration of faith.

I'd like to suggest a kind of reassessment of our tomb. In relating the tortuous history of the Julius monument, Michelangelo's pupil and his biographer, Ascanio Condivi, perhaps aptly termed it a "tragedy." Surely, he was reflecting some of Michelangelo's frustrations and he was lamenting, as many persons have since, that the tomb is merely a fragment of its original grand conception. But to imagine what the tomb might have been is to blind ourselves to what it is. Michelangelo devoted enormous energy to create one of the grandest and one of the most noble funerary ensembles of the entire Renaissance and, perhaps, of all time.

Condivi may have called it a tragedy, but he also concluded by saying, in his judgment, "The tomb, just as it is, botched and rebuilt, is yet the most impressive to be found in Rome and perhaps anywhere else." It is worth repeating because it's true: It's the most impressive tomb in Rome—and it's a statement that's confirmed daily by the number of persons who flock to visit San Pietro in Vincoli. It's one of the greatest tombs of the Renaissance, and it is one of the most visited tombs of all time.

Now let us turn our attention to one of those dear friends who, in encouraging Michelangelo's poetic and religious feelings, may also have unwittingly helped to shape the final form of the Julius tomb.

We're seeing here a portrait of Vittoria Colonna. Like Leah, Vittoria Colonna's beauty was more internal than external. Colonna was part of a large circle of friends and acquaintances that Michelangelo cultivated in Rome. Acutely conscious of his claim to nobility, the artist was particularly attracted, towards the latter part of his life, to persons of high social station. His friendship with Tommaso de' Cavalieri, for example, continued until the artist's death, even if somewhat diminished from the initial passionate intensity of the beginning of that relationship.

The artist found sustained nourishment and, I would think, spiritual guidance from his friendship with Vittoria Colonna, who was born in 1490 and died in 1547. She was the daughter of a noble Roman family and an accomplished poetess (published) that Michelangelo met while working on the *Last Judgment* and who died shortly after the artist completed the Julius tomb. For Colonna, Michelangelo made some exceptionally fine drawings and wrote some of his most fervent religious poetry.

This is probably the first drawing Michelangelo made for Vittoria Colonna, an exquisitely wrought masterpiece of the Crucifixion, Christ on the cross. Even if it's of modest materials and size—it is black chalk on paper, and it's only some 14½ inches high—it nonetheless has a kind of grandeur and impressiveness of presence. Note the upturned face and open-mouthed appeal of Christ, which forcefully suggests his anguished cry—"My God, my God, why hast thou forsaken me?"—on the cross. On receiving this drawing, Vittoria Colonna wrote to Michelangelo. In a letter, she wrote, "One

cannot see a better made, more life-like, and more finished image ... I have never seen a more finished thing."

Rarely has the world witnessed such a concentration of artistic excellence and religious fervor in such a small and vulnerable object. It's precious not for the humble materials from which it was made but because of its exquisitely refined artistry and the window it opens onto Michelangelo's life, his faith, and his friendships.

As with the many drawings that Michelangelo presented to his friend Tommaso de Cavalieri, this and every other drawing he made for Vittoria Colonna achieved instant fame. Everybody wanted to see them, and more than that, everybody wanted to have copies for themselves. Rarely could you get one from Michelangelo himself, and few did, but you could, then, commission painted versions, such as this very fine example, probably painted by Michelangelo's friend and professional associate Marcello Venusti. But just as with the Cavalieri drawings, there are multiple replications of this in various kinds of media.

The same is true of this *Gardner Pietà*, so-called because it's in the Isabella Stewart Gardner Museum in Boston, and this is among the drawings that Michelangelo made for Colonna that shows or combines the artist's recurring interest in the theme of the *pietà* with his profound attachment to the poet Dante. We are seeing here Christ, removed from the cross, slumping downward and forward as if towards his grave. His dead weight is barely supported by two children. Presumably they're angels, but they're wingless. But they're holding Christ's arms in a position that recalls the recent crucifixion—stretched out.

Mary raises her arms in appeal or supplication, to us and to heaven. And although art is always mute, we hear a plaintive cry; like in the previous drawing, you are encouraged to hear sound. In this case, Michelangelo has actually written on the cross above Mary's head an inscription, as if it's issuing from her. The words from her mouth are actually from Dante's *Paradise*, "*Non vi si pensa quanto sangue costa*," "No one thinks how much blood it costs." I think it's absolutely no accident that the words are from Michelangelo's beloved Dante, nor that those words are spoken by Beatrice in *Paradise*, because in many ways, Vittoria Colonna *was* Michelangelo's Beatrice: a trusted spiritual guide in Christian matters.

Ultimately, this and all of the Michelangelo drawings made for Vittoria Colonna and that were given to his good friends were widely disseminated in various media and widely admired, and this is just one of many examples of a painting made from a Colonna drawing.

Vittoria Colonna's death in 1547 came as shock and a serious blow to Michelangelo. To his close friend, the ecclesiastic Giovan Francesco Fattucci, Michelangelo lamented and wrote this: "Death deprived me of a very great friend, one who was devoted to me and I no less to her."

So it rings true when Condivi actually relates that Michelangelo "loved her so much that I remember having heard him say that what grieved him above all else was that when he went to see her as she was passing from this life, he did not kiss her brow or her face but simply her hand"—and that's what we see depicted in this 19th-century anecdotal painting. "Through her death," Condivi continues, "he [Michelangelo] many times felt despair, acting like a man robbed of his senses."

This is probably the only woman Michelangelo truly loved. Vittoria Colonna was 57; Michelangelo was 72.

Michelangelo found solace in words, and he wrote two exquisite madrigals, probably shortly after her death, and I'd like to read a fragment of one to you:

> But since heaven's stolen both that cordial flame
> and its splendor that warmed my life, sustained it, too,
> I'm a smothered coal, that's all: brief, feeble flashes.

And another madrigal reads like this:

> With her last breath, not quite,
> a moment even, God,
> from a world half aware,
> took back her beauty, but left our eyes a blur.
> Though she's interred in sod,
> not all lies buried there;
> we've still her charming poems, sweet and pure.

The poem refers to the sweet poems of Vittoria Colonna. Her "charming poems" remained to console him. Indeed, among Michelangelo's most valued treasures, his possessions, was a little

book of Vittoria Colonna's poetry, in which he bound 103 of her sonnets, along with an additional 40 poems that she had sent to Michelangelo from Viterbo, where she had gone into a nunnery. He equally valued the many letters that Vittoria Colonna wrote to him, although only five of these have been preserved. Michelangelo had a project, remember, to publish his poetry, and I think much of it was encouraged by Vittoria Colonna, but her death utterly killed his enthusiasm for this project, and Michelangelo's poems were never published in his lifetime—not till well after his death.

The death of such a friend naturally increased Michelangelo's already natural melancholic tendencies. He unburdened himself to that friend, Giovan Francesco Fattucci, in an emotional, disjointed, run-on sentence. Indeed, let me read this sentence to you. You can tell, can sense, his absolute despair.

> Having been very unhappy lately, I have been at home, looking through some of my things, there came to hand a great number of these trifles which I used to send you, of which I am sending you four, which I may have already sent you, you will say that I am old and crazy ["*vechio e pazo*"], and I assure you that only distractions keeps one from going crazy with grief, so don't be surprised, and reply to me about something, I beg you.

The letter and the poems that Michelangelo is writing and sending to Fattucci paint an extraordinarily vivid picture of a man utterly distracted by his grief. In rummaging through stacks of loose pages filled with poetry and old letters, Michelangelo suddenly has come across some verses that he had written out in a clean hand for Vittoria Colonna, some others that he shared with Fattucci many years ago, many other poems incomplete, none printed, as he had hoped. Now, all of a sudden, seeing them again, they all seemed terribly insignificant to him.

Nonetheless, he selected four of those old poems, "trifles," he says, "which I formerly sent you," and enclosed them in a letter to Fattucci, a few lines added "to prove that I'm still alive," he says. We don't know the precise verses that Michelangelo sent to Fattucci, but these two will give you the flavor of Michelangelo's sentiment, in a sense, something of Michelangelo's deep, deep concentration and salvation through poetry, especially at this extraordinarily emotional moment in his life.

The first reads like this:

> You, Love, gave my divine soul over to Time
> and imprisoned it, with a harsh destiny,
> within this mortal carcass, now frail and tired,
> What else can I do so as not to live this way?
> Without you, Lord, I'm deprived of every blessing,
> and the power to change fate is God's alone.

And one other:

> Once again a woman's beauty
> cuts me loose and spurs and lashes me;
> not only has Terce gone by,
> but None and Vespers, too, and evening is near.
> Between my birth and fortune,
> the one dallies with death,
> and the other can't give me real peace down here.
> I, who had come to terms
> with both my white head and my many years,
> already held in my hand the pledge of the next life,
> for which a truly penitent heart hopes.

Increasingly in the next few years, Michelangelo will be burdened with thoughts of death—of his friends, as well as his own. Nonetheless, there are still many things he would yet accomplish.

Lecture Thirty
The Capitoline Hill Projects; the *Brutus*

Scope:

This lecture is the first of several to consider Michelangelo's large number of architectural commissions in the city of Rome. In some ways, architecture occupied most of Michelangelo's creative energies in the last decades of his life. In this lecture, we will consider what Michelangelo did to renew and transform one of the most important sites in Rome: the Capitoline Hill, or Campidoglio, the earliest of his many Roman architectural commissions. Then, we will turn to one of the last sculptures that Michelangelo carved, the bust of *Brutus*, which is approximately contemporaneous with the Capitoline project and shares some of its republican overtones.

Outline

I. Rome, *caput mundi*: "the center of the world."

 A. The pontificate of Pope Paul III, whom we see again in a portrait by Titian, was a glorious time for Michelangelo. Thanks to Pope Paul, the artist turned increasingly to architecture and helped to transform the dilapidated ancient city of Rome into a modern Christian capital.

 B. Michelangelo's contribution to the future of Rome lay in the scale and audacity of the projects he undertook: the Campidoglio, the Farnese Palace, San Giovanni dei Fiorentini, Santa Maria degli Angeli, the Porta Pia, the Sforza Chapel, and St. Peter's.

II. The Capitoline Hill in ancient and Renaissance times.

 A. The Capitoline Hill, or the Campidoglio, was the geographical and ceremonial center of ancient Rome, site of the temple of Jupiter. But in the Renaissance, it was at the edge of the much smaller, less densely populated city.

 B. As we see in a drawing from the 1530s, by the Renaissance, the Capitoline Hill was an untidy conglomeration of dilapidated buildings; in fact, it was the site of criminal executions. The embarrassment of the site prompted Pope

Paul III to entrust Michelangelo with the task of refurbishing it.

C. On the left side of the drawing is the church of Santa Maria in Aracoeli, built over the site of the temple of Jupiter in the Middle Ages. To the right is the Conservator's Palace, the place where the various guilds of Rome gathered and had their offices. At the center of the hill, built over the ancient foundations of the Roman Tabularium (record office), is the senate building, which had served as a fortress in the Middle Ages.

D. The hill had been neglected during the Middle Ages and early Renaissance partly because the site was tied up with pagan history. Moreover, any enhancement of the civic center would draw resources away from St. Peter's, the ecclesiastic center.

E. We see a view of the Capitoline Hill in ancient times, from the Roman Forum looking up to a number of temples that crowned the hill. As mentioned earlier, in some cases, buildings had been erected on older foundations. Thus, the hill represented a layering of history, from ancient through medieval times and into the Renaissance.

F. The Capitoline Hill would have been the culmination of Roman triumphal processions, but in the Renaissance, one side of it was known as the cow pasture, and the entire population lived on the opposite side. One of the great accomplishments of Michelangelo was reorienting the hill to face the modern Renaissance city.

III. Michelangelo's transformation of the Capitoline Hill.

A. Michelangelo began the project of renewing the Capitoline Hill by relocating the equestrian statue of the emperor Marcus Aurelius, which we see here in a drawing by Marten van Heemskerck. Throughout the Middle Ages, the statue had been far from Rome's center.

1. Much of the statuary of ancient Rome had been destroyed in the Middle Ages, but the bronze of Marcus Aurelius survived because it was believed to be Constantine, the first Christian emperor.

2. By the Renaissance, the correct identity of this statue had been well established, but it was revered as a symbol of ancient authority. Moreover, Marcus Aurelius was a great writer and Stoic philosopher, and his book, the *Meditations*, had earned him respect as something of a proto-Christian thinker.

3. The statue had no association with the Capitoline Hill, but in moving it, Michelangelo invested the site with a venerated symbol of ancient thought.

B. As he had done with other projects, Michelangelo looked to the center to find a solution for the disorder of the Capitoline Hill. In architecture as in sculpture, he began by defining the torso; the rest was appendage.

1. The equestrian statue provided a center and a focus; the buildings, like the bones of a body, gave definition to the torso.

2. In architecture, space, as much as structure, is a key element. At the Capitoline, space helps to create a dynamic ensemble. The result is a giant outdoor room, an enclosed plaza that is open to the sky.

C. To mount the hill, one climbs a long, tapering ramp, the *cordonata*, which rises to a broad piazza. Just as he did with the staircase in the Laurentian Library, Michelangelo has made this ramp an exciting element of the architecture.

D. The central oval of the piazza is slightly domed, suggesting that we are standing on the domed top of the world.

1. The starburst pattern of the pavement was laid only in the 19th century, but it was originally Michelangelo's design.

2. In some ways, the paving mirrors the movement of visitors as they wander around the curvilinear paths of the piazza and return to *Marcus Aurelius* in the center.

E. At the same time, we sense a strong central axial movement toward the senate building.

1. The axis of the building is reinforced by the *cordonata* and by the framing of the *Marcus Aurelius*. Michelangelo moved the bell tower of the senate to the center of the building to help accentuate that central axis.

2. He also built the flanking stairs, which assist in forming a beautiful triangular composition of architectural and sculptural elements encompassing the *Marcus Aurelius* and two river god sculptures.

3. Finally, in the niche at the very center, behind the *Marcus Aurelius*, is a statue of Roma.

F. The two giant river gods, more than 10 feet long, were moved to the Capitoline Hill from a Roman bath complex. These statues represent the Nile and the Tiber, the river at the edge of the Roman Empire and the river at its center.

G. Articulating the edges of the trapezoidal space are the Conservator's Palace and, facing it, in mirror image, the Braccia Nuova, or "New Wing." They are at set at an irregular splayed angle to each other and to the central senate building, the Palazzo del Senatore.

1. Michelangelo designed the Braccia Nuova to provide balance and coherence to the ragged ensemble of existing structures.

2. On both the Braccia Nuova and the Conservator's Palace, Michelangelo employed one of his most important architectural inventions—the *giant order.* These are large pilasters, set on high bases and uniting two stories of the structures. The powerful vertical thrust of the pilasters is balanced by equally strong horizontals in the designs of the buildings.

3. The windows of the buildings have heavy pediments and surrounds, repeated redundantly. The parts are multiplied for decorative, not structural, purposes.

H. The basic vocabulary of an arcaded building comes from Brunelleschi, whose work we see in the Ospedale degli Innocenti. Michelangelo's structure seems heavy and block-like compared to Brunelleschi's, but it's also dense and richly detailed.

I. The senate building is distinguished from its more robust neighbors by large expanses of buff brick, less densely layered surfaces, and details that are more florid and less concentrated. This language of ornament signals its function as the principal government building of Rome.

J. Ornament endows a building with eloquence. As an

architect, Michelangelo learned how to balance structure and ornament. His buildings characteristically speak forcefully and with great clarity, but they also engage us on a more subtle and nuanced level.

K. Most of the Capitoline Hill project was realized after Michelangelo's death, based in part on an engraving of his design and thanks to the careful oversight of Tommaso de' Cavalieri. The complex is considered to be one of his masterpieces.

IV. *Brutus.*

A. The figure of *Brutus* is approximately contemporaneous with Michelangelo's work at the Campidoglio, and it's equally suggestive of the traditions of republican Rome. The *Brutus* is Michelangelo's only essay in portraiture, an idealized celebration of the famed republican Marcus Brutus, who murdered Julius Caesar.

B. Through much of the Middle Ages, Brutus was considered a sinner because he was a regicide, killer of a king. But in the 16th century, his reputation was rehabilitated as a man who stood up to a tyrant in favor of a noble cause—a free republic.

C. The parallel of Brutus's history with Michelangelo's own time is unmistakable.

1. An obvious tyrant, Alessandro de' Medici, ruled Florence until he was murdered in 1537 by a Florentine patriot. It seems almost certain that Michelangelo's *Brutus* commemorates this event.

2. Clearly, Michelangelo celebrates Brutus, representing him as a strong, determined, and principled hero. The *Brutus* is the most overtly political object Michelangelo ever made, and it powerfully confirms his lifelong belief in a free republic.

D. The head of Michelangelo's *Brutus* is turned sharply to his left, revealing the taut muscles of his thick neck. The powerful, frowning countenance and directed gaze are enhanced by the rippling eyebrows, deep-set eyes, and firmly pressed lips. The close-cropped hair contrasts with the comparative smoothness of the face and drapery.

1. These elements are textured by working the stone to differing degrees of finish.
2. There is nothing unfinished about these passages. The stone is carved to illusionistic ends, at the same time that the material is never denied.

E. The *Brutus* participates in a long line of realistic portraiture in Florentine art, such as we see here in a bust of Cosimo de' Medici by Mino da Fiesole. Also important as a precedent for Michelangelo would be the sense of lively action we see in Donatello, as in his terracotta *Niccolò da Uzzano*. Perhaps most important, Michelangelo's *Brutus* is clearly based on the famous portrait of the emperor Caracalla by an unknown artist.

F. In contrast to the depiction of the Roman emperor, Michelangelo has used the *non-finito* as a technique of representation in his *Brutus*.

1. The reality of the powerful figure, somewhere between life-size and colossal, is enhanced by the roughened surfaces.
2. One might even read these surfaces as an analogue to Brutus himself. He was a man of principles and action, fashioned in the roughhewn era of republican Rome.
3. Michelangelo has invented his own version of a Roman "republican" style, different from the slick finish and soft sensuality of Greek Hellenism and Roman imperialism, such as in the Caracalla bust.

G. The *Brutus* is one more instance of how Michelangelo fashioned originality from the inherited past. Although the *Brutus* is the epitome of the republican hero, it would never be mistaken for an ancient sculpture. As he did in the *Bacchus*, Michelangelo created a work that is more Classical even than ancient art.

Works Discussed:

Artist Unknown:

View of the Capitoline Hill before Michelangelo's Restoration, c. 1530, pen and ink with wash and chalk, $11 \times 16\frac{3}{4}$" (28.2×42.5 cm), Musée du Louvre, Paris, France.

Emperor Caracalla, 215–17 CE, marble, 28½" H (72 cm H), Musei Capitolini, Rome, Italy.

Maarten van Heemskerck:

View of Marcus Aurelius in Front of the Lateran, 5 × 8" (12.6 × 20.5 cm), Kupferstichkabinett, Staatliche Museen zu Berlin, Berlin, Germany.

Michelangelo:

Capitoline Hill (Campidoglio), Rome, Italy.

Brutus, marble, 37½" H (95 cm H), Museo Nazionale del Bargello, Florence, Italy.

Etienne Duperac:

Michelangelo's Design for the Capitoline Hill, 1568, engraving, 16¼ × 22" (56 × 41 cm), Graphische Sammlung Albertina, Vienna, Austria.

Mino da Fiesole:

Giovanni di Cosimo de' Medici, 1450s, marble, 20" H (51 cm H), Museo Nazionale del Bargello, Florence, Italy.

Donatello:

Niccolò da Uzzano, 1430–32, polychrome terracotta, 18⅛" H (46 cm H), Museo Nazionale del Bargello, Florence, Italy.

Suggested Reading:

J. S. Ackerman, *The Architecture of Michelangelo.*

W. E. Wallace, ed., *Michelangelo: Selected Readings*. See J. S. Ackerman, "Michelangelo's 'Theory' of Architecture."

G. Argan and B. Contardi, *Michelangelo Architect.*

H. Hibbard, *Michelangelo.*

W. E. Wallace, *Michelangelo: The Complete Sculpture, Painting, Architecture.*

G. d'Ossat and C. Pietrangeli, *Il Campidoglio di Michelangelo.*

W. E. Wallace, ed., *Michelangelo: Selected Readings*. See D. J. Gordon, "Giannotti, Michelangelo and the Cult of Brutus."

Questions to Consider:

1. Can you think of other world capitals that have such a significant history as Rome and were radically born or reborn through

design, architecture, and urban planning? How is each of your examples similar to, and different from, Michelangelo's transformation of the Roman capital?

2. How does Michelangelo approach architecture, given that he never had formal training in what is today a highly technical, rigorously organized, and regulated profession?

Lecture Thirty—Transcript
The Capitoline Hill Projects; the *Brutus*

Rome, *caput mundi*: Rome, the center of the world. It had been the center of the world in ancient times. Michelangelo helped to make it once again the center of the world.

This lecture is the first of several to consider Michelangelo's large number of architectural commissions in the city of Rome. In many respects, architecture occupied most of Michelangelo's creative energies in the last decades of his life and represents one of the greatest and most influential of his accomplishments.

In this lecture, we will consider what Michelangelo did to renew and transform one of the most important sites in all of Rome: the Capitoline Hill or, in Italian, the Campidoglio, so-called because it was the capital of ancient Rome. It was one of the seven hills of Rome and perhaps the most important of those seven hills. This was the first of Michelangelo's many Roman architectural commissions, undertaken at the urging of his remarkable patron Pope Paul III, who we see once again in our portrait by the artist Titian.

Pope Paul III's long pontificate, from 1534 to 1549, was a really glorious time for Michelangelo. He was at the apex of his fame, surrounded by friends and admirers, and working for one of the most discerning patrons of all time. Paul first commissioned Michelangelo to paint the *Last Judgment*, and then the Pauline Chapel, and finally, he entrusted his artist with projects that challenged him to become more than just a painter/sculptor. Thanks to Paul, Michelangelo turned increasingly to architecture and helped to transform a dilapidated ancient city into a modern Christian capital.

Michelangelo's contribution to the future of Rome lay in the scale and audacity of the vast numbers of projects he undertook: the Campidoglio, the Farnese Palace, San Giovanni dei Fiorentini, Santa Maria degli Angeli, Porta Pia, the Sforza Chapel, and last but not least, St. Peter's. Thus, over the course of the next few lectures, we will witness the maturation of an architectural genius. Now, of course, his architectural career began at San Lorenzo in Florence, but it was really nourished and it flourished in the city of Rome.

Here, we're looking at two maps of the city of Rome, and the Capitoline Hill, or the Campidoglio, was the geographical and

ceremonial center of ancient Rome. Here was the temple of Jupiter Optimus Maximus, which crowned the hill, from which departed all the roads that linked the far reaches of the empire. This was the heart of ancient Rome, but it was at the edge of a much smaller, less densely populated Renaissance city.

If we take a look at our 16th-century map—and remember that the Renaissance city barely fills the bend in the Tiber and by no means fills the 22-mile circuit of walls—so the Campidoglio, or Capitoline, approximately here, is in the center of the ancient city, but at the very edge of the Renaissance city, which lay towards the Tiber. If we look at a modern map, the Capitoline Hill is this, here, and its primary orientation was to the ancient Roman Forum, which lay on this side. But the Renaissance city was entirely on the opposite side of the Capitoline Hill. And so one of the primary things, the principal things, that Michelangelo accomplishes is to reorient entirely the direction that this hill faces and all of its architectural monuments.

Although no longer as impressive as it was 1,000 years previously, the Capitoline Hill still served as the civic center of Rome, and it was the seat of the local government in the city of Rome. It is, in some ways, the weak sister to the ecclesiastic center of St. Peter's, because the Roman civic government was by no means as powerful as the papal government.

As we see in this drawing from the 1530s, by the Renaissance, the ancient Roman capital and the former ceremonial center was an untidy conglomeration of dilapidated buildings, and in fact, the Capitoline Hill was the site of criminal executions. So it was no longer a place really that was a destination for pilgrims who came to Rome. Indeed, when the Holy Roman Emperor Charles V came to Rome in 1536, he, a modern emperor, desired to visit the ancient Capitoline Hill, but he was unable to mount because the slopes were too muddy to climb. This was an embarrassing event that evidently prompted Pope Paul III to entrust Michelangelo with the task of refurbishing the ancient capital.

The artist received an added incentive when he was made an honorary citizen of Rome in 1546, and thereby, he joined an illustrious group of individuals stretching all the way back to antiquity and including one of his favorite and greatest of poets,

Petrarch, who also had been granted an honorary citizenship of Rome.

If we look at our drawing, we want to note that on the left side is the great church of Santa Maria in Aracoeli, built over the site, actually, of the temple of Jupiter. This had been built in the Middle Ages and was part of the Capitoline complex. To the right is the Conservator's Palace, the place where the various guilds of Rome gathered and had their offices.

And then at the center of the hill, built over some ancient foundations of the Roman Tabularium, is the senate building. But note, for example, that throughout the Middle Ages, the senate also served as something of a fortress, and we can see the fortified tower. Notice also that the bell tower of the senate building is off center, and this is something that Michelangelo will actually move to help give a kind of symmetry to the whole complex.

But imagine taking this as your given and trying to make something out of this really muddy mess, to give it some kind of architectural coherence. I would suggest that part of the reason that the hill had been neglected so much through the Middle Ages and into the early part of the Renaissance was that, of course, the site was very much tied up with pagan history. These were some of the greatest of pagan monuments on the top of the Capitoline Hill. Moreover, any enhancement of the civic center would draw resources away from, and in some ways compete with, those of St. Peter's, the ecclesiastic center.

This would have been the view of the Capitoline Hill in ancient times, from the Roman Forum looking up to a number of temples that crowned the hill. We can still see the Tabularium, or what was the Roman record office, and it's still visible as a foundation for the senate building, which was built on top of it—even though, as I suggested, it was also partly a fortified fortress during the Middle Ages, and finally, it became the civic center of Renaissance Rome. So we're really looking at sort of a layering of history here, from ancient times through medieval times into Renaissance times.

So the ancient capital would have been the culmination of Roman triumphal processions, which would have wound through the Roman Forum and mounted up to the hill, but in the Renaissance, nobody lived on this side of the hill at all. In fact, the whole Roman Forum

was called the *campo vaca*, or the cow pasture; it was a place to pasture your sheep. The entire Renaissance city lived on the opposite side of the hill. And this is one of the great accomplishments of Michelangelo, in reorienting the capital to the modern city or the modern Renaissance city.

So this is what Michelangelo has done. We've just been looking at the Capitoline Hill from the Roman Forum towards this direction, and Michelangelo actually turns the Capitoline Hill around in order to face the modern city. It's a real challenge that Michelangelo faced in finding some kind of coherence from the jumble of ruined buildings and inarticulate buildings. Indeed, one of the things he did was build a second building right here up along the flank of the church.

This building was the Conservator's Palace, which existed, along with the senate building, at a very odd angle. Instead of trying to correct this angle, Michelangelo just replicated it by building a façade building on the opposite side to create a regularized trapezoidal space. So rather than trying to fight the preconditions, Michelangelo worked with the conditions given to him in order to create a beautiful and coherent space.

And how did he go about doing this? Well, he began the project in rather brilliant fashion, by relocating the equestrian statue of the emperor Marcus Aurelius, which we see here in a drawing by Marten van Heemskerck, as it had stood all through the Middle Ages at San Giovanni in Laterano, far from Rome's center, out by one of the major papal churches.

Now, this is an ancient bronze statue of the emperor Marcus Aurelius, the Roman emperor. It survived the despoliations of the Middle Ages in the mistaken guise of Constantine, the first Christian emperor. Much of the statuary of ancient Rome from the Middle Ages was either destroyed or burned in the lime kiln, or if it was a bronze it would have been melted down. But because this had been mistakenly identified as Constantine, it was actually celebrated as one of the great surviving antiquities.

Now by the Renaissance, the correct identity of this statue had been well established. So although it was known to be a portrait of the pagan emperor Marcus Aurelius, it continued to be revered as a symbol of ancient authority, especially because by then, it was more

than 1,000 years old. Moreover, Marcus Aurelius was a great writer, a great Stoic philosopher, and his book, the *Meditations*, was well known through the Middle Ages and earned him respect as something of a proto-Christian thinker.

So Michelangelo took this statue, which had absolutely no association with the Campidoglio whatsoever, and relocated it to the center of the Capitoline site. In moving the equestrian statue, Michelangelo was reinvesting the site with a venerated symbol, a venerated symbol that is both ancient and also considered pseudo-Christian, fused into one important monument. The statue then becomes the catalyst and the dynamic center of an architectural ensemble that is simultaneously both sober (appropriate to its civic function) but also magnificent (recalling what the Capitoline Hill had been more than a millennium earlier).

Now similar to many other projects—notably, St. Peter's and San Giovanni dei Fiorentini—Michelangelo looks to the center to locate a solution for the current disorder of the Capitoline Hill. In architecture as in sculpture, Michelangelo began by defining the torso; the rest was appendage. And there was plenty of appendage on this hill, all kinds of fragmentary buildings and disorder. And so, by putting this statue in the center, suddenly, it all begins to have coherence around the statue, and it's almost as if the architecture begins to fall into place around the very strong central torso that Michelangelo describes as the first object.

Thus, the equestrian statue of *Marcus Aurelius* is really the center of this complex. It's the focus. The buildings are like the skin and bones of a body; they give solid definition to the torso. In architecture, space, as much as building, is a key element. At the Capitoline, the space helps to create a dynamic ensemble. And what we have really is a complex. It's a giant outdoor room, a plaza enclosed and protected but open to the sky. In fact, almost everybody who visits the Capitoline immediately feels the sense of escape from the noise and chaos of the modern city. To climb up to the Campidoglio is to find a refuge, a bit of quiet, satisfyingly harmonious and infinitely dignified, in the otherwise chaotic and loud city of Rome.

To mount that hill, one climbs a long, tapering ramp, what is called the *cordonata*, which rises to this broad piazza. The ramp is broad enough for processions, and it's of a gentle enough slope that one can even ride a horse up. Like the staircase at the Laurentian Library,

the so-called "stairs" of this ramp are very easy to climb and they make one feel good. Recall just what he did at the Laurentian Library. Stairs are functional elements. They move us up in space. And in both of these cases, Michelangelo has made the staircase an exciting element of architecture, so that we feel as we mount the staircase as if we're rising above the mundane life and chaos of the city and becoming something new or coming into something new, which we are. This is how architecture can be a life-enhancing experience.

The central oval of this piazza is slightly domed. It suggests, then, that we are standing on the domed top of a world globe. We are, once again, the umbilicus of the world. This is Rome, *caput mundi*—head of the world.

The starburst pattern of the pavement was actually laid only in the 19th century, but it was originally Michelangelo's design, and it greatly enhances the interest in the center. It encourages us to move in a free and elastic way around the piazza, both actually moving and just visually moving. It gives a kind of dynamism to it. The lines of this design throw us outward to one of its 12 points only to return us always to Marcus Aurelius at the occupied center. The paving, in a way, mirrors our actual movement through and around the piazza. People tend to wander around on the gently arcing and curvilinear paths, constantly moving away and back toward the center.

But there's also, at the same time, a very strong central axial movement towards the culminating senate building. And if we look towards the senate building, we're coming up that *cordonata*, the axis is reinforced by the *cordonata*, by the fact that the *Marcus Aurelius* is perfectly framed by a symmetrical building. Michelangelo has moved the bell tower to the center of the building to frame, to help accentuate, that central axis. He has built the two flanking stairs on either side that give a beautiful triangular composition of architectural and sculptural elements that enhance the *Marcus Aurelius*, especially because he also moves these two large river gods here to enhance the complex. And finally, behind, in the niche at the very center, behind the *Marcus Aurelius*, is a statue of Roma, thereby reinvesting the Capitoline Hill with the memory of an ancient statue actually of Rome.

The architecture and the sculpture are employed to organize space and our experience. This is a very straight visual axis that leads directly from the *cordonata* to the senate building, but our actual movement through the space is then interrupted by the statue first, and then by the choice we have to make to mount up to the senate building either to the left or to the right.

The two giant river gods were both moved to the Capitoline Hill by Michelangelo. They're more than 10 feet long, and they came from a Roman bath complex. Thus, they have absolutely nothing to do with good government. So Michelangelo has taken these ancient pagan sculptures and changed them from being minor decorations in a pagan bathing institution to becoming prominent sculptures that help enhance the grandeur of their new home. And he even articulates them and gives them character. They are the Nile River on the left-hand side and the Tiber River on the right—the Nile representing a famous river at the edge of the Roman Empire, and the Tiber River, of course, representing a river at the very center, the very heart of empire.

Articulating the edges of the trapezoidal space are the Conservator's Palace on the left in this view and, on the right-hand side, facing it in mirror image, is the Braccia Nuova, or the "New Wing." They are at this irregular splayed angle to one another and to the central senate building, the Palazzo del Senatore.

Michelangelo designed a new façade for the Conservator's Palace, the building that was already there, and he built an entirely new building, the Braccia Nuova, here to face it and to be a mirror complement to it. He designed the Braccia Nuova to provide balance and coherence to the ragged ensemble of the existing structures, and as I suggested, utilizing that already given odd angle to create a very interesting, dynamic trapezoidal space.

On both of these buildings, Michelangelo has invented one of his most important architectural inventions—the so-called *giant order*. These are giant pilasters, and we can think of a pilaster as a section of a square column. They are on very high bases and they run through two stories. This is unusual. Usually, we have columns of pilasters that define one story, and then pile on to create a second story. Instead, Michelangelo's giant pilasters actually unite two stories, and their vertical thrust continues right up to the statuary. It's a very strong, powerful vertical thrust that is, then, beautifully

balanced by equally strong and emphatic and repeated horizontals, most obviously in the crowning entablature of the building and in the interrupted smaller entablatures over each bay of the building.

The result is a perfect balance of contending vertical and horizontal forces. Our surfaces are layered, and the articulation of the building is dense and multiple. The building appears, from a distance, quite strong and simple at first glance, but it has a polyphonic richness as one approaches. Note, for example, that in addition to the pilasters, there are columns on the lower story and columns framing the windows.

And, then, the windows themselves—they have very heavy window surrounds and extremely heavy pediments. There's a kind of multiplication of parts for decorative, not for structural, purposes. There's a kind of dense layering of the building that adds an infinite interest to it.

This basic vocabulary comes from Brunelleschi. Michelangelo inherited this vocabulary of an arcaded building from Brunelleschi, and we're seeing his great Ospedale degli Innocenti. But if we compare these two buildings, we begin to see what Michelangelo has done with the vocabulary of Brunelleschi in creating a foursquare solid structure. Michelangelo's seems heavy and block-like, but it's also dense and richly detailed. It's a highly sculptural building in comparison to Brunelleschi's rather thin-screened arcade.

The senate building is distinguished from its more robust neighbors by the great expanses of buff brick, the less densely layered surfaces, and the details that are more florid and somewhat less concentrated. The broad wall surfaces billow against architectonic restraints, like a slightly over-inflated cushion; windows appear like buttons about to pop off of taut surfaces. This language of ornament signals its important function as the principal government building—it's the new senate of Rome.

Ornament endows a building with eloquence. This is how buildings are individualized and how they "speak" to us. Now, as an architect, Michelangelo has learned how to balance strength and oratory, structure and ornament. His buildings characteristically speak very forcefully and with great clarity, but they also continue to engage us on a more subtle and nuanced level long after the strong first impression. Ornament is a constant surprise and an enduring quality

of his architectural vocabulary, but it's one of those things that many architects have a hard time controlling, knowing when to stop or how to keep it under wraps, so to speak.

Now, like many other architectural projects, most of the Capitoline was realized after Michelangelo's death, in part thanks to this engraving and the helpful oversight of his friend Tommaso de' Cavalieri, who was responsible for helping see this project through to completion. The strength and clarity of Michelangelo's initial design ensured that the final result largely reflected his intentions, and the complex is rightly considered to be one of Michelangelo's great masterpieces. He has really reinvested the Capitoline Hill with the grandeur that it had more than 1,000 years before.

I'd like to turn then to the figure of *Brutus*, which is approximately contemporaneous with Michelangelo's work at the Campidoglio, and it's equally suggestive of the traditions of republican Rome. Michelangelo carved the *Brutus* for his friend and fellow exile from Florence Cardinal Niccolò Ridolfi. It is Michelangelo's really only essay in portraiture. It's an idealized celebration of the famed republican Marcus Brutus, who murdered Julius Caesar.

But why should Michelangelo carve and celebrate Brutus, especially given that his beloved Dante, for example, condemned him and placed him in the lowest depth of hell? Is Brutus a hero or a sinner? Through much of the Middle Ages, he was a sinner because he was a murderer and he was a regicide, a killer of kings. But in the 16th century, this was a topic of real concern, and it accompanied discussions about the nature of good government and how to protect good government from tyrants.

Brutus, in effect, was rehabilitated as a man who stood up against a tyrant in favor of a noble cause. He was in favor of and defended a free and independent republic. Therefore, in the 16th century, Brutus was rehabilitated as something of a noble hero, a tyrannicide as opposed to a regicide, and one only needs to think of Shakespeare's *Julius Caesar*. We may not condone what Brutus did, but he certainly was a man of noble purpose standing up for a noble cause.

The parallel with Michelangelo's own time is unmistakable. An obvious tyrant, Alessandro de' Medici, was ruling Florence with an iron fist until he was murdered in 1537 by a Florentine patriot, a self-styled new Brutus. It seems almost certain that Michelangelo's

Brutus commemorates this event or, at least, allows one to draw an easy and rather obvious parallel between the ancient and modern versions of tyrannicide. And clearly, Michelangelo is celebrating Brutus, representing him as a strong, determined, and principled hero, not as a sinner to be condemned to hell. The *Brutus* is the most overtly political object that Michelangelo ever made, and it powerfully confirms that despite his sometimes conflicting loyalties, Michelangelo remained, at heart, a lifelong believer in a free republic.

Brutus is dressed in a toga-like cloak that is fastened by a large, figurated brooch on Brutus's right shoulder. The head is turned sharply to his left, revealing the taut muscles of the thick neck. The powerful, frowning countenance and directed gaze are enhanced by the rippling eyebrows, deep-set eyes, and firmly pressed lips. The mat of close-cropped hair contrasts with the comparative smoothness of the face and drapery. Each is textured by the working of the stone to differing degrees of finish, from the lumpy rawness of the hair to the exquisite net of parallel chisel marks that helps describe the woven fabric of cloth. There is nothing unfinished about these passages. The stone is carved to illusionistic ends at the same time that the material of stone is never denied.

Now, the *Brutus* partakes of a long line of tradition of realistic portraiture in Florentine art, and we see here a bust by Mino da Fiesole. Very important as a precedent for Michelangelo would be Donatello, the sense of lively action here in Donatello's *Niccolò da Uzzano*, the turned head and the extreme realism of this figure, although in terracotta as opposed to stone. And perhaps most important, the *Brutus* is clearly based on this famous portrait of the emperor Caracalla.

But in contrast to the Roman emperor, Michelangelo has utilized the *non-finito*, or rough finish, as a technique of representation. The reality and the immediacy of the powerful figure, somewhere between life-size and colossal, are enhanced by the roughened surfaces. One might even read them as an analogue to Brutus himself. He was a man of principles and action, fashioned in the roughhewn era of republican Rome. Michelangelo has invented his own version of a Roman "republican" style, different from the slick finish and soft sensuality of Greek Hellenism and Roman imperialism, such as the Caracalla bust.

The *Brutus* is one more instance of how Michelangelo fashioned originality from the inherited past. While the *Brutus* is the epitome of the republican hero, he would never be mistaken for an ancient sculpture. Like the *Bacchus*, Michelangelo has created a work that's more Classical even than ancient art.

Now having considered Michelangelo's refashioning of the center of the city of Rome, as well as his deep-felt attraction to the tradition and noble ideal of republican government, in our next lecture, we'll turn from the civic center of the Campidoglio to its counterpart, the equally ambitious ecclesiastic center at St. Peter's.

Lecture Thirty-One
The New St. Peter's Basilica

Scope:

This lecture is entirely devoted to Christendom's greatest monument and one of Michelangelo's greatest architectural achievements, the new St. Peter's Basilica. We will first discuss the history of the rebuilding of the church from the time of Pope Julius II until 1546, when Michelangelo took over the commission. Then, we will examine what Michelangelo did to rescue the building from nearly 30 years of ill-designed accretions. In subsequent lectures, we will consider other architectural and sculptural projects, but it is important to keep in mind that St. Peter's is the perpetual backdrop to all other endeavors and the constant concern of Michelangelo for the remainder of his life.

Outline

I. St. Peter's in the time of Michelangelo.

 A. By 1546, after more than 30 years of construction and destruction, St. Peter's was a depressing sight, as we see in a drawing by Marten van Heemskerck.

 1. Vaults linked the four massive piers, but the central crossing was open to the sky. The high altar and the grave of St. Peter were protected from the elements by a temporary structure. Broken pieces of nave columns and entablature lay where they had been pulled down in ruinous haste.

 2. The old building was left to deteriorate. The new structure was covered with scaffolding; festooned with ropes, cranes, and hoists; and surrounded by a disorderly pile of stone and mud. From near or far, St. Peter's looked more like a Roman ruin than a church.

 B. The building was granted a reprieve from further indignity when its architect, Antonio da Sangallo the Younger, died in September 1546.

 1. Many followers of Antonio da Sangallo were available to pick up the project, but Pope Paul III chose

Michelangelo, appointing him supreme architect of St. Peter's on January 1, 1547.

2. Michelangelo, now 71 years old, inherited a recalcitrant workforce and a bevy of thick-headed, obstructionist overseers who were loyal to the previous architect. He would devote the remaining 17 years of his life to St. Peter's.

C. We see a plan and a reconstruction of the original church. This venerated basilica was built in the 4th century under the emperor Constantine and is one of the first Christian churches.

1. St. Peter's is a typical early Christian basilica, with a large forecourt open to the sky and a broad nave leading to the altar.

2. On either side of the nave are four aisles, in addition to the transept (the crossing) and the shallow apse that surrounds the altar and the grave of St. Peter.

3. The old circus of Nero is lightly drawn in on the grand plan. St. Peter was buried just outside the circus, in a graveyard that was for exiles and Christians.

4. The building had been standing for more than 1,000 years, and by the Renaissance, the walls were seriously out of alignment and the roof leaked constantly.

D. Alterations to Old St. Peter's began in the mid-15th century, but the real business of building a new basilica was undertaken in 1506 by Pope Julius II, whom we see in a portrait by Raphael. As Michelangelo was painting the Sistine Chapel ceiling, he was a witness to the insensitive destruction of Constantine's venerable basilica and the incompetent and inarticulate efforts to replace it with a new church.

II. Architects of St. Peter's.

A. Pope Julius's first architect, Donato Bramante, was a brilliant designer but a sloppy engineer. We see the drawing made by Bramante for the new building.

B. The drawing shows one-half of a centralized plan. Around a central dome are four minor domes, and in the corners, four bell towers. The design, which has equal arms, is called a *Greek cross plan*.

1. This plan corresponds to the foundation medal that was laid into the foundations of St. Peter's when the building was begun in 1506.

2. Looking at the plan and the medal, we get a sense that Bramante's design was a bit fussy, and it also presented an important question: Could this somewhat spindly plan support the enormous weight of a centralized dome?

C. In his haste to erect the new building, Bramante pulled down the marble columns of the Constantinian basilica. In another drawing by Marten van Heemskerck, we see the basilica with the columns still standing. Because of his attraction to such features in his own architecture, Michelangelo was distressed by the loss of these venerated columns.

D. In constructing the four piers to support the central dome, Bramante underestimated the weight and thrust they would be required to sustain. We see the arches that were built to cross these piers, but they are not substantial enough to support the stone dome. In cutting these corners, Bramante impaired the structural integrity of the new church.

E. St. Peter's is the largest church in Christendom, the most imposing symbol of papal authority, and a crowning achievement of the Renaissance. But for most of Michelangelo's life, it was a chaotic mess.

F. Following Bramante's death in 1514, a succession of architects took over the building of St. Peter's. We see, for example, a design by the painter Raphael. In this plan, the Greek cross has been compromised by the extension of the nave, and the clarity of the interior space has become clogged with numerous overarticulated elements.

G. In the 1540s, Antonio da Sangallo took over the project and devoted years to constructing a truly stupendous wood model. It's an object to excite wonder but an utterly horrible design, which Michelangelo critiqued at length in a letter. Were in not for Sangallo's death in 1546, we might have lost both the Sistine and Pauline chapels.

III. Michelangelo as architect of St. Peter's.

A. When he was appointed supreme architect in 1547, Michelangelo returned to Bramante's initial conception,

while correcting its engineering deficiencies. We see a side-by-side comparison of the plans by the two designers. Note, for example, that Michelangelo gives greater muscularity to the rather thin walls drawn by Bramante.

 1. Michelangelo has also minimized Bramante's original plan, leaving us with, essentially, a solid cube. Within that cube is a square corridor of spaces around the central dome, and the plan is returned to the Greek cross, with equal arms, nave, and transept.

 2. The basic idea is Bramante's, but it is clarified, giving visual and physical access from every part of the church to the center.

 3. Perhaps most importantly, Michelangelo corrected Bramante's engineering defect by strengthening the corner piers.

B. Michelangelo began construction of his new plan by destroying much of what had gone before.

C. As he had done at the Campidoglio, Michelangelo employed the giant order to unite the various parts of St. Peter's.

 1. Looking at St. Peter's compared to Sangallo's plan, we see that the giant order of pilasters unites several stories of the structure. The vertical thrust of the pilasters is so great that it's only the weight of an entablature and the large attic area that contain the upward surge.

 2. The result is a perfect balancing of horizontal and vertical elements, each very strong but contained and counterbalanced.

D. The outer skin of St. Peter's represents a dynamic architectural geology. Like giant tectonic plates, great slabs of stone appear to rise, sink, slide, and buckle. Some thrust to the surface while others subside, especially in the "corners," where the collision of these masses results in squeezed, crumpling forms. The densely packed pilasters and numerous blind and open niches obliterate any simple wall surfaces.

 1. Although the geometry of the building is evident from the air and from inside, it's not so apparent when one stands close to the exterior.

2. Up close, the architecture is complex, ornamental, and difficult to grasp in its entirety. From a distance, however, the church is a compact sculptural mass.

E. The dome both continues and concentrates the vertical forces. From ground to lantern, the building rises in one continuous, breathtaking sweep. Again, up close, the dome is dense, complex, highly ornamented, yet from a distance, it's simple and majestic.

F. The compact, centralized building that we see so evidently from the air and from the rear was compromised in the later 16th century when the architect Carlo Maderno extended the nave, and the Greek cross plan was lost. Maderno then added a disproportionately large façade, cutting off the dome from view.

G. In the 17th century, Gian Lorenzo Bernini partially corrected some of Maderno's mistakes. As we see, the two bending arms of the *exedra* enclose a huge piazza, which becomes a stage set for the church and dome. The piazza and exedra also help reestablish a sense of proportion among the various elements—the church, dome, façade, and piazza.

IV. The dome of St. Peter's.

A. The solid mass and complex surfaces of the exterior of St. Peter's contrast with the open, spacious, luminous interior. At the center of this immense building is the grave of St. Peter, and over this venerated spot soars the majestic, light-filled dome, supported on four massive piers.

B. The dome is Michelangelo's greatest contribution to St. Peter's, yet it was scarcely begun during his lifetime. The strength of Michelangelo's architectural designs is so great that the building is rightfully considered his even though it was largely built by others following his death.

C. Two drawings show Michelangelo experimenting with different designs for the dome, with both semicircular and stilted profiles. (A stilted profile has a pointed dome with steep sides.) Michelangelo's final idea seems to have been to create a broad, semicircular dome, not unlike the dome on the Pantheon.

D. Before his death, Michelangelo agreed to have a model of

the dome built so that subsequent architects could abide by his design. The model is cut "in section" to allow builders to understand not only the overall design but the technical details, such as how the dome would be built with linked interior and exterior shells.

E. As at the Campidoglio, the model and engravings of St. Peter's helped to ensure that Michelangelo's design would be followed, although later, the decision was made to build a stilted, steep dome, rather than a hemispherical dome. Nonetheless, this change greatly enhances the visibility and beauty of the dome.

Works Discussed:

Maarten van Heemskerck:

Crossing of New Saint Peter's Basilica and Remnants of Old Saint Peter's, 1530s, pen and ink, 5¼×8¼" (13.5×21 cm), Kupferstichkabinett, Staatliche Museen zu Berlin, Berlin, Germany.

Interior View of the Nave of Old St. Peter's, c. 1532–37, pen and ink with wash, 8¾×10¾" (22.2×27.3 cm), Kupferstichkabinett, Staatliche Museen zu Berlin, Berlin, Germany.

Donato Bramante:

Plan for New St. Peter's, 1505, Gabinetto Disegni e Stampe degli Uffizi, Florence, Italy.

Raphael:

Pope Julius II, 1511, oil on panel 42¾×32" (108.7×81 cm), The National Gallery of Art, London, Great Britain.

Antonio da Sangallo the Younger:

Model of the Basilica of St. Peter's, 1539–46, wood, 24' 2"×19' 9"×15' (7.36×6.02×4.56 m), Museo Petriano, Basilica of St. Peter's, Vatican City, Rome.

Michelangelo:

St. Peter's Basilica, Vatican Palace, Vatican City, Rome.

Model of the Dome of St. Peter's Basilica, limewood with tempera, 16' 5"×
13' 2"×6' 6" (5×4×2 m), Vatican Palace, Vatican City, Rome.

Suggested Reading:

J. S. Ackerman, *The Architecture of Michelangelo.*

G. Argan and B. Contardi, *Michelangelo Architect.*

H. Hibbard, *Michelangelo.*

W. E. Wallace, *Michelangelo: The Complete Sculpture, Painting, Architecture.*

Questions to Consider:

1. Why did Michelangelo accept the commission for New St. Peter's when he had repeatedly declared "architecture is not my profession"?

2. Given that it took 150 years to complete the rebuilding of St. Peter's, what exactly did Michelangelo accomplish during his comparatively brief tenure, and why are we justified in considering the new church his?

Lecture Thirty-One—Transcript
The New St. Peter's Basilica

This lecture is entirely devoted to Christendom's greatest monument and one of Michelangelo's greatest architectural achievements—the building of New St. Peter's.

But after more than 30 years of building construction and destruction, St. Peter's was a depressing sight, as we see in this drawing by Marten van Heemskerck, a northern artist who visited Rome in the mid-1530s. There were vaults that linked the four massive piers, but the central crossing was still open to the sky. The high altar and the grave of St. Peter were protected from the elements by a temporary structure. Broken pieces of nave columns and entablature lay where they had been pulled down in rather ruinous haste. The old building was left to deteriorate; the new structure was covered with scaffolding, festooned with ropes and cranes and hoists, and surrounded by a disorderly pile of stone, mud, and the foul stench of animal droppings. Either from near or from far, St. Peter's looked much more like a Roman ruin than it did a new church.

The building was granted a reprieve from further indignity when the building's current architect, Antonio da Sangallo the Younger, died in September 1546. Now, the death of the pope's very prolific architect left many building projects incomplete, most notably, St. Peter's but also the Farnese Palace, and both of these will be inherited by Michelangelo.

There were plenty of other members of what Michelangelo disdainfully called the "*setta Sangallesca*" (the "Sangallo sect"), followers of Antonio da Sangallo, and most were competent builders if not very gifted designers. So why should Michelangelo, who is very busy right now painting the Pauline Chapel, enter the scene at all? After all, Michelangelo declared that "architecture is not my profession," and he was so busy he didn't even have time to write his own family. His niece Francesca claimed that Michelangelo had forgotten her.

Nonetheless, on January 1, 1547, Pope Paul III appointed Michelangelo supreme architect of St. Peter's "to his intense dismay and completely against his will," according to Vasari. Surely this was a dubious honor. Michelangelo was 71 years old. He inherited a recalcitrant workforce and a bevy of thick-headed, obstructionist

overseers who were as passionately loyal to the previous architect, Antonio da Sangallo, as they were skeptical of Michelangelo. So this appointment begins the final chapter—but a very, very long chapter—in Michelangelo's artistic career. He would devote the remaining 17 years of his life to St. Peter's.

Although in subsequent lectures we will consider other architectural projects and other sculptural projects, it's very important to keep in mind that St. Peter's is the perpetual backdrop to all of his other endeavors and a constant concern of Michelangelo for the remainder of his life.

I'm showing you here a plan and a reconstruction of the original church. Let's recognize the importance of the situation we're talking about. This is a venerated basilica, 1,000 years old, built in the 4th century under the emperor Constantine, one of the first of all the early Christian churches. It is a typical early Christian basilica. We see a large forecourt open to the sky, and on the plan, we see that wide forecourt here, and then a broad nave; the nave is that central aisle of the church that leads to the altar. On either side are four side aisles, a transept (the crossing), and that transept has the church of San Petronilla attached, where we saw the *Pietà* was originally located. And then there is a shallow apse that surrounds the altar and the grave of St. Peter.

If we note on this ground plan, this is the old circus of Nero lightly drawn in on the ground, and so St. Peter was buried just outside the circus, in a graveyard that was for exiles and Christians. But for more than 1,000 years, this building has been standing, and by the Renaissance, the walls were seriously out of line—some people estimate leaning as much as 10–15 feet out of line. The roof was constantly leaking, and so it was a truly problematic building, but nonetheless not one that can easily be replaced for its veneration and for its antiquity.

We're seeing here the portrait of our friend Pope Julius II. Alterations to the building of Old St. Peter's began in the mid-15th century, but the real business of building the new basilica was undertaken in 1506 by Pope Julius II. And remember, it's for this reason, the distraction of Julius, that Michelangelo's work was disrupted on the tomb, and he eventually, with the laying of the foundation stone for New St. Peter's, actually left Rome altogether.

So when Michelangelo returned, the building had been begun, and as he painted the Sistine Chapel ceiling, for example, Michelangelo witnessed the insensitive destruction of Constantine's venerable basilica and the sometimes incompetent and mostly inarticulate efforts to replace it with a new church.

Pope Julius's architect, Donato Bramante, was a brilliant designer but a sloppy engineer. But first, let's look at the brilliant design. What I'm showing you is the actual drawing that Donato Bramante made for the new building. It is given the designation Uffizi architectural drawing 1. This is the most significant drawing in the collection of the Uffizi that has more than 30,000 drawings in it, and this is designated drawing 1.

What we're looking at is one-half of a centralized plan. Around a central dome are four minor domes, and then in the corners, four bell towers. It's what we call a *Greek cross plan*. It has equal arms—both the transept and the nave are of equal length. And, therefore, since it's perfectly symmetrical, Donato Bramante has only drawn half a plan because the other half is precisely the same.

This drawn plan corresponds very well with the foundation medal that was made, so-called because a copy of this medal was actually laid into the foundations of St. Peter's when the building was begun in 1506. We see on the medal, for example, that central dome, the minor domes, and the four bell towers at the corners. Quite honestly, looking at the plan and the medal, we get a sense that Bramante's plan was a bit fussy, a little bit too much extra little stuff, but the most important question here is: Could honestly this somewhat spindly plan support the enormous weight of a centralized dome? And I'll come back to this question later in the lecture.

So the very day that the foundation stone was laid for New St. Peter's—April 18, 1506—is the day that Michelangelo left Rome for Florence. Little did he know that 41 years later, he would be called upon to rescue Bramante's original plan.

Meanwhile, Bramante set to work. However, in his haste to erect the new building, Bramante pulled down the ancient marble columns of the Constantinian basilica. In another drawing by Marten van Heemskerck, we see the ancient basilica standing still in part, and these are the columns of the Constantinian basilica that Bramante was so hasty that he pulled them down and virtually destroyed them.

And this loss really seriously upset Michelangelo. We know something of Michelangelo's attraction to columns in his own architecture and also these very venerated, old columns from the ancient basilica. He pointed out that it was one thing to place one brick on another, but it's much more difficult to make such a column.

Moreover, in constructing the four piers to support the central dome, Bramante significantly underestimated the weight and the thrust that they would be asked to sustain. What we're seeing are the arches that he's built to cross these piers, but what these arches are not substantial enough to do is to support an enormous weight and the thrust of a stone dome. So in cutting these corners, Bramante seriously impaired the structural integrity of the new church.

St. Peter's is the largest church in Christendom, the most imposing symbol of papal authority, and a crowning achievement of the Renaissance. But for most of Michelangelo's life, it looked something like this. It was a chaotic mess.

Now, following Bramante's death in 1514, a succession of architects took over the direction of the building of St. Peter's. They generally added or expanded Bramante's design; in this case, [we see] a design by the painter Raphael. All of a sudden, the neat central plan—that Greek cross—has been compromised with the extended nave. Raphael has extended the nave and lost something of the beautiful centrality of Bramante's plan. Also, the clarity of the interior space has become clogged with numerous overarticulated elements. Notice the fussy nave piers and the column screens in the transepts and around the apse. It's almost as if the ideas of the clear space of Bramante have become clotted, or it's a bit like hardening of the arteries inside this building.

Then in the 1540s, Antonio da Sangallo took over the project, and he devoted years to constructing this truly stupendous wood model. It's an object to excite wonder, but it's an utterly horrible design. When Sangallo's supporters praised this architectural extravagance as "a meadow where there would never be any lack of pasture," Michelangelo dryly responded: "That's only too true." It provided "pasture for dumb oxen and silly sheep who knew nothing about art." Now, we might suspect that Vasari cleverly invented this pungent exchange, except for the fact that we have an extant letter in

which Michelangelo offered a lengthy critique of Sangallo's project and a praise for the original project by Bramante, and I'd like to read you a part of this letter.

> It cannot be denied [Michelangelo writes] that Bramante was as skilled in architecture as anyone else, from the time of the ancients until now. [This is large praise from Michelangelo, who didn't really like Bramante personally but recognized the value of his plan.] It was Bramante who drew up the first plan for St. Peter's, not full of confusion, but clear and uncluttered, luminous and free on all sides so that it did not detract at all from the palace. It was regarded as a beautiful achievement, as is still manifest, and thus, anyone who has distanced himself from Bramante's arrangements, as did Sangallo, has distanced himself from the truth. And that this is so, anyone whose sight isn't clouded can see from his model, for with his outside ambulatory, Sangallo immediately took away every light from Bramante's plan. Moreover, it does so when it has no light itself whatsoever. And there are so many hiding places above and below, all dark, that they provide great opportunities for no end of vile misdemeanors, such as the concealment of outlaws, the counterfeiting of money, getting nuns pregnant, and other sordid misbehavior. And so in the evening after the church closes, it would need 25 men to seek out all those who are hidden there.

You might note that in Michelangelo's letter, he says that Sangallo's plan would actually result in the destruction of the nearby Pauline Chapel. It was an enlargement of Bramante's plan. "Nor," he says, "I believe, that even Sistine Chapel might not survive intact." Was this a spiteful move on Sangallo's part, being purposefully perverse? If not for his death as a saving grace, we might have lost both the Sistine and the Pauline chapels, that is, Michelangelo's entire oeuvre in fresco. But now, with Sangallo's death in 1546, Michelangelo was faced with rectifying this mess.

The model that we see here by Sangallo alone cost 4,000 ducats. He spent years and years building this model. It's a design by accretion and accumulation. Recall what we discussed about Michelangelo's invention of the giant order on the Campidoglio. Here these are little

orders, piled one on top of another and on top of another, like a wedding cake of accreted mess.

Thus, when Michelangelo said that Bramante had made a clear plan, it's clear that he, when he was appointed supreme architect of St. Peter's, returned to Bramante's initial conception, while correcting its engineering deficiencies. What we're looking at here is Bramante's plan on the left and Michelangelo's in comparison. Michelangelo stated that Bramante's plan was "not full of confusion, but clear, simple, luminous …a beautiful design." And so Michelangelo returns to the clarity of Bramante's design, with a greater muscularity given to the thin walls. Note how thinly drawn all the various parts of Bramante's plan are. They're given a kind of muscular vigor in Michelangelo.

Most importantly, what's happened with Bramante is everything is shrunk. There is a concentration of efforts here and an eliminating of minor spaces all around the exterior of this plan. So what we look at in Michelangelo, we're really looking at a solid cube, and within that solid cube is a square corridor of spaces around the central dome, and through the whole thing is the Greek cross of equal arms, nave and transept. The basic idea is Bramante's but clarified, giving it visual and physical access from every part of the church to the center. Every part of the church has immediate visual and physical access to the center.

And then very, very importantly, and perhaps most importantly, the engineering defect corrected is the strengthening of these great corner piers, which are rather insubstantial in Bramante's plan and made much more substantial in Michelangelo's plan—piers that could, in fact, sustain the weight and the thrust of a stone dome.

What's most remarkable, however, is that Michelangelo actually began constructing his new plan by destroying much of what had gone before. He had to tear down parts that had been built by Antonio da Sangallo. He had to tear down or redo the piers that had been built by Donato Bramante. This is an amazing thing, that after all this time, almost nothing has been accomplished on St. Peter's, and Michelangelo begins by destroying stuff that had been built. Of course, there was a tremendous outcry and objection on the part of the Sangallo sect, but it's a testament, I think, to Michelangelo and to

Pope Paul III that he completely trusted that Michelangelo knew what he was doing, and it's fortunate that he did.

So as at the Campidoglio, Michelangelo has employed the giant order to unite the various parts of St. Peter's. We're comparing now a piece of St. Peter's to Sangallo's plan. Notice how the giant order of pilasters unites what seems to be three stories, but in fact, it's more than six stories high, this building.

The vertical thrust of these great pilasters is so great that it's only the weight of this entablature and this very large attic area here that helps to contain this upward surge. It's a perfect balancing of horizontal and vertical elements, each very strong but contained and counterbalanced, very much what he had invented and accomplished at the Campidoglio, as well. The result is a compact sculptural mass versus the kind of higgledy-piggledy accretion of Sangallo's design.

The outer skin of St. Peter's is a sort of dynamic architectural geology. Like giant tectonic plates, great slabs of stone appear to rise, sink, slide, and buckle, some thrusting to the surface while others subside, especially in the so-called "corners," where the collision of glacial-like masses results in squeezed, crumpling forms. Wall surfaces are layered. They overlap and ripple with movement. The densely packed pilasters and numerous blind and open niches obliterate any simple wall surfaces.

Although the geometry of the building is clearly evident from the air and from inside, it's not so apparent when one stands close to the dynamic exterior. Up close, the architecture is complex, ornamental, and difficult to grasp in its entirety. However, from a distance, the church is a compact sculptural mass.

The dome both continues and concentrates all these vertical forces. From ground to lantern, the building rises in one continuous, breathtaking sweep. And just as with the rest of Michelangelo's architecture, up close, the dome is dense, complex, highly ornamented, and yet from a distance, it's simple, majestic, all of the contending forces resolved in that upward sweep, all detail subsumed by the majestic grandeur of the dome. A dome is a traditional metaphor for heaven.

Now the compact, centralized building that we see so evidently from the air and from the rear was compromised in the later 16th century when the architect Carlo Maderno extended the nave, then added a

disproportionately large façade. The dome actually gets cut off. The closer you come to St. Peter's façade, the dome disappears from one's view, which is clearly not the intention that Michelangelo originally had. The closer one got, the greater the sense of that vertical sweep of the dome, [which] was intended to be the most important part of the building.

Now the architect subsequent to Carlo Maderno was Gian Lorenzo Bernini in the 17th century. He partially corrected some of Maderno's mistakes. The two great bending arms of the so-called *exedra* enclose a huge piazza, which becomes, in a sense, a stage set for the church and the dome. As soon as we enter the piazza, it slows us down and it keeps us at a distance, because the piazza itself is so grand and there are so many places to walk in it, and there, in the piazza, the dome still dominates. The other thing it helps do, this entire piazza and the *exedra*, helps reestablish a sense of proportion between the various elements—between the church, the dome, the façade, and the piazza.

Now, as in a Gothic cathedral, the solid mass and extremely complex surfaces of the exterior of St. Peter's contrast with the open, spacious, luminous interior. We are dwarfed by the vast space. Everything is in proportion but on a greatly exaggerated scale. At the center of this immense building is the grave of St. Peter, and over this venerated spot soars the majestic, light-filled dome, supported on those four massive piers. The dome is an expansive, light-filled, and uplifting spatial experience. It is Michelangelo's greatest contribution to St. Peter's, yet it was scarcely begun during his lifetime. This is another case which demonstrates the strength of Michelangelo's architectural ideas and his designs. They were so powerful that the building constructed is rightfully considered his, even though it was largely carried out by others following his death.

We actually have two beautiful drawings that show Michelangelo is experimenting with different designs for the dome, both semicircular and stilted profiles. A stilted profile is one that's a pointed dome with steep sides. And we see both of those on this drawing here—the semicircular dome and then the more stilted, steep-sided dome here. Ultimately, it seems, as we see in the other drawing over here, Michelangelo's ultimate idea seems to have been to create a broad, semicircular dome. This is not unlike the dome on the Pantheon and on something of the same scale—raised very high on a ring of paired

columns and a thick cornice. Thus, the greatest surviving building of ancient Rome serves Michelangelo as the model for a new Christian church.

Now before his death, Michelangelo agreed to have a model of the dome built so that subsequent architects would abide by Michelangelo's design. We see the model here. It's cut "in section"—like an orange, in half—and thereby it permits the builders to understand not only the overall design but the technical details, such as how the dome would be built with linked interior and exterior shells. Unlike Sangallo's show-off model, this one actually served the practical function of guiding construction.

As at the Campidoglio, the model and the engravings of St. Peter's helped to ensure that Michelangelo's design would be followed. And, in fact, it was subsequently decided, after Michelangelo's death, to build a stilted, steep dome, rather than a hemispherical dome. It's a significant change of Michelangelo's presumed intentions, but I actually think that this is a change that greatly enhances the visibility and beauty of the dome. I'm all in favor of this particular change. It literally has now a higher, upstanding, more visible profile and, I think, [is] ultimately more beautiful in the skyline of Rome and is the model practically for every other church dome built in Rome afterwards. Moreover, Michelangelo had entertained both possibilities; therefore, it's still correct to give him ultimate credit for the beauty of the majestic dome.

So despite changes inflicted on the building during its approximately 150-year construction history, we rightly think of St. Peter's as Michelangelo's masterpiece. He worked on the building for less than 20 years, but in that time, he corrected what had gone before and he largely shaped what followed.

St. Peter's is the largest church in Christendom, a prominent symbol of papal authority, and a crowning achievement of Michelangelo's art. But it was also a continuous series of headaches, from construction debacles to management intrigue. He remained devoted to the project despite setbacks and the determined efforts of Duke Cosimo de' Medici to lure Michelangelo back to Florence. Cosimo went so far as to address a letter to Michelangelo directly, as "*Magnifico nostro carissimo*"—"Our Dearest Magnificent One," a remarkable way to address an artist. And I'd like to read you a portion of this letter:

Since the nature of the times and the reports of your friends give us some hope that you are not altogether disinclined to visit Florence to see your native land and your kin once again after so many years, we have thought it fitting hereby to exhort and entreat you to do so with all our heart, assuring you that it would be most gratifying to see you. Come freely in the expectation of being able to pass such time as suits you, living here entirely as you choose and to your own satisfaction, because to us it will suffice to see you here. Nor shall we ever do anything except to your honor and advantage. May the Lord God preserve you.

I don't think since Alexander the Great has such favor been bestowed on an artist—as Alexander the Great did for Apelles—by such a powerful ruler. The attention lavished on Michelangelo was really quite unusual, a reversal, really, of the normal patron/client relationship, with the prince offering every conceivable inducement to Michelangelo. Michelangelo admitted to being flattered and gratified, but he was also deeply conflicted. Michelangelo's lengthy reply reveals the 82-year-old artist anxious to please the duke but beset with worry, full of desire, weighed down by age and obligation. And I'd like to quote a part of this letter. This is Michelangelo replying to Cosimo:

Lord Duke: About three months ago, or a little less, I informed your lordship that I could not yet leave the construction of St. Peter's without great hurt to it and my own great shame, and that if I wanted to leave it at the desirable point, where it wouldn't lack what it must have, I would need a year, and felt that your lordship was agreeable to giving me that time. Now I have another letter, again from your lordship, which urges me to return more strongly than I had expected, so that I feel no little pain, because I am in more trouble and labor over the affairs of the construction than ever before. I believe the work will be finished by the end of this summer; nothing else is left for me to do after that but to leave the model of the whole thing here, as everyone begs of me, and then to return to Florence with a mind to rest there in the company of death, with whom I try to make friends day and night, so that he won't treat me worse than any other old men.

Michelangelo writes that he desires to rest with death—"*riposarmi con la morte*"—but not before St. Peter's can be left in competent hands. From this point forward, St. Peter's remained Michelangelo's foremost concern and his greatest hope for remission from his sins. As the Julius tomb was for the first half of his career, St. Peter's is the constant background against which the remainder of the artist's life is narrated.

So, as we take up, in our next lectures, a discussion of Michelangelo's various other architectural and urban projects around Rome, please keep in mind that St. Peter's is still far from complete. Indeed, every day that he could, Michelangelo tried to visit the building site and fell into despair when mistakes were made, always attributing these to the fact that he, with all these other multiple obligations, could not personally supervise every single detail of the giant undertaking.

St. Peter's was Michelangelo's greatest headache but, ultimately, his greatest triumph.

Lecture Thirty-Two
Michelangelo's Roman Architecture

Scope:

This lecture is the first of two that consider Michelangelo's rich architectural and urban interventions in the city of Rome. First, we will look at Michelangelo's additions and "corrections" to the Farnese Palace, begun by Antonio da Sangallo and left incomplete at his death in 1546. Next, we will consider Michelangelo's innovative designs for the new church of the Florentine nation in Rome, San Giovanni dei Fiorentini. Although the church was never built, Michelangelo's dynamic drawings for it vividly demonstrate his creative thinking and inventive, "sculptural" conception of architectural space.

Outline

I. The Farnese Palace.
 A. Although he is best known as a sculptor and a painter, Michelangelo was also an accomplished architect. Indeed, his architecture probably had more impact on subsequent centuries than did his more famous works of painting and sculpture. We'll begin this lecture with one of the exemplars of his architectural creativity—the Farnese Palace.

 B. The palace is located in the heart of the most densely settled part of Rome, the Campus Martius, in the bend of the Tiber River. Almost all of the Renaissance city was concentrated in this area, which of course, presented serious space limitations to the structure.

 C. We see a view of the front façade of the Farnese Palace, set in a gigantic urban square. The Farnese family literally destroyed a part of the city to create this huge palace.

 D. When Michelangelo took over the project, the scale, the overall design, and much of the façade were already complete, at least to the third-story level. Michelangelo recommended that the third story of the palace be enlarged and raised to a much greater height than the other two.

1. He was immediately accused of contravening the rules of Classical architecture and proportion, especially as they were codified by the 1st-century Roman architect Vitruvius.
2. The "rules" would suggest that all three stories of the building would be of equal height, and the uppermost cornice would be in proportion to the uppermost floor, that is, to a single story. We see something of these rules exemplified in the Colosseum.
3. Michelangelo's upper cornice for the Farnese Palace is massive, but it is correct to the eye because it was designed to be in proportion not to one story but to all three.
4. The three stories of the Farnese Palace *look* to be equal even if the third story is much higher. The cornice *looks* in proportion to the large building. Anything smaller would be entirely inadequate—almost like a building with shaved eyebrows.
5. In coming to this solution for the Farnese Palace, Michelangelo was influenced less by reading the rules as written by Vitruvius than by actually looking at ancient buildings, such as the Pantheon. The interior cornice in the Pantheon is also massive, but it appears in perfect proportion to the rest of the building and the tremendous volume of space enclosed by the building.
6. Michelangelo made a wood model of this part of the cornice that was itself more than 15 feet tall. The model seemed to be out of scale until it was hoisted up, when it fell into perfect proportion with the rest of the building.

E. Aside from the main façade and cornice, Michelangelo's principal contribution to the Farnese Palace was the third story of the courtyard façade.

1. The courtyard windows, in particular, reveal Michelangelo's innovative vocabulary, although at first glance, the third story seems little different from the two designed by Sangallo. With a closer look, we can see that Michelangelo has achieved a sensitive, almost seamless blending of two rather different designs.
2. Michelangelo's design is dense and more complex than Sangallo's. Note the layered pediments supported by

triglyph-like corbels, which in turn, rest on lion heads and scroll-like brackets. The box-like window frames slip downward, as if the whole ensemble were giving way under the enormous weight of the top-heavy pediments.

3. We have a surviving drawing for the Farnese windows, which seems enormously complicated. However, the multiple lines and dense overlays are probably not evidence of Michelangelo changing his mind as much as the artist finding a graphic equivalent to his highly original sculpted ideas.

II. San Giovanni dei Fiorentini.

A. The Florentine community of Rome resided in the bend of the Tiber River on a trio of three short streets that branched from one of two bridges.

B. The new Florentine church was to be located at the intersection of two of these streets on an irregular plot of land subject to the seasonal flooding of the Tiber. The site was well suited for a compact, centrally planned building.

C. Discussion regarding the church of San Giovanni dei Fiorentini had begun as early as 1518 during the pontificate of the first Florentine pope, Leo X. Virtually every Florentine architect, and some foreign ones, showed interest in this project, with the somewhat predictable result that nothing much was accomplished. Michelangelo was approached in mid-1559 by members of the Florentine community to make a design for the church.

D. Renaissance architects, including Leonardo da Vinci, dreamed of building a centralized church, but few were ever realized. A rare example that actually was built in the early 16th century was Santa Maria della Consolazione in Todi.

E. Michelangelo's initial ideas may have been partly influenced by such precedents as Leonardo's design and the church at Todi, but even more important were the early Christian churches of Rome, such as the round centralized church of Santo Stefano Rotondo. The plan shows ring upon ring of columns and walls growing from the center.

F. Three of Michelangelo's drawings amply attest to his

imaginative ideas for such a church. The first of these appears most indebted to early Christian precedents, such as Santo Stefano. The fundamental character of both plans is the expansive, open space under a central dome, mounted on a ring of columns.

1. Michelangelo then worked outward with a series of radial additions, but he appears somewhat uncertain about when to stop adding rings. It's doubtful whether the thin external shell and an interior ring of 16 columns would be enough to support the enormous weight of a dome.

2. We see, even in this failed design, a fundamental principle of Michelangelo's architectural thinking: He approaches architecture as dynamic space rather than as enclosing box. He starts with the central dome, not with the enclosing walls.

3. In the course of drawing three different designs for San Giovanni, Michelangelo goes through a similar process of condensation and consolidation as we saw at St. Peter's, always thinking from the inside out, from the core of the building to the external shell.

G. Early Christian and Byzantine centralized churches, such as that at San Vitale in Ravenna, partly inform Michelangelo's second drawing for San Giovanni.

1. In this case, his plan was mainly generated by corridors of space emanating from the four corners of a central square.

2. The design once again reveals Michelangelo's tendency to think, architecturally, from the inside out and according to internal space rather than the enclosing shell.

3. The plan is a distinct advance in clarity and spaciousness over the more linear and cluttered radial design of the first drawing, but it is still doubtful whether the thin, spindly plan could support a dome.

4. Note, however, that the supports for a dome have begun to cluster; instead of single columns, they've become compound piers. The eight of them create an interesting octagonal interior space.

H. The experiments of the first two drawings bore fruit in the

most finished of the series, surely one of the most impressive architectural drawings by any Renaissance draftsman. We can easily trace the lineage of the final design here through the previous two, but now Michelangelo is thinking of the plan as a spatial mass defined by massive piers and enclosed within a solid block of material.

1. The eight thick piers that support the dome have now become part of the external wall. Thus, an engineering problem becomes part of the aesthetic solution and the appearance of the church.

2. In contrast to his earlier designs, where space was barely contained within a thin shell, the interior space of this design seems to have been excavated from a solid block of material. The building appears massive and sculpted.

3. As at St. Peter's, the subsidiary spaces are themselves dynamic and interesting while spatially and organically connected to the center.

III. The end of the project.

 A. Michelangelo's standard procedure in his final years was to make drawings, which were then copied by assistants, including a man named Tiberio Calcagni, about whom we will hear more. Calcagni carried the designs to Florence, where Cosimo de' Medici inspected them and chose the one we last saw. Unfortunately, this design was never built.

 B. The building that rises today on the Tiber embankment is a rather banal pile by the architect Giacomo della Porta. Nonetheless, we need only look at the plan of a church by the 17th-century architect Bernini to realize how it relates to the dynamic oval forms of Michelangelo's San Giovanni drawing.

IV. Michelangelo's architectural legacy.

 A. In completing the Farnese Palace, Michelangelo showed the way beyond the textbook and the drafting board. In this project and San Giovanni, he employed drawings in a new and dynamic fashion, discovering a means of suggesting three-dimensional spatial qualities in the flat and comparatively small medium of two-dimensional drawings.

 B. More importantly, Michelangelo liberated architects from

the rules of Vitruvius, which had been enormously influential in the Renaissance. Even Vasari feared Michelangelo's "license" in architecture, but the artist served as an inspirational model for the best of creative designers. In this way, Michelangelo's approach to architecture was one of his most enduring legacies.

Works Discussed:

Artist Unknown:

Plan of Santo Stefano, Rome, Italy.

Plan of San Vitale, Ravenna, Italy.

Antonio da Sangallo the Younger:

Palazzo Farnese, façade, Rome, Italy.

Michelangelo:

Palazzo Farnese, façade, Rome, Italy.

San Giovanni dei Fiorentini, Rome, Italy.

Design for a Window, chalk and wash on paper, 16½ × 11" (41.9 × 27.7 cm), The Ashmolean Museum of Art and Archaeology, Oxford, Great Britain.

Plan for San Giovanni dei Fiorentini, 121A, c. 1559, pencil, pen and ink, and watercolor, 16⅞ × 15¼" (42.8 × 38.6 cm), Casa Buonarroti, Florence, Italy.

Plan for San Giovanni dei Fiorentini, 120, Casa Buonarroti, Florence, Italy.

Plan for San Giovanni dei Fiorentini, 124, Casa Buonarroti, Florence, Italy.

Leonardo da Vinci:

Plan for a Church, 1485–88, chalk and ink, 9⅛ × 6½" (23.2 × 16.5 cm), Bibliotheque de l'Institut de France, Institut de France, Paris, France.

Gian Lorenzo Bernini:

Plan of Sant'Andrea al Quirinale, Rome, Italy.

Suggested Reading:

J. S. Ackerman, *The Architecture of Michelangelo*.

G. Argan and B. Contardi, *Michelangelo Architect*.

H. Hibbard, *Michelangelo*.

W. E. Wallace, *Michelangelo: The Complete Sculpture, Painting, Architecture*.

Questions to Consider:

1. What did Michelangelo mean when he stated that an artist must have "compasses in the eyes"?

2. Pretend you are the patron. Which of the three designs for San Giovanni dei Fiorentini would you have selected and why?

Lecture Thirty-Two—Transcript
Michelangelo's Roman Architecture

This lecture is the first of two that will consider Michelangelo's rich architectural and urban interventions in the city of Rome. First, we'll consider Michelangelo's additions and "corrections" to the Farnese Palace, begun by Antonio da Sangallo but left incomplete when that architect died in 1546. Secondly, we'll consider Michelangelo's very innovative designs for the new church of the Florentine nation in Rome, so-called San Giovanni dei Fiorentini—St. John of the Florentines. Although this church was never built, Michelangelo's dynamic drawings vividly demonstrate his creative thinking and his very inventive "sculptural" conception of architectural space.

So although he's best known as a sculptor and a painter, Michelangelo was also a great and accomplished architect. Indeed, his architecture probably had more impact on subsequent centuries than did his more famous works of painting and sculpture. No one could imitate the *Pietà* or the *David* or the Sistine Chapel, but many persons learned from his architectural innovations. Once declaring that you "must have compasses in your eyes," Michelangelo developed an architectural aesthetic based not on the rules of Classical antiquity and their codification in any number of architectural treatises, but on his own judgment, informed by a profound understanding of the past exemplars, combined with his individual creativity.

The first of these projects is the Farnese Palace. It was the principal seat of the powerful Roman family the Farnese. The palace is located in the very heart of the most densely settled part of Rome, right in here, in the Campus Martius, in the bend of the Tiber River. And this is where almost all of the Renaissance city was concentrated, but of course, this was also a serious limitation of space. So architecture here is subject to serious urban limitations. This is a project for Michelangelo's patron Pope Paul III, who has been responsible—as we have already seen—for the *Last Judgment*, the Pauline Chapel, the Capitoline Hill, and assigning Michelangelo as architect of St. Peter's.

So it's yet another project undertaken for the great patron Pope Paul III after Antonio da Sangallo's death in 1546. We're looking at a view of the front façade of the Farnese Palace. It's a gigantic urban

square around this palace that emphasizes the façade, and it was absolutely cut out of the heart of the densely settled urban fabric. On your right-hand side is a view of the streets around the Farnese Palace, giving a sense of the kind of density of urban settlement from which the Farnese literally destroyed a part of the city in order to create this gigantic palace that only emphasizes how powerful this family is—currently, [one member is] a pope.

When Michelangelo took over the project, the scale, the overall design, and much of the façade were already complete, at least to the third-story level. Michelangelo recommended, then, that the third story of the Farnese Palace be enlarged and a much greater height than the other two. He recommended raising the height of the third story and greatly increasing the scale of the crowning cornice, this part, of the overall building.

He was then immediately accused of contravening the rules of Classical architecture and proportion, especially as they were codified by the 1st-century Roman architect Vitruvius. The "rules" would suggest that all three stories of the building would be of equal height, and the uppermost cornice would be in proportion to the uppermost floor, to a single story. We see something of these rules exemplified by the Roman Colosseum, for example, where every one of the three stories is exactly the same height and the uppermost cornice is in proportion to that third story.

So Michelangelo is accused of contravening the rules. Precisely. The upper cornice of the Farnese Palace is massive, as it was designed to be in proportion not to one story but to all three stories. Thus, it is correct according to the eye, which is precisely what Michelangelo meant by "having compasses in one's eyes," rather than correct by a book or any prescribed set of rules. For Michelangelo, the Classical past was not a fixed set of rules to be slavishly imitated but, instead, offered a rich inheritance that was merely the starting point for his own fecund imagination.

In order to make sound judgments, the artist must be able to judge if it will *look* correct.

The three stories of the Farnese Palace *look* to be equal even if the third story is much higher. The cornice *looks* in proportion to the large building. Anything smaller would be entirely inadequate— almost like a building with shaved eyebrows.

Now, in coming to this solution for the Farnese Palace, Michelangelo was influenced less from reading the rules as written by Vitruvius than by actually looking at ancient buildings, such as the Pantheon, the best preserved of ancient buildings. The interior cornice in the Pantheon is also massive, but it appears in perfect proportion to the rest of the building, of the tremendous volume of space enclosed by this building. The sequence of moldings and the overall profile of the Pantheon cornice are actually very similar to that used by Michelangelo on the Farnese Palace.

Now we know that Michelangelo made a full-scale wood model of this part of the cornice. The model was more than 15 feet high as it sat on the ground. It towered over anyone and it seemed way out of scale when it was sitting down on the ground. In fact, Michelangelo's nasty and very competitive rival, Nanni di Baccio Bigio, complained that Michelangelo had made a model so enormous that although it was only of wood, they would still have to shore up the walls of the Farnese Palace.

But then, of course, the model was hoisted into position, and from far below seemed to be in perfect proportion to the scale of the building. Scale here, then, is dependent on context and judgment of the eye, not according to any kind of set rules. The incident is a small example of how Michelangelo thought flexibly and creatively about architecture and how he could adjust, really, his work to the lesser work of previous architects.

Now, aside from the main façade and cornice, Michelangelo's main contribution to the Farnese Palace was the third story of the courtyard façade, which we're seeing in this view. The courtyard windows, in particular, reveal Michelangelo's innovative vocabulary although, at first glance, the third story seems little different from those designed by his predecessor, Antonio da Sangallo. Can you really see very much of a difference between the third and second stories? This is one of the many examples, I would say, of Michelangelo's abilities to integrate his work with that of his predecessors. Here, a very sensitive, almost seamless blending of two really rather different designs, especially if we take a closer look at them—Michelangelo on the left; Antonio da Sangallo on the right.

Now we begin to note Michelangelo's originality and his many strange and original features. Michelangelo's design is dense and more complex than Antonio da Sangallo's. Note the layered

pediments supported by triglyph-like corbels, which in turn, rest on lion heads and scroll-like brackets, and the box-like window frames that slip downward, as if the whole ensemble were giving way under the enormous weight of the top-heavy pediments. This weight also helps "lock" the windows into the wall, as opposed to Antonio da Sangallo's windows that seem to float in brick expanses.

Now, don't worry about all this architectural vocabulary, for the truth is, probably none of its exactly right. The reason is that Michelangelo is inventing architectural parts and decorative combinations for which we really have no adequate vocabulary. I'd say that it's stonework that looks like loosely nailed carpentry—it's full of invention and inventive combinations.

One must imagine the stonemasons attempting to carve these very innovative designs according to Michelangelo's verbal and drawn instructions. How do you do it, since it's so contravening of all previous rules? In fact, we do have this surviving drawing for the Farnese windows. At first sight, the drawing appears enormously complicated, perhaps even unreadable, as if Michelangelo were drawing one idea on top of another, which is, in fact, the case. But the multiple ruled lines and the dense overlays are probably not evidence of Michelangelo changing his mind as much as the artist finding a graphic equivalent to his highly original sculpted ideas.

The drawing, in fact, actually suggests the layered effects seen in the final windows. Probably the craftsmen who actually carved these windows used such drawings to build a wooden prototype, which they could then use as a model to guide their work.

Michelangelo, therefore, was able to complete the Farnese Palace and create a satisfying building from a rather unpromising beginning. Let us now turn our attention to a different set of circumstances, in which Michelangelo is free to design a building from scratch, and this is the church of San Giovanni dei Fiorentini, the Florentine church in Rome.

The Florentine community of Rome resided in the bend of the Tiber River in a trio of three short streets that branched from Ponte Sant'Angelo, which is only one of two bridges across the Tiber River. And these three branched streets are the most important. The Via Banco Santo Spirito [is] in the center, so named because of the Zecca, or the mint, that was prominently situated at the head of the

street. A newer street, named after Pope Paul III, was the Via Paolina that connected Ponte Sant'Angelo to a very long, straight street called the Via Giulia since it was laid out under Pope Julius II. The Via Giulia parallels the Tiber River and ran to one of the few other crossovers at Ponte Sisto, named after Julius's uncle, Sixtus IV.

The new Florentine church would be located at the intersection of these two very important straight streets. Here, there was an irregular plot of land directly on the Tiber River, which before the 19th-century embankments were built, was flooded with seasonal regularity. There was limited space here to build a church; however, the site was perfectly suited for a compact, centrally planned building. Here, we're looking down the long, straight Via Giulia, from the plot of land where the new church of the Florentine nation was to be built. Urbanistically sited to command views down two of the very few straight streets in all of Renaissance Rome, this was a very premier siting for a new building.

Now, discussion regarding the new church of San Giovanni dei Fiorentini had begun as early as 1518 during the pontificate of the first Florentine pope, Leo X. Virtually every Florentine architect, and some foreign ones as well, showed interest in this project, with the somewhat predictable result that nothing much was accomplished. Antonio da Sangallo was the most prolific in providing plans for a new church—there are some 10 designs of his that are preserved in the Uffizi. But with Sangallo's death in 1546, this was yet another project inherited by Michelangelo.

Michelangelo was approached, after some delay, in mid-1559 by members of the Florentine community to make a design for the church, but he was unwilling to consider the proposal unless the current duke of Florence, Cosimo de' Medici, approved it. The reason is obvious. Michelangelo's hesitation is that he has numerous architectural projects already underway, most notably St. Peter's. But Duke Cosimo, certain that Michelangelo was the best person for the job, immediately obliged the artist by writing a gracious letter in which he requested that Michelangelo furnish a design for a new church. Cosimo, who had been trying for some years to lure Michelangelo back to Florence, would at least be able to employ the artist here on a Florentine project in Rome.

Now the Renaissance had, for its entire length, dreamed of building a centralized church. Few were ever realized. Even St. Peter's was

originally designed as a centralized Greek cross church. Leonardo da Vinci, we see in a drawing here, designed many plans for centralized churches, few of which were actually built. A rare example that actually was built in the early 16th century is in Todi—Santa Maria della Consolazione—but this is one of the rare instances of a centralized church actually getting built, even though every architect in the Renaissance seemed to dream of it as an ideal solution, including Michelangelo for San Giovanni.

Michelangelo's initial ideas may have been partly influenced by such precedents as Leonardo and the church at Todi but even more important were the centralized churches, the early Christian churches, of Rome, such as this example, the round centralized church of Santo Stefano Rotondo, the plan of which we see on the right here. It is ring upon ring of columns and walls growing from the center, somewhat like a set of tree rings.

Now, we have a number of drawings that permit us to follow Michelangelo's process of design. We have three plans, in particular, amply attesting to Michelangelo's very imaginative ideas. This drawing is probably the first. It appears most indebted to the early Christian precedents, such as Santo Stefano. The fundamental character of both plans is the expansive, open space under a central dome, mounted on a ring of columns. The central space under the dome, then, is the heart of the design and the building

Then Michelangelo worked outward with a series of radial additions. However, he appears somewhat uncertain about when to stop growing his tree rings. Think of the exterior wall as the tree's bark. Michelangelo's exterior skin is a bit ragged and uncertain. The exterior wall is characterized by an accumulation of unarticulated piers and wall segments. It causes us to have a pleasing symmetrical design, but the real question is structural: Could this design actually support a dome? It's doubtful whether the extremely thin external shell and an interior ring of 16 columns would be enough to support the enormous weight of a dome.

Thus, the plan is clear at the center, from where it began, from where it was generated, but not towards the edges, where there are many awkward and unresolved elements. It's a beautiful drawing but probably would not result in a successful building. This is a

wonderful example, I think, of Michelangelo first learning from a precedent before developing his own original solution.

However, we see, even in this failed design, a fundamental principle of Michelangelo's architectural thinking: He approaches architecture as dynamic space rather than as enclosing box. He starts with the central dome, not with the enclosing walls. This drawing and the other two that we will examine offer very good evidence of his manner of proceeding from the core of a building to its outward skin. In the course of drawing three different designs for San Giovanni, Michelangelo goes through a similar process of condensation and consolidation as we saw at St. Peter's, always thinking from the inside out, at the core of the building to the external shell.

Once again, in our second drawing, early Christian and Byzantine centralized churches, such as that at San Vitale in Ravenna, partly inform Michelangelo's second drawing for San Giovanni, also in the Casa Buonarroti. In this case, his plan was mainly generated by corridors of space emanating from the four corners of a central square. We see him actually dotting the square here, and then around each of those dots, he draws parallel lines that represent corridors of space that help generate the internal structure or the internal space of the building.

The design once again reveals Michelangelo's tendency to think, architecturally, from the inside out and according to internal space rather than the enclosing shell. The plan is a distinct advance in clarity and spaciousness over the more linear and cluttered radial design of the first drawing, but it is still doubtful if the thin, spindly plan could support a dome. Note, however, that the supports for a dome have begun to cluster, coalesce; instead of single columns, they've become compound piers. The eight of them create a very interesting octagonal interior space, and they are more robust but not necessarily enough to sustain a dome. What we're witnessing, though, is Michelangelo beginning to translate from design into structure and actually think of the physical realities of building a building.

The result here is internally spacious, more spacious than the first design, but externally not quite coherent and compact. Once again, note how the exterior wall is a bunch of sort of fragmented elements. It's an interesting design on paper but would be somewhat incoherent as a building if we were looking at it from the street.

Well these two experiments of these first two drawings bore fruit in the most finished of the series. It's surely one of the most impressive and dynamic architectural drawings by Michelangelo or any Renaissance draftsman. We can easily trace its lineage of the final design here through the previous two, but now Michelangelo is thinking of the plan as a spatial mass defined by massive piers and enclosed within a solid block of material.

He's especially thinking about the requirements of supporting the weighty dome. Those thick eight piers that support the dome have now become part of the external wall. Thus, an engineering problem becomes part of the aesthetic solution and the aesthetic appearance of the church. These are dynamic, sculptural piers, and as in the previous drawing, pairs of swiftly drawn parallel lines help to define corridors of space that radiate from the central dome.

However, in contrast to his earlier designs, where space was barely contained within a thin shell, the interior space of this design seems to have been excavated from a solid block of material. Thus, the building appears massive and sculpted. The internal space is dynamic and symmetrical, well contained within the structure's thick epidermis. Instead of constructing space, Michelangelo has excavated it. One can almost imagine San Giovanni dei Fiorentini as a block of ice that has been melted from the inside by hot water.

For all of its familiarity and frequent reproduction, this sheet is visually stunning and still a surprise when it's seen "in the flesh." First of all, it's very big. It's a full *braccia* wide—that is, an arm length, or nearly two feet—so two feet square, very large for an architectural drawing in the Renaissance.

And as at St. Peter's, the subsidiary spaces are themselves dynamic and interesting while, at the same time, spatially and organically connected to the center. These chapels have a kind of dynamism and an immediate connection to the centralized space. Note the sort of sculptural qualities of the wall of the four chapels and the dynamic articulation of the wall surfaces. And Michelangelo is still in the process of exploring these particular details. It's a fascinating drawing, showing Michelangelo actually still in the stages of experimenting, even though creating what is ostensibly a "finished" design.

Now, Michelangelo's standard procedure in his final years was to make drawings, which were copied neatly then by assistants. For this and several other architectural projects, Michelangelo had the help of a faithful and capable assistant, Tiberio Calcagni. Calcagni came from a respectable Florentine family, despite his infelicitous last name, which means "heels." We'll hear more about Calcagni in our next lecture.

Calcagni supervised the construction of a wood model based on this latter drawing, and he carried the various designs to Florence for Duke Cosimo de' Medici to inspect. Cosimo selected this design as the most beautiful of the three. Unfortunately, delays, money problems, and Michelangelo's death just four years later meant that his design was never built.

In contrast to Michelangelo's powerfully articulated, centralized church, the building that rises today on the Tiber embankment is a rather banal pile by the architect Giacomo della Porta. It is yet another unfinished project but also another instance in which the ideas had an important influence on subsequent architectural design.

One need only look at the plan of the church of the great 17th-century architect, Gian Lorenzo Bernini, to realize how it relates to the dynamic oval forms of Michelangelo's San Giovanni drawing. Note especially the ring of chapels in Bernini's Sant'Andrea in comparison to those of Michelangelo. Again, the chapel is excavated from the solid materials of an exterior oval wall, the oval church itself a kind of dynamic legacy from Michelangelo.

I'd like to say something, a further word, on Michelangelo's architectural legacy. It may seem peculiar to have devoted a lecture here to a building that was never built and to another that was mostly carried out by a previous architect. But the Farnese Palace, at least, is a major landmark in Rome, and thanks to Michelangelo's intervention, it's far more interesting and satisfying than it might have been.

Not only did Michelangelo successfully complete a rather banal building, but he showed the way beyond the textbook and the drafting board, and he employed drawings in a new and dynamic fashion, discovering a means of suggesting three-dimensional spatial qualities even in the flat and comparatively small medium of two-dimensional drawings. Thus, three-dimensional wood models were

now richly supplemented by the much more flexible and inventive medium of drawings. This is an initiation of a revolution in architectural draftsmanship that has persisted to our own time.

However, for all their interest and flexibility, drawings on paper do not always translate well into actual buildings. There are the mitigating factors of light, scale, and the movement of people through a city. Little do we realize how important these factors are in our perception of architecture. For the same reason, you will need to go to Rome to experience Michelangelo's architecture in person. In which case, the Farnese Palace will seem much more interesting in person than ever it will be in photographs.

Even more importantly, Michelangelo liberated architects from the rules, and this is no small matter because the period we're talking about is the Renaissance. Perhaps one of the most exciting moments in the entire Renaissance was the rediscovery of the ancient treatise on architecture by the Roman architect Vitruvius found in St. Gall in the 15th century. From that moment on, all of a sudden, the Renaissance had a glimpse of precisely how Rome had gone about building itself an empire. They had concrete evidence of precisely what it took to build a Classical building. Vitruvius had an enormous impact on architecture in the 15th and the 16th [centuries] and on. It was reprinted over and over again, translated from the Latin into Italian, illustrated, and constantly mined and constantly referred to by every single architect of the Renaissance.

So when Michelangelo liberates you from the rules, he's radically moving away from a fairly embedded tradition. Any hack can learn the rules, but a creative designer is a different order of being. Without rules, many architects will lose courage, and some pretty dreadful buildings can result. In fact, you might actually say that much of architecture is nothing but the rules. One has to learn those rules in order to build a building that is stable and sound and functional.

So this is precisely what Vasari meant when he wrote about Michelangelo's architecture. He feared Michelangelo's license in architecture. Now remember, Vasari used this when he was describing the Laurentian Library vestibule, one of Michelangelo's much earlier architectural projects. Already from the very beginning of Michelangelo's architectural career, he was departing from the

rules, and Vasari immediately recognized that while in some ways it was liberating and Michelangelo was brilliant in the liberation, that many others were going to be much less successful in deviating from those rules.

And now that we've come to Rome, it's even more impressive. It was one thing to have architectural license in Florence, without that huge weight of tradition sitting on top of Florence, but in Rome, you're surrounded by any number of examples of Classical architecture, which could immediately be referred to as exemplars of the rules. And now Michelangelo's license is even more radical as he undertakes these various buildings in Rome.

And so it's extraordinarily impressive what Michelangelo has done, and for the best of creative designers, Michelangelo served as an inspirational model. And, of course, he's going to do something of the same at St. Peter's, because no Classical rules, no model, no previous building looked anything like St. Peter's. And so let's keep in mind as we continue to discuss Michelangelo's architecture in our next lecture that St. Peter's is also still under construction, and Michelangelo's typical way of working in architecture is to constantly make changes, constantly invent new solutions to the problems as they arise.

Architecture may not have been Michelangelo's profession, as he claimed, but it certainly was one of his most enduring legacies.

Lecture Thirty-Three
Michelangelo's Roman Architecture, Part 2

Scope:

This lecture continues the previous consideration of Michelangelo's architectural and urban projects for Rome. First, we examine the highly innovative gate that he designed for the city, the Porta Pia. Then, we consider Michelangelo's interventions in the partially ruined baths of Caracalla and examine how he transformed this pagan place of leisure into a Christian church. Finally, we look at the Sforza Chapel, designed for the church of Santa Maria Maggiore. In each case, Michelangelo's conceptions are as much sculptural as architectural.

Outline

I. Urban renewal.

 A. Two of the projects we'll discuss in this lecture—the Porta Pia and the Church of Santa Maria degli Angeli—were undertaken for Pope Pius IV (r. 1559–1565), who made great strides in turning the city of Rome into the capital we see today.

 B. Both the Porta Pia and Santa Maria degli Angeli were located far from the city center. They were part of Pius's efforts to develop the sections of the city called the *disabitato*—the uninhabited part of Rome.

 1. Pius laid out a long, straight street (the Via Pia, now the Via Venti Settembre) that extended from Monte Cavallo (the Quirinale Hill) to the distant city wall, which we see on a modern map.

 2. On a 16th-century map of Rome, we see that the city hadn't yet filled up the area of the *disabitato*. Everywhere, there was evidence of the city's former grandeur, but it was now mostly ruins.

 C. The gate designed by Michelangelo stood near the Castra Praetoria, the ancient camp of the Praetorian Guard. Outside this gate, the road continued northeast toward Mentana and

into the Sabine Hills.

II. The Porta Pia.

 A. The most important gate of Rome is the Porta del Popolo, which faces north, the same direction from which most visitors come to the city. The Porta Pia was far from the inhabited city center.

 B. Thus, the Porta Pia was then, and still is, seen mainly from within the walls, as in the view we see here. In electing to give the gate an unexpected inward orientation, Michelangelo was thinking as an urban designer.

 1. As mentioned, the most important point of entry into the 22-mile circuit of walls around Rome was the Porta del Popolo. In contrast, the Porta Pia was a port of egress, mainly viewed when Roman residents departed the city for their villas north and east of the city.

 2. Thus, the Porta Pia does not serve the traditional defensive function of a gate. Rather, it suggests a lighter mood, preparing us for the leisure activities that await beyond the walls.

 C. The upper part of the gate was added subsequently, and scholars are uncertain about how much of it was Michelangelo's original design. Given the gate's whimsical appearance, however, it's evident that this later architect was indulging in the same sort of effort as Michelangelo.

 D. Michelangelo worked out his ideas in dense, multilayered drawings that anticipate the three-dimensional surfaces of his architecture. On one such drawing, we can trace the gate's evolution from a conservative to a more extravagant design, from an architecture that obeys rules and employs Classical language to a new and highly original conception.

 1. Michelangelo started out by drawing a low, flat lintel, which he expanded to create a truss-shaped doorway; he then enclosed a single semicircular pediment within a triangular pediment.

 2. It's characteristic of Michelangelo to layer architectural elements, such as door surrounds, pediments, and cornices, as we saw in his designs for the Farnese Palace

windows. This approach serves the purposes of design rather than strict function.

 3. The physicality of the drawing and the constant revision find counterparts in Michelangelo's contemporaneous figural drawing, especially his late religious works.

E. From the dense working of the drawing, Michelangelo was able to extract a remarkably coherent and vigorous portal design. Although the drawing is not too different from the door that was actually built, revisions were made.

 1. The gate retains some of the qualities anticipated in the preliminary drawing, such as the three-dimensionality of the stone architecture.

 2. The gate also reveals numerous novel features, such as multilayered pilasters with ear-like appendages and a triangular pediment broken in the center and enclosing yet another fragmented, curved pediment, the parts of which look something like giant springs under tension.

F. With this gate and other designs, Michelangelo invented his own architectural vocabulary.

 1. For instance, we see examples of Michelangelo's *kneeling windows*, so called because the window surrounds extend to the ground and appear to be somewhat anthropomorphic.

 2. The upper wall is decorated with carnival-like crenellations capped by travertine balls.

 3. The architectural elements here are rendered as if they're taffy, stretched and gooey. They are as unexpected as they are inventive and, ultimately, inexplicable.

G. The Porta Pia metamorphoses the genre of the fortified city gate. The traditional purposes of protecting the city and marking its boundary are still present, but they are subverted through whimsy and the grotesque. The Porta Pia is, at once, a city gate, an urban marker, a papal celebration, and an extravagant fantasy.

III. Santa Maria degli Angeli.

 A. New structures, such as the Porta Pia, presented Michelangelo with the opportunity to realize highly original architectural designs. However, no equivalent license was

permitted by Pope Pius's commission to transform the Roman baths of Diocletian into a Christian church.

B. The bath complex was an ancient, mostly ruined building more than 1,000 years old. The "givens" in this commission were enormous—literally—but not very promising. It seems to have offered Michelangelo little room to invent.

C. We see a plan of the original bath complex. As was his usual practice, Michelangelo began by articulating the center and divesting it of all excess matter. Ingeniously, he then turned the central hall into an oversize transept. The nave was composed of a sequence of smaller, cross-axial spaces, beginning with a round vestibule (the ancient *tepidarium*, or warm-water pool) and leading to the huge transept, then culminating in a newly built, barrel-vaulted choir.

D. Different from the strictly axial approach to the altar that is usual in most Christian churches, the experience in Santa Maria degli Angeli is much more digressive. After entering the dark rotunda, most visitors pause to wander about the spacious and light-filled crossing, before once again proceeding toward the darkened ambiance of the choir.

E. Our view on the right-hand side is not toward the altar but along the cross-axis, looking at the giant volume of the transept. This was originally one of the main pools of the Roman baths. As we see on the plan, it's even larger than the main nave of the church. Compared to most other Christian churches, this feature represents an interesting reversal of emphasis between nave and transept.

F. Michelangelo concentrated his efforts on the sublime interior space at the expense of the dilapidated façade. Thus, from the street, there are few signs to signal even the presence of a church.

G. In the modern city of Rome, it is often convenient for pedestrians to pass through the large building rather than to walk around it. Thus, Santa Maria degli Angeli retains some of the bustle that typified its original function as a large public institution.

IV. The Sforza Chapel.

 A. The Sforza Chapel, commissioned by Cardinal Guido

Ascanio Sforza, is one of many chapels attached as architectural accretions to the early Christian basilica of Santa Maria Maggiore.

1. The church dates to the 5th century; we see it as a simple early basilica with a large single nave and side aisles.
2. Michelangelo made some drawings for the chapel and offered the services of his assistant, Tiberio Calcagni, for realizing them.

B. The chapel offers an initial impression of utter simplicity and serenity, but it's actually a forcefully articulated and exciting space. The unusual plan is formed as a circle.

C. Notice also the square marked by four columns, a square that forms the area of the altar, and one-third of a square that forms the entrance vestibule into the chapel. These simple, overlapping geometries—circle enclosing a square—are more sensed than immediately apparent.

D. On stepping into this intimate space, we are drawn to the prominent sail vault billowing forth from what we might call fractured entablature. In looking up, the geometry and simplicity of the centralized space becomes immediately apparent.

E. Paradoxically, the four piers that support that central vault are responsible for both the dynamism and the stability of the chapel.

1. The columns mark the corners of a perfect square, even while they appear to advance forcefully into the middle of the centralized space.
2. Stretched pieces of wall membrane, protuberant pedestals, and portions of entablature are pulled along by the advance of the columns.

F. The transepts of this smallish chapel are curved recesses left over from these architectural tectonics. They provide quiet if shallow refuges for prayer and for the burial monuments of the Sforza family.

G. The chapel was much admired by Michelangelo's successors. It foreshadows, for example, the dynamic designs of such Baroque architects as Bernini in the church of Sant'Andrea and Francesco Borromini in the San Carlo

alle Quattro Fontane. The chief lessons these two 17th-century architects learned from Michelangelo was that space is fluid and that architecture can be dynamic and exciting.

V. Michelangelo's architectural legacy.

 A. It may seem peculiar to have devoted two lectures to structures that, in some instances, were never built or that only partially reflect Michelangelo's contributions. But as we've said, many of the master's ideas were realized by subsequent artists and architects.

 B. All the details may not be Michelangelo's, but all the inventions and innovations certainly are. They are rightfully considered his creations, even if partly carried out by others. Most importantly, they reflect his attitude and approach to architecture—open, dynamic, and flexible.

 C. Michelangelo's chief legacy was in liberating architects from the rules. Just as Classical antiquity and his contemporaries served to inspire Michelangelo, so did Michelangelo have a profound impact on subsequent architects.

Works Discussed:

Baths of Diocletian, Rome, Italy.

Michelangelo:

Porta Pia, Rome, Italy.

Study for the Porta Pia, c. 1560, brown wash over black chalk, 18½ × 11" (47 × 28 cm,) Casa Buonarroti, Florence, Italy.

Santa Maria degli Angeli, Rome, Italy.

Santa Maria Maggiore, Rome, Italy.

Sforza Chapel, Santa Maria Maggiore, Rome, Italy.

Gianlorenzo Bernini:

Sant'Andrea al Quirinale, Rome, Italy.

Francesco Borromini:

San Carlo alle Quattro Fontane, Rome, Italy.

Suggested Reading:

J. S. Ackerman, *The Architecture of Michelangelo*.

G. Argan and B. Contardi, *Michelangelo Architect*.

H. Hibbard, *Michelangelo*.

W. E. Wallace, *Michelangelo: The Complete Sculpture, Painting, Architecture*.

W. E. Wallace, ed., *Michelangelo: Selected Readings*. See E. B. MacDougall, "Michelangelo and the Porta Pia."

Questions to Consider:

1. Earlier in the course, we described Michelangelo's first impressions on arriving in Rome. What would be yours if the first thing you saw of Rome was the Porta Pia? Is it a serious or humorous work of architecture?

2. Why was it important for Michelangelo and the pope to transform a Roman bath ruin into a Christian church? Can you think of other examples in which a pagan building has been transformed into a Christian monument?

Lecture Thirty-Three—Transcript
Michelangelo's Roman Architecture, Part 2

This lecture continues the previous one in considering Michelangelo's architectural and urban projects for the city of Rome. First we will examine the highly innovative gate that Michelangelo designed for the city, the Porta Pia. Secondly, we'll consider Michelangelo's interventions in the ruined baths of Diocletian, and examine how he transformed this pagan place of leisure into a Christian church. And finally, we'll look at a more modest chapel that he designed for the church of Santa Maria Maggiore—the Sforza Chapel. In each one of these cases, Michelangelo's conceptions are highly inventive and original, as much sculptural as architectural.

As I suggested in the last lecture, I really honestly think that Michelangelo's final and arguably his most important legacy was architecture—extraordinarily innovative as an architect.

Now two of these projects—the first two we'll discuss—the Porta Pia and the Church of Santa Maria degli Angeli—were undertaken for Pope Pius IV, who reigned from 1559 to 1565. This is the last of the many popes for whom Michelangelo worked. Pope Pius made great strides in turning the city of Rome into the capital that we see today, laying the foundations and preparations for it to become the great Baroque city of the subsequent century.

Michelangelo was an important ally and an agent in these efforts at urban renewal and glorification. Both the Porta Pia and Santa Maria degli Angeli were located far from the city center—then and still today. They were part of Pius's efforts to develop the great swath of the parts of the city that were called the *disabitato*—the uninhabited part of Rome. He actually laid out a long straight street, aptly named the Via Pia, after him (now the Via Venti Settembre). It was extended from Monte Cavallo (the Quirinale Hill) all the way to the distant city wall.

So on the modern map of Rome this is the Via Venti Settembre that leads from the center of the city. We've been concentrating our attention so much on the Renaissance part of the city in the bend of the Tiber River. So Pius is trying to settle or encourage settlement in the *disabitato*, the part well beyond, but still well within the city walls. So the Via Venti Settembre went all the way out to the city

wall to the Porta Pia, and also out there the Church of Santa Maria degli Angeli, built into the baths.

On our 16th-century map of Rome we see even in the late 16th century that the city hasn't yet filled up that area of the *disabitato*. This is the Via Pia leading all the way out to Porta Pia, and alongside here would be Santa Maria degli Angeli. This whole area was densely settled in ancient times, but it was sparsely inhabited all through the Renaissance.

On these large tracts of open land, the city's wealthy elite tended to build luxury villas and cultivated gardens and vineyards out in this area of Rome. Everywhere, there was evidence of the city's former grandeur, but it was now mostly overgrown ruins. There were great but ruined hulks of buildings, battered stretches of the frequently repaired but largely nonfunctioning aqueducts, and some of the stretches of the ancient walls. The newly created gate that was designed by Michelangelo stood near the Castra Praetoria. This is the ancient camp of the Roman Praetorian Guard. Now the Castra Praetoria was also, in ancient Roman times, located far from the Roman center. The Caesars lived on the Palatine Hill towards the center of Rome and they wanted the Praetorian Guard located out towards the edge. And this is the part of the city that we're now concentrating on.

Outside this gate, the road continued northeast towards the town of Mentana and onwards into the Sabine Hills. And we see on the 16th-century map the continuation of the Via Pia out to Mentana and then the beautiful Sabine Hills. I'd like you to note the relationship of the two very most important gates. Of course, the one we're going to talk about today, the Porta Pia; but the really most important gate of Rome is the Porta del Popolo. This is the one that faces north and this is the direction in which most visitors came to Rome and the gate through which almost every visitor to Rome proceeded, as did Michelangelo when he first arrived in Rome in 1496. So he's now working on a part of Rome that's really terribly remote and far from the inhabited center.

The Porta Pia was then and still is today seen, therefore, mainly from within the walls, as in this view. It's a very curious orientation. Gates are generally defensive bastions with some kind of threatening appearance, exuding hostility to an external enemy. They almost

always face outwards, projecting the power of the city. However, this gate faces inwards, towards the city of Rome. Now this is very purposeful, and in electing to give the gate this unexpected orientation, Michelangelo was fully cognizant of the dynamics of urban settlement and movement. He's really thinking as an urban designer.

During the Renaissance, most visitors arrived from the north and entered Rome, as I said, through the Porta del Popolo, which was certainly the busiest and most important point of entry in the whole circuit of 22-mile walls. In contrast, the Porta Pia was a port of egress, mainly viewed when Roman residents departed the city for their great villas and the suburban retreats that dotted the Sabine Hills north and east of the city. Thus, this is obviously a gate that no longer serves the traditional function as a defensive element. Rather, it suggests a very different, non-bellicose mood that surprises and delights us with its whim and its fantasy. In a sense, the architecture helps to prepare us for the activities that lie beyond the walls—farming, leisure, relaxation. These are the pastimes of *otium*, not *bellum*—pleasure, not war. So a gate that faces us as we leave the city.

Now when we discuss the gate we're rather uncertain about the upper part of this gate, which was certainly added subsequently, and it's uncertain to what degree it actually is the responsibility of Michelangelo's design. But it almost doesn't matter, since we're talking about a gate full of whimsy and fantasy; that if the subsequent architect also indulged in the same sort of effort, then he's only following Michelangelo's own preparatory design.

Now Michelangelo worked out his ideas in dense, multi-layered drawings that anticipate the three-dimensional surfaces of his architecture. This is just one example that we have. On this sheet, for example, we can trace the gate's rapid evolution from a conservative to an ever more extravagant design, from an architecture that obeys rules and employs classical language to a new and highly original conception.

Notice how the drawing reveals the artist's characteristically intense concentration on a problem, his manner of combining alternative solutions, and his tendency to enlarge the design in the course of drawing. He started out by drawing a low, flat lintel, and then he expanded it to create a truss-shaped doorway, and then he took a

single semi-circular pediment and enclosed it within a triangular pediment.

So it's characteristic of Michelangelo to take architectural elements, such as door surrounds and pediments and cornices, and to double and layer them. We've been seeing this ever since he started designing architecture, and we saw it especially in his designs for the Farnese Palace windows. It's a kind of architectural redundancy, Michelangelo compacting one idea on top of another. It serves the purpose of design rather than strict function.

I would say the physicality of the drawing and the constant revision actually find counterparts in Michelangelo's contemporaneous figural drawing, especially his late religious works, where we'll see that the hand appears reluctant to abandon the sheet. We'll discuss these in a future lecture. But it's Michelangelo's tendency, clearly here, later in life to draw, redraw, and overdraw, one on top of another, to provide numerous simultaneous ideas on a single drawn sheet.

So from the dense working of the drawing, Michelangelo was able to extract a remarkably coherent and vigorous portal design. It's not that far different from the door that was actually built—as the one on this drawing—and it has something of that same kind of architectural redundancy shown in the density of ideas laid on top of one another. And yet there are still revisions and changes that are made. Michelangelo's designs are merely one alternative in a fluid design situation with very few fixed solutions. He's constantly revising and constantly changing his mind.

Nonetheless the gate retains some of the qualities anticipated in that preliminary drawing. For example, the three-dimensionality of the heavy stone architecture is powerfully evoked even in the fragile and small medium of drawing. The resulting gate reveals numerous novel features—multi-layered pilasters with ear-like appendages, a triangular pediment broken in the center and enclosing yet another fragmented curved pediment, the parts of which look something like giant springs under tension.

In architecture there is really a name for every part of a building, every detail; but once again architectural vocabulary fails us here, as Michelangelo is largely inventing his own vocabulary, or at least

radically transforming the words and syntax of the conventional language of classical architecture.

And what do we get from these kinds of attitudes towards architecture? Freeform and fluid, extravagant, overly decorated windows floating in broad expanses of brick, like this one. These are examples of an important Michelangelo invention, his so-called *kneeling windows*, because the window surrounds extend all the way to the ground and appear to be somewhat anthropomorphic—as if it's slipping to its knees, or perhaps even kneeling in prayer. It's almost possible to imagine such a window winking at us. It has a kind of lively character to it. Windows, after all, are mere functional items, allowing light and air inside, but these are extravagant in their sort of verbosity.

The upper wall is decorated with these carnival-like crenellations capped by travertine balls. The architectural elements here are rendered as if they're soft taffy, stretched and gooey—melting, almost. They're as unexpected as they are inventive, ultimately inexplicable. Really, they serve as delightful decorations. Crenellations back in the Middle Ages were part of the defensive mechanisms behind which people would shoot arrows, but one can hardly imagine that that's the purpose in this case.

The Porta Pia metamorphoses the genre of the fortified city gate. Rather than asserting military might, the gate now has become a kind of porous diaphragm. It signals the edge of "civilization," between the city and the countryside, between urbanity and rusticity. The traditional purposes of protecting the city and marking its boundary are still present but they are subverted through whimsy (*fantasia*) and the grotesque. We can kind of appreciate what Michelangelo has achieved here by asking the simple questions: Are those cannon balls or carnival decorations adorning the wall? Is this a fortified gate or is it a giant mask, a grotesque mask?

Thus can architecture help shape our human mood. In passing through such a gate, we pass from the hectic and sophisticated city to the slower rhythms of the country. In the proper mood—and perhaps heading out of Rome to enjoy life in our country villa—the gate will speak to you in its unexpected, yet delightfully invented language. The Porta Pia is at once a city gate, an urban marker, papal celebration, and extravagant fantasy. Yet, because of its somewhat

©2007 The Teaching Company.

remote location and unexpected design, it remains one of Michelangelo's least familiar architectural works.

Let us now turn to the second of these great urban projects. Wholly new structures such as the Porta Pia or San Giovanni dei Fiorentini, which we discussed in our last lecture, presented Michelangelo with the opportunity to realize highly original architectural designs. However, there was no equivalent license permitted by Pope Pius's commission to transform the Roman Baths of Diocletian into a Christian church.

This was a mostly ruined ancient building more than 1000 years old. The "givens" in this commission were enormous—literally—but not very promising. It seems to have offered Michelangelo little room to invent. But let us not underestimate Michelangelo's architectural genius, and let's watch and see how he went about solving a problem of transforming a pagan institution into a Christian church.

The ancient complex was far from the inhabited city center and included a vast number of large and small halls, service facilities and open courts, almost all of which were in ruinous condition. How did Michelangelo see beyond the ruins? How did he shape such dross into a monument? Somehow, Michelangelo had the vision to transform this largely dilapidated pagan structure into the new and triumphant expression of the Christian faith. How did he do it?

This is a plan of the whole complex of the Baths of Diocletian. So as was his usual practice, Michelangelo looked to the center, to the torso, to clarify the shape of things. Approaching the baths as if it were a ragged hunk of marble, Michelangelo articulated a figure within the block. Michelangelo gave form and coherence to the sprawling structures, and most impressive of all, he changed this pagan institution of pleasure into a holy sanctuary. But looking at this gigantic complex, realizing most of it is in a ruinous condition, where is that torso? Note this very small inner part, the best preserved part of the entire baths. It's actually a gigantic church that he will build embedded, sort of discovered, within this sprawling complex.

Just as at St. Peter's Michelangelo began by articulating the center and divesting it of all excess matter, ingeniously, Michelangelo turned the huge volume of the well-preserved central hall into an oversize transept with the nave composed of a sequence of smaller,

cross-axial spaces beginning with a round vestibule—the ancient *tepidarium* or warm-water pool—and leading to the huge crossing or transept, then culminating in a newly built, barrel-vaulted choir. And we see that *tepidarium* leading into this gigantic transept and the new choir that was constructed by Michelangelo. And all of this is discovered, excavated from within this gigantic bath complex with only really that central hall being the best preserved of the building.

Different from the strictly axial approach to the altar that is usual in most Christian churches, the experience in Santa Maria degli Angeli is much more digressive. After you enter the dark entrance rotunda, most visitors pause or wander about the spacious and light-filled crossing, before once again proceeding towards the darkened ambiance of the choir. So we come in this way, and one's tendency is then to suddenly start to wander around the transept, which is very different from most Christian churches, which direct us in a very direct and axial manner straight to the main altar, which is actually located here in the darkened choir.

So our view on the right-hand side here is actually not towards the altar but along the cross-axis, looking at the giant volume of this space—the transept of the church. This was what was originally one of the main swimming pools of the old Roman baths, that's now been transformed into the transept, or the crossing arm. As you see on the plan, it's larger even than the main nave of the church. It's an interesting reversal of emphasis between nave and transept compared to most other Christian churches.

Now, Michelangelo concentrated his efforts on the sublime interior space at the expense of the dilapidated façade. This is not unlike the way he designed the San Giovanni dei Fiorentini, if you recall—from the inside out—so, too, at Santa Maria degli Angeli. Thus, from the street there are really very few signs to signal even the presence of a church except for a prominent cross situated high on the wall over the entrance. Michelangelo has forged a Christian monument from the pagan past. At the same time he's firmly maintained continuity with antiquity. Looking at it from the street, we really do not anticipate a Christian church lying behind what appears to be still a lot of ruins. Now to have created coherence from such unlikely circumstances is, I think, testament to Michelangelo's powers of imagination and his organization.

In the congested modern city of Rome, it is oftentimes convenient for pedestrians actually to pass through rather than to walk around the large building. It is part of a gigantic complex. Thus, when so many other ecclesiastic structures in the city are little more than quiet refuges, if not completely deserted, Santa Maria degli Angeli actually retains some of the bustle that typified its original function as a large public institution. It's now located very close to the modern train station, and there's actually a lot of urban traffic that passes through this space.

And now let's turn our attention to the third of these urban interventions. We're looking here at the façade of Santa Maria Maggiore and a view of the interior of the Sforza Chapel.

Death interrupted most of Michelangelo's architectural projects; however, his imprint was strong enough that many were carried out in conformity with his designs. And a good example of this is the Sforza Chapel, another little known architectural jewel in the early Christian basilica of Santa Maria Maggiore. The Sforza Chapel is so called because it was commissioned by Cardinal Guido Ascanio Sforza, who was the nephew and former chamberlain of Pope Paul III—as you'll remember, one of Michelangelo's favorite, most important patrons. Michelangelo was busy and very old at this point in his life, but for persons close to his affections, such as the Sforza, the artist made exceptions, and this is certainly one of them.

The Sforza Chapel is one of many chapels attached as architectural accretions to the ancient early Christian basilica of Santa Maria Maggiore. Santa Maria Maggiore dates way back to the 5th century and we see it as a simple early Christian basilica with a large single nave and side aisles. And what we're looking at then is, over the centuries, a gradual accretion of chapels along either side of it, and the Sforza Chapel is this one. We're going to concentrate here. Michelangelo made some drawings and offered the capable services of Tiberio Calcagni, who deserves some credit for realizing this lesser known masterpiece of Michelangelo's late architecture.

As in so many of the artist's architectural projects, there is much more than meets the eye. The chapel offers an initial impression of utter simplicity and serenity, but it's actually very forcefully articulated and a very exciting space. The unusual plan is formed of a circle, which we see visible only as quarter segments of a curving

wall here and here. But on the ground plan we can easily see the circle forming the central part of the plan.

There is a square marked by four columns, and a square that forms the area of the altar, and one-third of a square that forms the entrance vestibule into the chapel. These are simple and overlapping geometries—circle enclosed over a square. However, they are more sensed than immediately apparent to the visitor.

On stepping into this intimate space, one is drawn to the prominent sail vault billowing forth from pieces of what I might call fractured entablature, as if they'd slightly exploded, firecracker-like. In looking up, the geometry and simplicity of the centralized space becomes immediately apparent. Thus, all of a sudden the firecracker is over. The dynamic, elastic space is harmoniously resolved in the beauty and simplicity of that billowing sail vault.

Paradoxically the four piers that support that central vault are responsible both for the dynamism and the stability of the chapel, a way that Michelangelo paradoxically uses architectural features for multiple purposes. The giant monolithic columns mark the corners of a perfect square, even while they appear to advance forcefully upon the middle of the centralized space. Stretched pieces of wall membrane, protuberant pedestals, and portions of entablature are pulled around like taffy along with the forceful advance of the columns, and they do seem to march into that central space. This is architecture in motion and very, very exciting.

The transepts of this smallish chapel are curved recesses left over from these architectural tectonics. They provide quiet if shallow refuges for prayer and for the burial monuments of the Sforza family at the center of each of these bowed walls. Although located in the prominent church of Santa Maria Maggiore, the Sforza Chapel remains a quiet refuge. Like the Porta Pia, it is one of the least familiar works by Michelangelo. But it was, however, much admired by Michelangelo's successors.

For example, the Sforza Chapel is an architectural jewel that foreshadows the dynamic designs of such Baroque architects as Gian Lorenzo Bernini. His church of Sant'Andrea is on the left, and San Carlo alle Quattro Fontane on the right, by Francesco Borromini. What did these two highly creative 17th-century architects learn from Michelangelo? That space is fluid; walls bend, bow, stretch;

architecture lives and breathes like a vibrant organism; it can be dynamic, fluid, malleable, exciting—all of these things we associate with Baroque architecture, all of it seen in a nutshell in some of Michelangelo's own architecture.

In all of these cases, the centralized spaces of these churches—Bernini and Borromini—are much more interesting in person and can hardly be captured in photographs. Architecture becomes very stabile, nonmalleable when seen in photography. Michelangelo created masterpieces, yes, but he also unleashed the imagination of so many others who followed him.

I'd like to say a further word about Michelangelo's architectural legacy. It may seem peculiar to have devoted these last two lectures to buildings that in some cases were never built, or to buildings that only partially reflect Michelangelo's contributions. But at this point in our course, we should realize that many of Michelangelo's ideas were realized by subsequent artists and architects, even well after the master's death. This was true of the Capitoline Hill, St. Peter's, and the projects discussed in this lecture.

All the details may not be Michelangelo's, but all the inventions and innovations certainly are. They are rightfully considered his creations even if partly or mostly carried out by others. And most importantly, they reflect his fundamental attitude and approach to architecture—open, dynamic, inventive, flexible. In any case, it's fallacious to attempt to surgically separate what is Michelangelo's and what is his followers'. It's best to recognize his designs and welcome his long-lasting impact.

In every case, these buildings are much more satisfying in person, largely because architecture is so dependent on light, urban context, and the movement of people in and through these buildings. Thus, it may be a long walk to go out to the Porta Pia, but its fantasy and extravagance will be all the more rewarding for having traveled so far from the city center. Today, unfortunately, rather than open countryside, we're met by endless, crowded, and ugly suburbs, but as a result, we will enjoy all the more Michelangelo's refreshing architectural originality, which so obviously stands out from its dreary surroundings.

Most importantly, Michelangelo liberated architects from the rules. He served as an inspirational model. Just as classical antiquity and

his contemporaries served to inspire Michelangelo, not as models to slavishly follow, but as possible solutions that could be creatively emulated, so did Michelangelo have a profound impact on subsequent architects. Indeed, much of the originality of the 17th and 18th centuries would have been impossible without Michelangelo's creative contributions.

Lecture Thirty-Four
Piety and Pity—The *Florentine Pietà*

Scope:

This lecture considers a single sculpture by Michelangelo and a singular work of art, the *Florentine Pietà*. We know that Michelangelo carved the *Florentine Pietà* to be his own grave marker. As such, it is an intensely personal and deeply meaningful work of art made, not on commission or for another patron, but for himself alone. It is the visual realization of the artist's last will and testament. With this work, the artist began to prepare himself for death.

Outline

I. The *Florentine Pietà*.

A. The subject of death preoccupied Michelangelo in his final years, and the *Florentine Pietà* was to be his grave marker. The sculpture was carved in Rome but later transferred to Florence, hence the name *Florentine Pietà*.

B. *Pietà* literally means "pity" or "compassion." In art, a *pietà* usually describes the expression of sorrow over the dead body of Christ.

C. In this sculpture, we see Christ and the Virgin Mary, Mary Magdalene, and a large male figure holding Christ upright from behind.

1. This figure may be Joseph of Arimathea, the disciple "who was a man of means" and who offered his own rock-cut tomb where Christ was buried.

2. Alternatively, it may be Nicodemus, a Jewish elder who became a secret follower of Christ. It's characteristic of Michelangelo that he does not insist on one identity or the other.

II. Difficulties in scale and carving.

A. The *Florentine Pietà* is, after the *David*, the largest and most ambitious of Michelangelo's sculptures. In carving it,

Michelangelo returned to one of his earliest subjects and to a challenge posed by the *Laocoön.*

1. From the time of its discovery in 1506, Michelangelo had been aware that the three-figure *Laocoön* group had not been carved from a single block of marble, as Pliny had maintained.

2. This knowledge merely intensified the challenge: Could a modern artist do what antiquity had failed to accomplish? Would it be possible to excavate four figures from a single block, each in proper relation and proportion to the others and all composed in a manner that would be harmonious, artistic, and meaningful?

B. As we have seen repeatedly, Michelangelo tended to change his mind in the course of carving, even quarrying extra-large blocks of marble so that he would have sufficient material to do so. But there is little excess stone in the *Florentine Pietà.*

1. The Virgin is too small in comparison to Christ and the figure of Nicodemus. In fact, there is not enough stone left to finish her face without compromising the more realized head of her dead son. Similarly, Michelangelo did not leave sufficient stone to finish carving her hand.

2. Michelangelo encountered an even more intractable problem in carving Christ's left leg. Either the marble broke or was purposefully removed; the leg was later trimmed in an effort to make a repair. This repair would have been contrary to the artist's belief that true sculpture is created from a single block of marble.

3. The breaking or removal of Christ's leg and the diminishing amount of marble may have resulted in Michelangelo's abandoning the sculpture.

4. Remarkably, most visitors fail to notice that Christ is missing a limb, and even when the absent leg is noted, few people are disturbed by Christ's dismembered state.

C. Whatever its "faults," we can say of the *Florentine Pietà* that it compares well with one of the few other multi-figure sculptures carved in Michelangelo's lifetime, the *Madonna and Child with St. Anne* by Francesco da Sangallo.

1. Michelangelo has carved a far more successful, tight-knit composition of four figures, not three.

©2007 The Teaching Company.

2. Sangallo's figures are stiff, compositionally awkward, and wooden, without the narrative drama of Michelangelo's sculpture.

III. The Magdalene.

A. We see two works that Michelangelo might have known from his exposure to Florentine art during his youth: Fra Angelico's *Pietà* and *The Deposition* by Rogier van der Weyden.

1. Michelangelo's sculpture is called a *pietà*, but more properly it is, like the Rogier, a deposition: a scene of Christ being taken to his tomb.

2. The presence of Mary Magdalene in the van der Weyden and in Michelangelo's sculpture hints at a number of narrative moments in the Passion story. Yet this is the first and only time that Michelangelo represented Mary Magdalene in sculpture. Given the deeply personal nature of the work, we must assume that she is intended to play a significant role in the group's meaning.

B. One hears frequent complaints about the depiction of Mary Magdalene: She's too small, or she was finished by Michelangelo's assistant, Tiberio Calcagni, which is partly true. Closer analysis reveals, however, that her size is appropriate to who she is and varies depending on the viewing angle, as we see in two differing perspectives.

C. The inclusion of the Magdalene, her pose, her diminutive size, and the overall relation to the rest of the group are Michelangelo's own decisions, and therefore, they deserve thoughtful consideration.

1. Although she is commonly represented in scenes of the deposition, she is less frequently part of a *pietà*, especially in sculpture. She appears in this sculpture at a time when Michelangelo was writing penitential poetry, and just like the Magdalene, was acutely conscious of his sins even while yearning for union with Christ.

2. The Magdalene kneels on the left side of the group, which is the privileged right hand of her Lord and savior. Christ's right arm and hand fall across her shoulder and his fingers lightly touch her back. The

Magdalene's is the only face turned to us; she addresses the spectator and presents the body of Christ.

3. She is a young, nubile girl, who is pressed close to Christ's naked flesh, but actual contact is averted. As in his earlier painting of the *Noli me Tangere*, Michelangelo has heightened the tension instigated by the physical proximity of Christ and the Magdalene and, thereby, suggests both her former life as a sinner and her new life as a devoted follower of Christ

4. Her unseen left hand embraces Nicodemus, to whom she is a counterpart. Like Michelangelo, the Magdalene and Nicodemus are penitent figures who yearn for salvation through Christ.

D. The Magdalene's diminutive size is more apparent than real, for she grows and diminishes in stature and importance depending on the angle from which the sculpture is viewed.

1. Physically and iconographically, she is a marginal figure, in a comparable relationship to the group as the allegories of time are to the dukes in the Medici Chapel or the *Rachel* and *Leah* are to the *Moses* on the monument of Julius II.

2. As we noted in a previous lecture, the modest size of *Rachel* and *Leah* was purposeful so that they would not compete with the *Moses*. The same is true in the *Florentine Pietà*, where the Magdalene helps to frame Christ.

E. It is likely that Michelangelo's trusted assistant, Tiberio Calcagni, completed the Magdalene. She is more finished than the other figures and, thus, less appealing to the modern viewer.

IV. Nicodemus.

A. Most scholars agree that the hooded figure behind Christ is a self-portrait of the aging artist, probably in the guise of Nicodemus, who came to Christ in the 11th hour.

B. Michelangelo's hooded figure and the unpolished features of the face suggest the veil of night under which Nicodemus revealed his faith. Once again, Michelangelo has used the fall of natural light and the *non-finito* for expressive ends.

C. The sculpture is an eloquent expression of faith, intended to mark Michelangelo's grave, but the artist never completed it. Perhaps for Michelangelo, to finish the sculpture would mean bringing the marble to life and resigning himself to death.

D. Michelangelo expressed this paradox in poetry, revealing his acute consciousness of the transitory nature of life and the futility of art.

 1. Michelangelo writes that art had become a "great peril" to his soul. How could he hope to make something divine from something material? How does one carve the spiritual in stone?

 2. For any number of technical and psychological reasons, the sculpture was destined to remain unfinished. Ultimately, Michelangelo gave the *Pietà* to his friend Francesco Bandini and permitted Tiberio Calcagni to repair it.

V. Assessment.

 A. Michelangelo did not destroy nor did Calcagni ruin what was the master's most ambitious and difficult essay in marble. At once a *pietà* and a deposition, a grave memorial and a narrative icon, a real and a spiritual portrait, the sculpture brings together several themes in Michelangelo's art and life.

 B. The figures of Nicodemus and the Magdalene are at the periphery of Christ's life and Michelangelo's marble group, but to those figures falls the responsibility of sustaining and presenting Christ's body and of speaking to us. In these figures, we see ourselves, the sinner and the secret follower of Christ, and through their intercession, we gain access to our Lord and a means to salvation.

 C. In carving this theme once again in the *Rondanini Pietà*—the subject of our next lecture— Michelangelo eliminated these accessory figures. Salvation, he seems to have realized, was to be achieved mainly through personal devotion to Christ.

 D. In the *Florentine Pietà*, Michelangelo's youthful hubris as a marble carver came to an end. He continued to carve but failed to complete any other sculptures. In the midst of carving the *Pietà*, Michelangelo wrote: "The soul gains

more, the more it loses the world/And art and life do not go well together;/In which, then, should I place my further hope?"

E. In the end, Michelangelo placed his hope in his devoted assistant and close friends, who ensured that the *Pietà* survived, if not as the artist's funerary monument, then at least as an eloquent cenotaph and artistic masterpiece.

Works Discussed:

Michelangelo:

Florentine Pietà, c. 1547–55, marble, 7' 8" (2.08 m), Museo dell'Opera del Duomo, Florence, Italy.

Artist unknown:

Laocoön, 1st century BCE, marble, 7' (2.1 m), Museo Pio Clementino, Vatican Museums, Vatican City, Rome.

Francesco de Sangallo:

Madonna and Child with St. Anne, 1526, marble, Orsanmichele, Florence, Italy.

Fra Angelico:

Pietà, 1438–40, tempera on panel, 15 × 17¾" (38 × 45 cm), Alte Pinakothek, Munich, Germany.

Rogier van der Weyden:

The Deposition, 1450, oil on panel, 43¼ × 37¾" (110 × 96 cm), Galleria degli Uffizi, Florence, Italy.

Suggested Reading:

H. Hibbard, *Michelangelo*.

C. de Tolnay, *Michelangelo: The Final Period*.

F. Hartt, *Michelangelo's Three Pietàs: A Photographic Study by David Finn*.

W. E. Wallace, *Michelangelo: The Complete Sculpture, Painting, Architecture*.

W. E. Wallace, ed., *Michelangelo: Selected Readings*. See W. Stetchow, "Joseph of Arimathea or Nicodemus?"

Questions to Consider:

1. Michelangelo's contemporaries and modern scholars have all failed to adequately explain why Michelangelo abandoned the *Florentine Pietà*. Of the many possible reasons, which do you find most likely?

2. Is the *Florentine Pietà* a successful work of art? Is it really a "work of art"? Can it, should it, have ever been finished?

Lecture Thirty-Four—Transcript
Piety and Pity—The *Florentine Pietà*

This lecture considers a single sculpture and a singular work of art—the *Florentine Pietà*. We know that Michelangelo carved this sculpture to be his own grave marker. As such, it's intensely personal and a deeply meaningful work of art made not on commission or for anybody else but for himself. It is the artist's last will and testament.

The artist's biographer, Giorgio Vasari, relates that early one evening—and this must have been sometime in 1553 most likely—Vasari stopped by Michelangelo's house in Marcel dei Corvi in Rome to pick up a drawing for delivery to the pope. Michelangelo answered the door holding a lamp. Vasari explained his errand, and while the two friends were chatting, Michelangelo's servant, Urbino, went upstairs to fetch the drawing. Even in the poor light of the hour, Vasari noticed that Michelangelo was working on a large marble sculpture of the *Pietà*. As Vasari moved to get a closer look, Michelangelo let the lamp drop from his hand and suddenly the room was plunged into darkness. The artist turned to his friend and said in a plaintive tone: "I am so old that death often tugs at my cloak. One day my body will fall just like that lamp, and my light will be put out."

Clearly Michelangelo was thinking about death, a subject that increasingly preoccupied the artist in his final decades. Now thinking back on this incident, Vasari also realized that Michelangelo did not want him looking at that sculpture, at least not until it was complete. But would it ever be complete? Could it ever be complete? Michelangelo suffered conflicting feelings about this late masterpiece, and ever since, we've been speculating why.

This is the marble sculpture that is the subject of Vasari's anecdote. It was carved in Rome, given away, and later transferred to Florence, which is why it's known as the *Florentine Pietà* to distinguish it from other versions of the subject, especially the earlier masterpiece in St. Peter's basilica. The *Florentine Pietà* now is currently in the Museo dell'Opera del Duomo in Florence, and it's displayed as a work of art, not as a grave marker as Michelangelo originally intended.

Let's consider the subject matter, and the title that we've attached to this work: *Pietà*. *Pietà* literally means "pity" or "compassion." In art,

a *pietà* is usually described in the expression of sorrow—the lament of Mary, and sometimes others—over the dead body of Christ. Indeed, we see here the dead Christ collapsed—or collapsing—into the arms of his mother. On the left is Mary Magdalene, and standing behind is a large male figure who's largely responsible for holding Christ upright.

This may be Joseph of Arimathea, that is, the disciple "who was a man of means" who offered his own rock-cut tomb where Christ was buried. Alternatively—and this is the identification I and many other scholars favor—it is Nicodemus, a high-ranking Jewish elder who became a secret follower of Christ. Nicodemus came under the cloak of night to declare his faith, and then he piously accompanied Christ throughout his torment, the Passion, and the burial. However, it's characteristic of Michelangelo that he does not insist on it being one identity or the other. He permits us, in a way, to approach and understand the work on multiple levels, even possibly identifying that same figure in different guises.

But let us first consider some of the mundane but nonetheless important and inescapable facts about the *Florentine Pietà*. This sculpture is, after the *David*, the largest and most ambitious sculpture that Michelangelo ever carved. I'd like to repeat that because I don't think many people recognize it: This is the largest and most ambitious sculpture that Michelangelo ever carved. It's volumetrically a much larger block of marble than the *Moses* or any one of the Accademia *Slaves*. But even more importantly, it is a multi-figure group, and infinitely more complex and challenging to carve a multi-figure group than one or two figures.

And I'd like to dwell for a moment on some of the complexities that Michelangelo undertook in carving this sculpture. In carving a *pietà*, Michelangelo was returning to one of his very earliest subjects, and in carving more than one figure from a single block of stone, he was taking up an early challenge posed by the most famous sculpture, the *Laocoön*. To carve a multi-figure sculpture from a single block of marble was a challenge set forth by the *Laocoön* to Michelangelo.

From the time of its discovery in 1506, Michelangelo had been aware that the three-figure group of *Laocoön* was not in fact carved from a single block of marble, as the ancient Roman historian, Pliny, had maintained in describing it. But this knowledge merely

intensified the challenge for Michelangelo. Could a modern artist do what antiquity had failed to accomplish? Not only did Michelangelo attempt to rival antiquity but here to surpass it, by carving four figures from a single block of marble.

Now the problems of carving a three-figure group such as the *Laocoön* are enormous. Those attendant to carving four figures from a single block are exponentially more complex. In fact, it was a feat rarely attempted in the whole history of sculpture, even by Bernini or the great marble technicians of the 17th and 18th centuries. One not only has to get the proportions of one figure correct, but the proportional relationships between figures. If you change one part of the sculpture, it usually means that you have to change other parts, until finally one is forced to adjust all parts.

Vasari implicitly recognized the exceptional undertaking by describing Michelangelo's *Pietà* as "an exhausting work, rare in stone." It's rare altogether. When Vasari saw the group in progress he actually thought it was five figures, and that was one way of applauding what a tremendous challenge Michelangelo had undertaken. Vasari anticipated that when it was finished "it will surpass every other work of his given the difficulty of carving such perfect beings from that block."

So how was it possible, even given the large size of the marble, to excavate four figures from a single block, each in proper relation and proportion to the others, and all composed in a manner that would be harmonious, artistic, and meaningful? This was an enormous technical challenge, the greatest, perhaps, that Michelangelo undertook, rivaling something of what he did with the *David*.

As we have seen repeatedly, Michelangelo tended to change his mind in the course of carving marble. Since the time of the first slaves that he carved for the tomb of Julius II, Michelangelo had learned to quarry extra large blocks of marble so that he would have sufficient material to change the form and the disposition of figures as he carved. And if you recall some of those slaves, how he excavated deeply into the block, made changes as he went, refashioning the limbs—but imagine doing that for one figure, trying to do it for multiple figures. You move one, you have to move another. There is little excess stone in the *Florentine Pietà*. He's trying to make use of every inch of that block.

The Virgin is already too small in comparison to the Christ and the standing figure of Nicodemus. In fact, there really is not enough stone left to finish the Virgin's face without compromising the more realized head of her dead son. You continue to polish and carve the Virgin's head, you begin to cut into Christ. Similarly, Michelangelo has not left sufficient stone to finish carving the Virgin's hand, which helps to support Christ. If you complete the hand in a fully three-dimensional manner you'd begin to disfigure the already finished and polished torso on which it rests. So the hand has a kind of flattened and unfinished character to it, but to round it out and to polish it is to start to cut into Christ himself.

So recall this basic rule of marble carving: Carving is a reductive medium, or as Michelangelo described it, "the art of taking away." Every chisel stroke removes marble. It may help to define one form, but it leaves less with which to realize other forms and other figures.

Michelangelo encountered an even more intractable problem in carving Christ's left leg. As we see in this view of the group, it is missing altogether. The marble may have broken while Michelangelo was carving it, or maybe the leg was purposefully removed because of poor material or a change of intention. In any case, the leg stump has now been trimmed and has an excavated hole in it to receive an attachment, but this is an effort at repair that undoubtedly was undertaken after Michelangelo gave up on the work. But any such expediency as this is contrary to Michelangelo's notion that true sculpture is created from a single block of marble without ever having recourse to extra marble or attachments. Indeed, this is the very challenge posed by antiquity—to carve more than one figure from a single block.

The breaking or removal of the leg of Christ and the diminishing amount of marble, especially if the leg were to be recarved from the remaining marble, these are the sorts of problems whose cumulative effects may have resulted in Michelangelo abandoning the sculpture. Now perhaps we are reluctant to imagine the mature Michelangelo meeting potentially irreconcilable problems, but it seems that we are witness to a combination of technical impediments that plagued this sculpture. It may be difficult to admit, but Michelangelo may have failed on the technical front. He seems capable of doing anything, and yet maybe this is one of those cases where he failed. In addition,

there were significant personal impediments that I'll consider toward the end of this lecture.

It is somewhat remarkable that most visitors fail to notice that Christ is even missing a limb. Even when the absent leg is noted, few persons are terribly disturbed about Christ's dismembered state. They tend to avoid this view, preferring to move around to the left where the missing leg is less evident, and the group appears more complete. Indeed, that's exactly how it's exhibited in the museum—artfully turned so as to disguise the missing leg. Although Michelangelo could not have been happy with the group's imperfect condition, it is to us still a moving work of art and a masterpiece worthy of display in a museum.

Whatever its "faults," we can say of the *Florentine Pietà* it still compares well with one of the few other multi-figure sculptures ever carved in Michelangelo's lifetime, and that's this group of the *Madonna and Child with St. Anne* by Michelangelo's friend and sometimes assistant, Francesco da Sangallo, in the church of Orsanmichele in Florence. Francesco da Sangallo was a member of that Sangallo "sect," but one of the ones that Michelangelo actually liked, the son of Giuliano da Sangallo, another member of that family that Michelangelo was friendly with.

In comparison to his younger contemporary, Michelangelo has carved a far more successful, tight-knit composition of four, not just three, figures. In contrast, Sangallo's figures are a bit stiff, compositionally awkward, emotionally wooden, and altogether without the human interaction, narrative drama, and pathos that makes Michelangelo's sculpture so moving. Christ's missing leg is by no means an impediment to our judging Michelangelo the far superior sculptor here.

Now that we've considered some of the technical challenges of carving such an ambitious sculpture, let's more carefully consider its subject and its personal significance to Michelangelo.

These are two works of art that Michelangelo may well have known from his earliest exposure to Florentine art during his time in the Ghirlandaio workshop and subsequently in the Medici household: It's a Fra Angelico on the left, and the Northern Renaissance artist, Rogier van der Weyden, on the right.

Of course, it's much easier to arrange a multi-figure composition in a painting, and it's altogether easier to relate a narrative in paint than in sculpture. So let's further consider the exact subject represented here, and how it relates to Michelangelo's so-called *Pietà*.

We call Michelangelo's sculpture a *pietà*, but more properly it is, like the Rogier van der Weyden, a deposition: Christ is being carried to the tomb or lowered into the tomb. Michelangelo has distilled the narrative to its essentials—Christ, Mary, and two close followers—with the tomb merely implied, as Christ will shortly slide from their grasp and sink into the earth.

But note the presence of Mary Magdalene in the front of the Rogier van der Weyden painting and, of course, also on the left in Michelangelo's sculpture. Her presence hints at a number of narrative moments in the Passion story. She helps prepare Christ for burial, and subsequently, Mary Magdalene is the first witness to Christ's resurrection. Thus, her presence prompts us to think of the extended narrative with which she's associated. This is the first and only time that Michelangelo ever represents Mary Magdalene in sculpture. But why is she included? Given the deeply personal nature of the work, we must accept that she's there for a reason, and is intended to play a significant role in the group's meaning.

And yet, one hears frequent complaints about the *Mary Magdalene*; that she's too small or that she was finished by Michelangelo's assistant, Tiberio Calcagni—which is partly true, but that's scarcely reason enough to warrant dismissing her from consideration. I will argue that her size is appropriate to who she is, and varies depending on the angle from which the sculpture is viewed, as you can see immediately from these two differing viewpoints.

The view on the left is the one preferred, since the sculpture composes nicely and Christ's missing leg is not so evident; but the *Magdalene*, from this view, looms rather large. This is the view also of the group as it's installed in the Museo dell'Opera del Duomo in Florence. She's much smaller when you see the sculpture from the other side, one rarely preferred by viewers or most photographers, but largely only because it more obviously reveals the missing leg of Christ. Otherwise—except for the leg—it's a very satisfying view of an also beautifully composed sculptural group.

The inclusion of the *Magdalene*, her pose, her diminutive size, and the overall relation to the rest of the group are Michelangelo's own decisions, and therefore they deserve our more thoughtful consideration. So why include her? Condivi evidently was cognizant of some novelty when he introduced his laudatory description of the sculpture, by writing that Michelangelo was "a man so full of ideas, he gave birth to something new every day."

The inclusion of Mary Magdalene is itself significant. While she is commonly represented in scenes of the deposition, she is less frequently part of a *pietà*, especially in sculpture, and in neither case is she essential to the iconography of the subject. She may be an unexpected inclusion, but Michelangelo has elected to include her. She appears at a time when Michelangelo was writing deeply affecting penitential poetry, and just like the Magdalene, was acutely conscious of his sins even while yearning for union with Christ. So let us try and see the Mary Magdalene in a positive light.

The Magdalene kneels on the left side of the group, which is the privileged right hand of her lord and savior. She helps to sustain the dead body. Christ's right arm and hand fall across her shoulder and his fingers lightly touch her back. The *Magdalene* is the only face turned to us; she addresses the spectator and presents the body of Christ. Condivi is even more specific in describing her as "performing the office of the dead." And indeed, we see her holding the winding sheet within which Christ's body will be wrapped for burial, and she's helping to lower that body. While the *Magdalene* does not literally perform the office of the dead, she does suggest a narrative and a liturgical dimension to the scene that unfolds before us.

She is a young, even nubile girl, whose small breasts are pressed extremely close to Christ's naked flesh but any actual contact is averted by a thick fold of drapery and the chaste inclination of her upper torso—away from Christ. As in his earlier painting of the *Noli me Tangere*, Michelangelo has heightened the tension instigated by the physical proximity of Christ and the Magdalene, and thereby discovers a means of suggesting both her former life as a sinner and a prostitute, and her new life as a devoted follower of Christ.

Her unseen left hand embraces Nicodemus to whom she is a counterpart, suggested even in the counterpoised juxtapositions of their heads—tilted in opposite directions. Like Michelangelo

himself, the *Magdalene* and *Nicodemus* are penitent figures who yearn for salvation through Christ. Thus, the linked figures of Nicodemus and the *Magdalene* lend a special poignancy to a sculpture that Michelangelo intended to mark his own grave. They have gained proximity to their lord through their faith and intense personal devotion. Michelangelo, too, wished to gain such a proximity.

The *Magdalene*'s diminutive size is more apparent than real, for she grows and diminishes in stature and importance depending on the angle from which the sculpture is viewed, as I said. She's physically and iconographically a marginal figure, in a comparable relationship to the group as the allegories of time are to the dukes in the Medici Chapel or the *Rachel* and *Leah* are to the *Moses* on the monument of Julius II. The scale of these latter figures, especially in relation to the *Moses*, inspires frequent and often negative comment.

As we noted in our previous lecture, Michelangelo could have created *Rachel* and *Leah* on any scale; he certainly had plenty of marble available to him. The modesty of their size was purposeful. Michelangelo has observed what I call a decorum of size and finish. Thus, the *Rachel* and *Leah* do not compete with the *Moses*; rather, like a chorus, they are foil and counterpoint. So too in the *Florentine Pietà*. The Magdalene helps to frame Christ. She serves to attract and direct our attention, and she leads us in prayer and contemplation. She is a mere whisper in a hushed communion with the dead.

It is likely that Michelangelo's trusted assistant, Tiberio Calcagni, perceived the beauty of the *Magdalene* and wished to fulfill its promise by completing it. Thus, she is more finished than the other figures, and thus less appealing to the modern viewer. Do you note now how we've become so conditioned to Michelangelo's *non-finito* that we've begun to prefer it? And so when we have a finished figure, we find it unappealing. At the same time, however, Calcagni modestly abstained from intervening on any of the other obviously incomplete figures of *Christ* or *Mary*, and the still rough-chiseled *Nicodemus*. Rather, he repaired the group as best he could, and he may have done much less than is often supposed.

There is nearly unanimous agreement that the hooded figure behind Christ is a self-portrait of the aging artist, probably in the guise of Nicodemus, who came to Christ in the eleventh hour. Michelangelo

now believed that he too had reached the eleventh hour of his life; moreover, there was a long tradition from the Middle Ages that Nicodemus was a sculptor, yet another reason for Michelangelo to identify with him.

Michelangelo's hooded figure, and the unpolished features of the face, suggest the veil of night under which Nicodemus revealed his faith. Once again, Michelangelo has employed the fall of natural light and the *non-finito* for very expressive ends. In these features, Michelangelo has carved his autobiography. Like Nicodemus, who revealed himself in the hour of Christ's need, Michelangelo here declares himself devoted to his savior. The sculpture is an eloquent expression of faith. He intended it to mark his grave; but here lay a dilemma.

Vasari, who evidently did not understand why Michelangelo never completed the sculpture, fabricated a tale of how the artist, frustrated with the quality of the stone and irritated by the persistent nagging of his servant, took a hammer to the work. Scholars too have speculated at length on the reasons why Michelangelo damaged and then abandoned a work of such obvious personal importance. But perhaps that's the very issue. To carve one's own tomb memorial is to confront, in inescapable fashion, one's own mortality. To finish the sculpture was to bring the marble to life and to resign oneself to death.

Michelangelo expressed this paradox in poetry: "...with false conceptions and great peril to my soul, to be here sculpting divine things." Both the sculpture and the contemporaneous, deeply felt autobiographical poem, reveal Michelangelo's acute consciousness of the transitoriness of life and the futility of art. Indeed, art had become, at this point in his life, a "great peril" to his soul. It is, after all, the ultimate paradox. How does one make something divine from something material? How does one carve the spiritual in stone? Therefore, for any number of technical and psychological reasons, the sculpture was destined to remain unfinished. Ultimately, he gave the *Pietà* to his friend, Francesco Bandini, and permitted his assistant, Tiberio Calcagni, to repair it.

Michelangelo did not destroy nor did Calcagni ruin what was the master's most ambitious and difficult essay in marble. Despite damage and its troubled history, the sculpture remains a moving and satisfying work of art. At once a *pietà* and a deposition, a grave

memorial and a narrative icon, a real and a spiritual portrait, the sculpture brings together several themes in Michelangelo's art and life.

What is significantly different is the presence of Nicodemus and the Magdalene, figures at the periphery of Christ's life and of Michelangelo's marble group. But to those figures fall the responsibility of sustaining and presenting Christ's body and of speaking to us, through glance and gesture and by means of their more articulated, portrait-like characters. In these figures we see ourselves, the sinner and the secret follower of Christ, and through their intercession we gain access to our Lord and a means to salvation. They are the bearers of Christ, and of his promise of eternal life.

In carving the theme once again in the *Rondanini Pietà*—the subject of our next lecture— Michelangelo eliminated these accessory persons. Salvation, he seems to have realized, was to be achieved mainly through personal devotion to Christ.

In the *Florentine Pietà*, Michelangelo's youthful hubris as a marble carver came to an end. He continued to carve but failed to complete any other sculptures. Already, for more than 20 years, he had not signed himself "Michelangelo *scultore*." Rather the artist turned to drawing, prayer, and poetry, some of which shares many affinities with this poignant work—deeply meditated, much reworked, and often unfinished. In the midst of carving the *Pietà*, Michelangelo mused in an incomplete sonnet. He wrote:

> The soul gains more, the more it loses the world
> And art and life do not go well together;
> In which, then, should I place my further hope?

In the end, Michelangelo placed his hope in his devoted assistant and close friends and they ensured that the *Pietà* survived, if not as the artist's proper funerary monument, then at least as an eloquent cenotaph and artistic masterpiece.

Lecture Thirty-Five
The *Rondanini Pietà* and the Late Poetry

Scope:

This lecture considers some of Michelangelo's final works in sculpture and drawing, among the most profoundly spiritual and deeply moving works of Christian art ever made. First, we'll consider the *Rondanini Pietà*, which Michelangelo worked on for a number of years and up to just a few days before his death. We'll then introduce a series of drawings of the Crucifixion in which the artist's most personal thoughts and prayers are revealed. With these works, Michelangelo prepared himself for death.

Outline

I. The *Rondanini Pietà*.

 A. In his last years, Michelangelo plumbed the depths of his faith in the private realms of poetry, drawings, and occasional works of sculpture. He now carved only to keep himself busy and spiritually nourished.

 B. Until just a few days before his death, Michelangelo worked on the so-called *Rondanini Pietà*, named for the Roman family palace where it long stood. There is no indication that the sculpture was intended for anyone but the artist himself.

 C. It is difficult to describe the subject of the sculpture. We call it a *Pietà*, but it is radically different from the other two versions of the same subject carved by Michelangelo and unlike anything else he ever made.

 1. In contrast to his earlier masterpiece in Rome, carved more than 60 years previously, the *Rondanini Pietà* appears to be an emaciated fragment—unfinished, unresolved, unpolished. Its incompleteness is in radical contrast to the perfectly finished earlier work.

 2. The earlier pyramid of solid forms and idealized beauty has become an unstable vertical of wasted flesh. The first work offers a vision of eternal beauty and salvation through resurrection; the other, a vision of desiccation and loss.

©2007 The Teaching Company.

3. Yet both these sculptures represent the same subject and elicit some of the same responses, albeit through different means. Both are visions of death, and both lead us to contemplate the miracle of life after death.

4. In the earlier *Pietà*, we seem to be seeing Christ as we will after the Resurrection—as a perfect human body. In the *Rondanini Pietà*, we are reminded of the sacrifice that *precedes* the Resurrection—the suffering that led to Christ's eventual triumph.

5. In these two sculptures, we witness a genius meditating on the same theme at either end of his long life. We can almost see them as visual autobiographies—the first, proudly signed and full of self-confidence; the latter, a wasting away, a preparation for the grave.

6. Even the nearly contemporaneous *Florentine Pietà* is a markedly different conception of the same subject. The composition of this sculpture is a tightly knit pyramid of substantial bodies that contrasts with the flame-like ethereality of the *Rondanini*.

7. As he did so often in his life, whether in sculpture or in architecture, Michelangelo has pared down the subject to its essentials—a mother inadequately supporting the lifeless body of her dead son. All extraneous figures have been expunged.

II. The thought behind the *Rondanini*.

A. As we see in a drawing, Michelangelo first conceived this work as a deposition. The two groups toward the center of the sheet, carrying Christ to the tomb, were the first drawn.

B. Three subsequent drawings, however, two on the left and one on the extreme right, explore the idea of a two-figure composition—less narrative and more sculptural in conception.

C. In these latter drawings, especially in the tightly entwined two-figure composition at the extreme left, we see the body of Christ slumped in the straining arms of the Virgin Mary. These recall something of the relationship between Christ and Nicodemus in the *Florentine Pietà*.

III. A close look at the sculpture.

 A. Mary stands on a rock and embraces but scarcely supports the dead weight of her child. Defying logic and gravity, Michelangelo's figures are suspended in an impossible composition and a timeless moment.

 1. The semi-standing pose and unfinished character of Christ lend him greater animation than might be expected of a dead body.

 2. Christ's head turns and at least one eye appears to gaze toward his mother's hand resting on his shoulder. Their bodies fuse into one; they who once were of one flesh become so again.

 B. If we look at the sculpture less poetically and, perhaps, with less forgiveness, we see an artist with too little stone remaining to give each figure full definition.

 1. The evidence of multiple changes is most obvious in the detached stalk of Christ's right arm. This fragment is a remnant of an earlier composition, attesting to a larger and more muscular body.

 2. Curiously, as though it was now invisible to the artist, Michelangelo never bothered to remove the fragment.

 3. Without the evidence of that truncated arm, we would scarcely imagine that Michelangelo had made so many radical changes while carving. Rather than an anomaly, perhaps we should accept this as incontrovertible evidence of the artist's standard working procedure.

 C. A side view of the sculpture reveals the extent of Michelangelo's relentless excavation of the block. The abstracted forms suggest a tongue of flame or one of the bird sculptures by Constantin Brancusi. Such rising, flame-like shapes represent the slimmest hope for Christ's Resurrection.

 D. Michelangelo was always carving, and he rarely finished— forever confronting the unavoidable paradox of representing spiritual things in material form.

 1. As he carved, he created a real human body, but every subsequent blow of his hammer contributed to Christ's torment. In anguish, the artist lamented in a poem: "My wicked ways, the allure of vanity/amid the shadows of

the life I live,/O help me counter these, help and forgive!"

2. In the *Rondanini Pietà*, Michelangelo has carved a miracle, transforming stone first into flesh, then into spirit. Sculpture, the most physical of the arts, is made to express the ineffable. Through Michelangelo's art, we gain access to the central mystery of Christ's sacrifice.

3. Yet the supremely gifted artist felt a profound sense of futility. His poetry is sometimes as fragmentary as his sculpture: "No one," he once lamented, "has full mastery before reaching the end of his art and his life."

IV. Crucifixion drawings.

A. We find eloquent counterparts to the *Rondanini Pietà* in some black chalk drawings that Michelangelo made of the Crucifixion. In one example, we note a similar sense of desiccation in both the sculpture and the drawing.

B. In drawing and poetry, the artist distilled matters of his faith. In the Crucifixion drawings, he approached Christ through the marks of chalk on paper.

C. In one drawing, for example, John appears ghost-like, walking toward us, hunched over and with a fearful demeanor.

1. On the other side of the cross, Mary extends her right arm in a gesture that presents her son and expresses her grief. At the same time, her arms are folded across her chest, a private clutching at sorrow.

2. In this double set of limbs, as in the repeated shivering contours of the figures, we see not anatomical freaks but figures in motion, successive moments in a tragic drama. We're scarcely bothered by the fact that Mary has three arms because they represent grief in its various manifestations.

3. Michelangelo has passed beyond naturalism to create a transcendent image, a visual equivalent of the equally non-naturalistic form of his religious poetry. In a poetic equivalent to these haunting drawings, Michelangelo appeals to Christ: "O Lord, in my last hours,/stretch toward me your merciful arms,/take me from myself and make me one who'll please you."

D. Again and again, Michelangelo drew the same subject, as if yearning to grasp the miracle and meaning of Christ's sacrifice.

 1. In another example, Mary and John huddle close to the cross as though seeking the last bit of warmth in the dying flesh of their savior.

 2. Christ hangs limply, his face obscured by the shadow of death. His drooping head and matted hair suggest his expiration, yet in his last living moment, he commends his mother to John's care.

 3. Like Michelangelo, John and Mary are hoping that Christ still lives, and they wish to share the burden of his suffering by their proximity.

 4. In drawing a figure touching Christ, Michelangelo himself is touching Christ. This is how art can be belief and how a man's profound faith is manifested in art.

E. Into these precious and deeply personal drawings, Michelangelo poured some of his last creative energies. At times, the poet and the artist were one and divine, because like God, Michelangelo had created life from inert materials. But as a man, he would never be perfect, and he would leave much incomplete, including these remarkably eloquent images.

F. These drawings permitted Michelangelo to approach, even identify with, Christ. In the repeated contours, we're witness to the artist's hand creating and caressing his Lord.

V. Late religious poetry.

A. In our admiration for Michelangelo's many great works, we sometimes forget his importance as a poet. Even though the project to publish his poetry fell through, many of his poems gained wide circulation in his lifetime. As early as the 1530s, some of Michelangelo's madrigals were set to music, and some are still occasionally performed.

B. A sonnet that begins with the famous line "*Non ha l'ottimo artista alcun concetto*" is one of Michelangelo's best known poems, partly because the opening quatrain suggests a theory of artistic creation. In English, the line reads: "There is nothing within a block of marble that cannot be realized by the superior artist, provided his hand obeys his intellect."

The poem must have been written in a rare moment of confidence.

C. In the history of art, William Blake is probably the only other artist equally accomplished in poetry and in art. And Blake, like Michelangelo, has been similarly subdivided by later scholars.

D. Michelangelo's great nephew was responsible for publishing the first edition of the artist's poetry.

 1. To preserve Michelangelo's reputation, the gender of many persons addressed in these poems was changed, especially the love poems written for Tommaso de' Cavalieri.

 2. John Addington Symonds, the great Victorian biographer of Michelangelo, deserves the credit for recognizing and celebrating the true character of Michelangelo's poetry, both in terms of the gender referents and its profound personal content.

E. Michelangelo's poetry constitutes a significant body of literary work, perhaps less well known than his great works of sculpture, painting, and architecture but no less important for a full understanding of his genius.

 1. In his final years, Michelangelo carved very little, but he wrote reams of poetry. No amount of creativity, however, whether in poetic or sculptural form, could stave off the inevitable.

 2. "Death," Michelangelo wrote, "has robbed me of the thoughts of my youth." Death was an ever-present companion in the artist's old age.

Works Discussed:

Michelangelo:

Rondanini Pietà, 1556–64, marble, 6' 3⅝" (1.92 m), Castello Sforzesco, Milan, Italy.

Studies for a Pieta and an Entombment, black chalk on off-white paper, 7 × 11" (18 × 28.1 cm), The Ashmolean Museum of Art and Archaeology, Oxford, Great Britain.

Crucifixion, chalk, 16 × 8½" (40.5 × 21.8 cm), The Royal Collection, London, Great Britain.

Crucifixion, 1562–64, chalk and wash heightened with white, 17 × 11½" (43.2 × 28.9 cm), Musée du Louvre, Paris, France.

Crucifixion, 1550–60, British Museum, London, Great Britain.

Crucifixion, chalk, 15 x 8 ¼" (38.2 x 21 cm), The Royal Collection, London, Great Britain.

Crucifixion, black chalk with lead white, 16¼ × 11" (41.2 × 27.9 cm), British Museum, London, Great Britain.

Suggested Reading:

H. Hibbard, *Michelangelo*.

C. de Tolnay, *Michelangelo: The Final Period*.

W. E. Wallace, *Michelangelo: The Complete Sculpture, Painting, Architecture*.

Michelangelo Buonarroti, *Complete Poems and Selected Letters of Michelangelo*, C. Gilbert, trans.

Michelangelo Buonarroti, *The Poetry of Michelangelo: An Annotated Translation*, J. M. Saslow, ed.

Michelangelo Buonarroti, *The Complete Poems of Michelangelo*, J. F. Nims, trans.

Michelangelo Buonarroti, *The Complete Poetry of Michelangelo*, S. Alexander, trans.

W. E. Wallace, ed., *Michelangelo: Selected Readings*. See P. Joannides, "'Primitivism' in the Late Drawings of Michelangelo: The Master's Construction of an Old-age Style."

R. Wittkower and M. Wittkower, *The Divine Michelangelo: The Florentine Academy's Homage on His Death in 1564*.

Questions to Consider:

1. How do Michelangelo's sculptures and drawings relate to his poetry?

2. How do Michelangelo's various representations of the *Pietà* and the Crucifixion correspond to the various stages of the artist's life?

Lecture Thirty-Five—Transcript
The *Rondanini Pietà* and the Late Poetry

This lecture considers some of Michelangelo's final works in sculpture and drawing, among the most profoundly spiritual and deeply moving works of Christian art ever made. First, we'll consider the *Rondanini Pietà*, which Michelangelo worked on for a number of years and up to just a few days before his death. We'll then introduce a series of drawings of the Crucifixion in which Michelangelo's most personal thoughts and prayers are revealed in the private medium of drawing. With these works, the artist prepared himself for death.

While continuing his work as an architect in the public sphere, Michelangelo simultaneously plumbed the depths of his faith in the more private realms of poetry, drawings, and occasional works of sculpture. Quite remarkably, for an artist who previously had signed himself "Michelangelo *scultore*," in the last 30 years of his life, Michelangelo completed just three sculptures—the *Rachel* and *Leah* for the tomb of Julius II, and the bust of *Brutus*.

The *Florentine Pietà* discussed in our last lecture was destined for his own grave but it was broken and given away. And the *Rondanini Pietà* was begun for no ostensible reason, except to keep himself busy and spiritually nourished. Neither of these *pietàs* was ever finished, and maybe they never could be finished. Nonetheless, it seems that Michelangelo found peace and refuge in work. As a public artist, he hoped that his devotion to St. Peter's would ensure the salvation of his soul. In private, he continued to carve marble, to draw, and to write poetry, much less certain that he would be saved, given that he increasingly viewed his life as wasted and full of sin.

Until just a few days before his death, Michelangelo worked on this sculpture, the so-called *Rondanini Pietà*, named for the Roman family palace where it long stood. It's now located in the Castello Sforzesco in Milan. There is no indication that the sculpture was intended for anyone but the artist himself. He carved to maintain his healthy vigor into extreme old age, and in the hopes for a remission from his sins. Carving was a counterpart to Michelangelo's late religious poetry, most of which he wrote as a form of private devotion and consolation. I'd like to give you an example:

My dear Lord, you who alone can clothe and strip our souls, and with your blood purify and heal them of their countless sins and human impulses. …

And there it breaks off, as incomplete as many of his works of art. It seems that both poetry and carving were forms of prayer, a way of bringing himself closer to God—salvation through creation.

It's difficult to describe the exact subject of this sculpture. We call it a *pietà* but it is radically different from the other versions of the same subject made by Michelangelo, and unlike anything else he ever made. In contrast to his earlier masterpiece in Rome, carved more than 60 years previously, the *Rondanini Pietà* appears to be an emaciated fragment—unfinished, unresolved, unpolished. Its incompleteness is in radical contrast to the perfectly finished earlier work.

That earlier pyramid of solid forms and idealized beauty has become, instead, an unstable vertical of wasted flesh. The one offers a vision of eternal beauty and salvation through resurrection; the other, at least ostensibly, a vision of desiccation and loss. Before the first, we stare in awe and admiration; before the *Rondanini*, we are encouraged to weep.

Yet, perhaps these sculptures are not so different as they seem at first sight. After all, they do represent the same subject and thus they elicit some of the same responses, albeit through very different means. Both are visions of death, and both lead us to contemplate the miracle of life after death. In the earlier *Pietà*, it is as if we already were seeing Christ as we will after the Resurrection—as a perfect human body. In the *Rondanini Pietà* we are rather reminded of the sacrifice that *precedes* the Resurrection—the suffering that led to Christ's eventual triumph.

In these two sculptures, we are privileged witnesses of a genius meditating on the same theme over the course of his entire long life. Indeed, these two sculptures, separated by more than 60 years—60 years of triumphs and numerous travails—are bookends to a long and creative life. We can almost see them as two visual autobiographies—the first, proudly signed and full of self-confidence; the latter, a wasting away, a preparation for the grave.

Even the nearly contemporaneous *Florentine Pietà* is a markedly different conception of the same subject. In the *Florentine Pietà*, the

©2007 The Teaching Company.

figures have a weight and a solidity. The composition is a tightly-knit pyramid of substantial bodies that contrasts markedly with the flame-like ethereality of the *Rondanini*.

As so often in his life, whether in sculpture or in architecture, Michelangelo has pared down the subject to its essentials—a mother inadequately supporting the lifeless body of her dead son. All extraneous figures have been expunged. We're confronted by an uncompromising portrayal of loss.

Now we can witness something of Michelangelo's process in this moving drawing in the Ashmolean Museum. Michelangelo began this drawing thinking of a deposition. The first two groups drawn were the two towards the center of the sheet where the figures carry Christ to the tomb. They suggest the narrative action of a deposition. Three subsequent drawings, however, two on the left and one on the extreme right, explore the idea of just a two-figure composition—less narrative and more sculptural in conception.

In these latter drawings, and especially in the tightly entwined two-figure composition at the extreme left, we see the lifeless body of Christ slumping in the straining arms of the Virgin Mary. These recall something of the relationship between Christ and Nicodemus in the *Florentine Pietà*, which, of course, was still in Michelangelo's possession and obviously still very much on his mind.

So from the beginning of this sheet, a three-figured deposition grows gradually to a two-figure abstraction on this single sheet of paper, within the space of perhaps 15 minutes of drawing.

Let us look more carefully at the sculptural counterpart to those drawn experiments. Mary stands on a rock and embraces but scarcely supports the dead weight of her child. Defying logic and gravity, Michelangelo's figures are suspended in an impossible composition and a timeless moment. The semistanding pose and unfinished character of Christ lends him greater animation than might be expected of a dead, slumping body. Note that Christ's head turns and his eye appears to gaze towards his mother's hand, which rests on his shoulder. It's a tender intimacy between the two figures. Their bodies fuse into one. They who were once of one flesh, are of one flesh again—the beginning and the end of life coming full circle.

Now if we look at the sculpture less poetically and perhaps less forgivingly, then one sees an artist with too little stone remaining to give each figure full definition. Michelangelo carved and recarved, removing one idea after another as he cut deeply into the tall, thin block. The evidence of multiple changes is most obvious in the detached stalk of Christ's right arm. This haunting fragment is a ghostly remnant of a much earlier composition, attesting a one-time much larger and more muscular body.

Recall the rule—marble carving is the process of "taking away." To change one part requires changes throughout. There have been some very serious changes between the first carving of Christ's right arm and now. In a sense, we're privy to the entire process of the artist seeking a solution and perhaps never finding it and, meanwhile, the marble is wasting away.

Now, curiously, as though it was now invisible to the artist, Michelangelo never bothered to remove that earlier, more muscular arm. It actually reminds me of some prehistoric cave painter who sees only the image that they are currently painting. All previous representations were no longer living, no longer relevant, and therefore no longer seen.

Without the evidence of that truncated arm, we would scarcely imagine that Michelangelo had made so many and such radical changes while carving. It is a moving testimony of the artist's relentless search, and relentless assault upon the block. We should accept this as incontrovertible evidence of Michelangelo's usual working procedure, how much marble he did tend to use.

Now a side view of the sculpture reveals the extent of how deeply Michelangelo has excavated into the block of marble. The abstracted forms suggest a curling tongue of flame, or one of the wingless bird sculptures of Constantin Brancusi about to take flight, or at least some kind of abstract work of art. But in thinking of the sculpture in these terms—as living, flame-like, or rising—we also implicitly acknowledge a fundamental character of Michelangelo's invention. Even though ostensibly representing death, Michelangelo also suggests that Christ is alive, or will live again, and therein lies the slimmest hope for his resurrection.

We're attuned and appreciative of the sculpture's radical abstraction, but the artist, he surely saw only the son of man, imagined his love

for his Lord and the painful loss of the mother. Michelangelo was always carving, and he rarely finished, forever confronting that unavoidable paradox of representing spiritual things in material form. As Michelangelo carved he created a real human body, but then every subsequent blow of the hammer and the chisel contributed to Christ's torment and to his eventual death. The lacerated surface of this marble was a perpetual, painful reminder of the mortification of Christ's flesh for which Michelangelo the artist/sculptor was responsible. In anguish, Michelangelo lamented in a poem, "My wicked ways, the allure of vanity amid the shadows of the life I live, O help me counter these, help and forgive!" The poetry is as anguished as the sculpture.

In the *Rondanini Pietà*, Michelangelo has carved a miracle, transforming stone first into flesh and then into spirit. Sculpture, the most physical of all the arts, is made to express the ineffable. Thanks to Michelangelo's art, we gain access to the central mystery of Christ's sacrifice. Yet the supremely gifted artist felt a profound sense of futility, perhaps even guilt, in carving. His poetry is oftentimes as fragmentary as his sculpture. "No one," he once lamented, "has full mastery before reaching the end of his art and the end of his life." Michelangelo, the supremely gifted artist, acknowledges that mastery only comes in old age, and then is necessarily accompanied by futility and death.

We find eloquent counterparts to the *Rondanini Pietà* in some black chalk drawings that Michelangelo made of the Crucifixion. I'm showing you one as an example here. There is a similar sense of desiccation, a wasting away of the flesh, a vision of death in the material form of stone or chalk. In both, Michelangelo was attempting to evoke spiritual thoughts through material means.

In drawing and poetry, Michelangelo distilled matters of his faith. In this series of extraordinarily moving and intensely personal drawings of the Crucifixion, Michelangelo approached Christ through the caressing marks of chalk on paper. He drew and drew, in physical contact with his Lord. We're scarcely bothered by the indistinct forms, the faceless figures, for we feel more than we see in these evocations of pain, sorrow, and ultimate loss.

John appears ghost-like, walking towards us, hunched over and with a fearful demeanor. On the other side of the cross Mary extends her

right arm in a gesture that presents her son and expresses her extreme grief. At the same time her arms are folded across her chest, a private clutching at sorrow. In this double set of limbs, as in the repeated shivering contours of the figures, we see not anatomical freaks but figures in motion, successive moments in a tragic drama.

I think we're scarcely bothered by the fact that Mary has three arms—first spread and then crossed protectively across her chest—for they represent grief in its various manifestations. Michelangelo has passed beyond naturalism to create a transcendent image, a visual equivalent of the equally non-naturalistic form of his religious poetry. In a poetic equivalent to these haunting drawings, Michelangelo appeals to Christ, "O Lord, in my last hours, stretch toward me your merciful arms, take me from myself and make me one who'll please you."

Michelangelo's poetry eloquently describes his own drawings. At times, poetry and drawing must have been made together. One imagines Michelangelo hearing poetry as he drew; and conversely, he must have envisioned these haunting images as he put words to paper. As we have repeatedly seen in this course, Michelangelo moved easily between poetry, drawing, and sculpture. Each is simply a different form of shaping, the fashioning of art from raw materials, whether they're words or chalk or stone.

Again and again he drew the same subject, as if yearning to grasp the miracle and the meaning of Christ's sacrifice. In imitation of his Lord, Michelangelo identifies with him by feeling the pain of his suffering. Every mark on the paper exists in a liminal moment between creating living flesh and evoking the pain of death, the translation of material matter into spirit.

Mary and John huddle close to the cross as though seeking the last bit of warmth in the dying flesh of their savior. Christ hangs limply, his face obscured by the shadow of death. His drooping head and straggling, matted hair suggest his expiration, yet in his last living moment he commends his mother to John's care. Like Michelangelo, John and Mary are hoping that Christ still lives. They wish to somehow share the burden of his suffering by their proximity. In drawing a figure touching Christ, Michelangelo is touching Christ. This is how art can be belief and how a man's profound faith is manifested in art.

But recall the size of these objects. They are monumental in significance and suggestion, yet they are mere sheets of fragile, handmade paper, scarcely 16 inches high, and made for no other eyes than the artist's own. In these precious and deeply personal objects, Michelangelo poured some of his last creative energies. At times the poet and the artist were one, and divine, because like God, Michelangelo has created life from inert materials. But as a man, he would never be perfect, and he would leave so much incomplete, including these remarkably eloquent images.

These drawings permitted Michelangelo to approach, even identify with Christ. In the repeated contours we're witness to the artist's hand actually creating and caressing his Lord. In a perfect fusion of art and life, before these images, the viewer is moved to prayer and to poetry, thus lending voice to their mute pain. I can personally attest to this, for when I first held these drawings in my hands in the privacy and the hushed atmosphere of the drawing rooms of the Louvre, and the British Museum, and Windsor Castle, I was moved to compose poetry in Italian, and I am no poet, especially not in a foreign language. And I will spare you my poetry.

Rather, like most other commentators, I assume that Michelangelo's late religious poetry serves as the perfect complement to these drawings. For example:

> Let not your holy eyes in judgment gaze
> at my past. Heedless be your chaste ear,
> Nor point out my transgressions with your arm severe.
> Let your blood alone wash and glaze
> and touch my faults. Let full pardon enfold
> me, abounding all the more, the more I grow old.

The poems eloquently evoke the drawings and vice versa.

In the last 15 years of his life, Michelangelo carved just these two *pietàs*. They were his tomb, testament, and epitaph, his means of dying well. Death was central to his thoughts, his waning life, and his meditative poetry. These are eloquent and profoundly moving sculptures, although both, we must acknowledge, are radically incomplete. For whom is Michelangelo, the highly successful artist, making art?

In our admiration for Michelangelo's many great works, we sometimes forget or underestimate his importance as a poet. Even though the project to publish his poetry fell through, many of his poems gained wide circulation in Michelangelo's own lifetime. As early as the 1530s, some of Michelangelo's madrigals were set to music, one by the Master of the Sistine Choir, Costanza Festa, and the other by Jean Conseil, a French member of the same choir.

The much-respected Franco-Flemish composer, Jacques Arcadelt, set two of Michelangelo's madrigals to music, which were published in 1543, and are still occasionally performed. A few years later, the Florentine humanist, Benedetto Varchi, selected one of Michelangelo's sonnets as the principal text for a learned discourse delivered before the members of the Florentine Academy. The sonnet, which begins with the very famous line, "*Non ha l'ottimo artista alcun concetto*" is one of Michelangelo's best known poems, thanks in part to Varchi's published commentary, but also because the opening quatrain suggests a theory of artistic creation. In English, it goes something like this: "There is nothing within a block of marble that cannot be realized by the superior artist, provided his hand obeys his intellect."

Now, Michelangelo's poem was written in a moment of rare confidence, the artist believing that for superior artists, the hand would obey the intellect. Unfortunately, this was not always the case, and as we have repeatedly seen in this course, Michelangelo sometimes very rarely enjoyed the hand perfectly obeying the intellect. In many poems Michelangelo reveals that, in fact, he had much more trouble and he had great difficulty in realizing in material form what resides in his intellect and spirit.

Now in the history of art, William Blake is probably the only other artist as accomplished in poetry as in art, like Michelangelo. And Blake, like Michelangelo, has been similarly subdivided. Art historians have shown greatest interest in the art; literary scholars, ultimately interested in the poetry; and very rarely does any one scholar encompass both and show equal interest and give equal weight in accordance to both the poetry and the art.

In this, and especially in the last few lectures, I have tried to give you a flavor of Michelangelo's poetry, but it's hard to do it justice—like his humor and much of his literary output, which, I hope, you now realize is considerable.

Michelangelo's great nephew was responsible for publishing the first edition of Michelangelo's poetry. But he was concerned, and to preserve Michelangelo's reputation, he changed the gender of many persons addressed in these poems, especially the love poems written for Tommaso de' Cavalieri. Thus poems that were directed to a young man appeared now, in published form, as if they were directed to an unknown female recipient.

It was John Addington Symonds, the great Victorian biographer of Michelangelo, who deserves the credit for first recognizing and celebrating the true character of Michelangelo's poetry, both in terms of the gender referents and also its profound personal content.

Michelangelo's poetry constitutes a significant body of literary work, perhaps less well known than his great works of sculpture, painting, and architecture, but no less important for a full understanding of his genius. In his final decades, Michelangelo carved very little, but he wrote reams and reams of poetry. But no amount of creativity, whether in poetic or sculptural form, could stave off the inevitable, and the increasingly prevalent reflections on death. "Death," he wrote, "has robbed me of the thoughts of my youth." Death was ever present, an ever present companion into Michelangelo's old age, and as you now know, his old age was extended for many, many years.

Lecture Thirty-Six
Death of Michelangelo—The Master's Legacy

Scope:

In this lecture, we relate the final weeks of the artist's life—vividly captured in his extant correspondence. The removal of his body to Florence was inspiration to construct an elaborate tomb in his honor in the Pantheon of Florence, Santa Croce, where he shares space with such luminaries as Niccolò Machiavelli, the statesman Leonardo Bruni, the composer Gioacchino Rossini, and the great scientist, Galileo Galilei, who was purposefully buried directly opposite Michelangelo. We will then consider Michelangelo's immediate and more long-lasting legacy: from the founding of the Florentine Academy to the celebration of the artist by Sir Joshua Reynolds in his *Discourses*, delivered before the members of the Royal Academy in London.

Outline

I. The final decades.

 A. The 1540s had appeared to be a decade of great promise for Michelangelo. The Julius tomb was finally brought to completion. The artist was working for an enlightened patron, Pope Paul III. He had a circle of friends and money to invest in land and business ventures.

 1. Michelangelo was a flourishing poet, was lauded by contemporaries, and was about to go to press with a selection of his poems. He enjoyed the patronage of princes, the protection of the pontiff, and the attentions of the rich and the powerful.

 2. He had many reasons to be content, but before the end of this decade, events conspired to spoil these happy circumstances.

 B. By the 1550s, death had claimed many of Michelangelo's close friends, as well as his great patron Pope Paul III and King Francis I, a potential patron and the artist's final hope for the liberation of Florence. In 1555, the last of Michelangelo's four brothers died, prompting the

melancholic reflection that his family would die out.

C. Now in his 80s, Michelangelo suffered from kidney stones. He lamented that he was "groaning day and night, unable to sleep or to get any rest whatsoever." He was grateful to be in the care of a good doctor, but he added, not surprisingly, "I believe more in prayers than in medicine." His ailment even prompted some facetious verses about bodily functions.

D. The maladies of old age and thoughts of death were Michelangelo's constant companions in the final two decades of his life. He wrote frequently of his age in his last 20 years, and he lived in expectation of death; the inexorable creep of age was his constant companion. "No thought is born which does not have death within it," he wrote.

II. Last years.

A. Michelangelo was still active, often going to oversee work at St. Peter's. But by 1560, the artist's age—then 85—made daily attendance increasingly difficult. Moreover, he was now responsible for multiple building sites scattered across Rome, including the Campidoglio, Santa Maria degli Angeli, Porta Pia, and St. Peter's.

B. On the days he rode to St. Peter's, Michelangelo could have seen his early sculpture of the *Pietà*, a masterpiece finished more than a half century previously. The youthful work, with its boastful signature across the chest of Mary, may have been a source of justifiable pride, but just as likely it helped stimulate the melancholic thoughts that permeate his poetry: "The soul means more, the more the world means less." Michelangelo was clearly withdrawing.

C. Months before he died, Michelangelo wrote a letter to his nephew Leonardo, thanking him for sending the 12 "most excellent and delicious cheeses," which the faithful Leonardo continued to send every year, along with flasks of Trebbiano wine, and batches of new linen shirts. The artist had once shared the cheeses and wine with the pope, especially Pope Paul III, but all his friends were now dead.

D. Michelangelo continued carving on the *Rondanini Pietà*. At the same time, he was carving the small wood crucifix we see here. It's less than 11 inches high, probably meant as a

gift for Leonardo. It is far more monumental and moving than its diminutive size and incomplete state would suggest

E. On Saturday, February 12, 1564, Michelangelo worked all day on his feet, carving on the *Rondanini Pietà*. He was just three weeks shy of turning 89. Suddenly he was struck by fever and visibly began to fail. Just two days later, Michelangelo's friend and assistant, Tiberio Calcagni, wrote to Leonardo of the artist's illness.

F. The world watched as Michelangelo approached death. Fully conscious of his hero's place in history, Giorgio Vasari wrote to Duke Cosimo de' Medici in 1560, "the ancients are surpassed by the beauty and grace of what his divine genius has been able to achieve." In the Renaissance, there could be no higher praise.

G. In February 1564, Calcagni wrote to advise Michelangelo's nephew, Leonardo, to hurry to Rome. Michelangelo died on February 18, 1564, in the early evening. That same year—1564—William Shakespeare and the great scientist Galileo Galilei were born.

III. Aftermath.

A. As a gift for Michelangelo's nephew, Daniele da Volterra cast a portrait of the artist in bronze. We see Michelangelo as a well-dressed gentleman, as he wished to be remembered and for which recognition he had labored all his life.

B. On the morning after Michelangelo's death, a judge and notary made an inventory of the artist's house, showing more interest in the furniture than in the artworks. In the workshop at the back of the house, the notary recorded several unfinished works, including the *Rondanini Pietà*, along with a box of drawings and another containing cash.

C. Although Michelangelo died in Rome, his body was immediately stolen and returned to Florence, packed in straw and smuggled along with other goods. In Florence, Duke Cosimo de' Medici authorized an elaborate funeral and helped sponsor the creation of the artist's tomb in Santa Croce by members of the newly founded Artists' Academy (the *Accademia del Disegno*).

D. Vasari's revised edition of his bestselling *Lives of the Artists,*

published in 1568, just four years after the artist's death, brilliantly served to celebrate the entwined heroes—Michelangelo and his Medici benefactors.

IV. Michelangelo's legacy.

 A. Opposite Michelangelo's tomb in Santa Croce is the tomb of the great scientist and astronomer Galileo Galilei.

 1. The location of this tomb was no accident because Galileo claimed to have been born on the same day that Michelangelo died.

 2. In the Renaissance, there was a firm belief that the spirit of genius passed from one generation to the next through such coincidences.

 B. From early in his career Michelangelo insisted on his special status. He believed firmly in his aristocratic origins, and he acted and dressed the part. We see two of the many portraits celebrating Michelangelo not as an artist but as a Florentine patrician.

 1. Michelangelo was no ordinary craftsman; rather, his art was a coveted commodity made for a privileged few.

 2. Michelangelo's relations with his patrons were extensions of social bonds founded on favor, friendship, and family. He was an aristocrat who made art.

 C. Michelangelo's legacy is greater than the sum of his works. More than any of his contemporaries, he significantly raised the stature of the profession, from craftsman to genius, from artisan to gentleman. He demanded respect from his patrons, and he earned tremendous prestige as an artist.

 D. Perhaps one of Michelangelo's greatest legacies was his collaboration with Ascanio Condivi and Giorgio Vasari in fashioning his biography. Through his biographers, the artist left us an enduring legend.

 E. Except during the 17th and early 18th centuries, when Raphael was considered the supreme genius of Renaissance art, Michelangelo's reputation has steadily grown.

 1. Sir Joshua Reynolds, whom we see in a self-portrait, was a great English painter and the first president of the English Royal Academy of Artists.

2. Between 1769 and 1790, in his capacity as president of the academy, Reynolds delivered 15 discourses on art that were intended as instructions and guidelines for young artists to achieve greatness.

3. In the last of these lectures, Reynolds held up Michelangelo as the model for young artists to follow to achieve perfection.

F. Michelangelo's life continues to fascinate us, and his sculpture, painting, and architecture continue to astonish. We cannot help but wonder at the humanity, tenacity, and awe-inspiring accomplishments of such a man. He employed his incomparable gifts and a transcendent genius to create sublime works of art, for the world and for all time.

Works Discussed:

Michelangelo:

Crucifixion, wood, Casa Buonarroti, Florence, Italy.

Rondanini Pietà, 1556–64, marble, 6 ' 3⅝" (1.92 m), Castello Sforzesco, Milan, Italy.

Pietà, 1498–99, marble, 5' 8½" (173.9 cm), Basilica of St. Peter's, Vatican City, Rome.

Daniele da Volterra:

Bust of Michelangelo, c. 1570, bronze, 23¼" (59 cm), Museo Nazionale del Bargello, Florence, Italy

Giorgio Vasari:

Tomb of Michelangelo, 1570, marble and oil on panel, Santa Croce, Florence, Italy.

Giovanni Battista Foggini (and others):

Tomb of Galileo, 1722–27, marble, Santa Croce, Florence, Italy.

Giulio Bonasone:

Bust portrait of Michelangelo facing right set within a cartouche, 1546, engraving, 9⅜ × 7" (23. 8 × 17.6 cm), The British Museum, London, Great Britain.

Jacopino del Conte:

Portrait of Michelangelo, c. 1535, oil on canvas, 34 ¾ × 25¼" (88.3 × 64.1 cm), Casa Buonarotti, Florence, Italy.

Joshua Reynolds:

Self-Portrait with the Bust of Michelangelo, 1780, oil on panel, 50 × 40" (127 × 101.6 cm), Royal Academy of Arts, London, Great Britain.

Suggested Reading:

H. Hibbard, *Michelangelo.*

C. de Tolnay, *Michelangelo: The Final Period.*

W. E. Wallace, *Michelangelo: The Complete Sculpture, Painting, Architecture.*

W. E. Wallace, ed., *Michelangelo: Selected Reading.* See P. Joannides, "'Primitivism' in the Late Drawings of Michelangelo: The Master's Construction of an Old-age Style."

R. Wittkower and M. Wittkower, *The Divine Michelangelo: The Florentine Academy's Homage on His Death in 1564.*

Questions to Consider:

1. Is Michelangelo's current reputation deserved? How much of this reputation was a creation of the artist, of Vasari and Condivi, of subsequent centuries, and of our own penchant to celebrity worship?

2. What is Michelangelo's greatest legacy to the future of humankind?

Lecture Thirty-Six—Transcript
Death of Michelangelo—The Master's Legacy

And so we've arrived at our final lecture. I'd like to just take a minute to review some of the facts of the final decades of Michelangelo's life. The 1540s appeared to be a decade of great promise. The Julius Tomb was finally brought to completion. The artist was working for an enlightened patron, Pope Paul III. He had a tight-knit circle of friends. He had money to invest in land and business ventures, and his nephew, Leonardo, had initiated the search for a suitable bride who would perpetuate the Buonarroti line.

Michelangelo was a flourishing poet, was lauded by contemporaries, and was about to go to press with a selection of his poems. He enjoyed the patronage of princes, the protection of the pontiff, and the attentions of the rich and the powerful. He had succeeded in "raising up" his family, one of his lifelong ambitions. He had many reasons to be content, but before the end of this decade events conspired to spoil these happy circumstances.

The 1550s proved very different. By then death had claimed his close friends Vittoria Colonna, Luigi del Riccio, Sebastiano del Piombo, and Pietro Bembo, as well as Pope Paul III, that great friend and patron, and King Francis I, a potential patron and his final hope for the liberation of Florence.

In 1555 the last of Michelangelo's four brothers died, prompting the melancholic reflection that his family was not destined to survive. Indeed, at this moment it hung by a thread. Only Leonardo, his nephew, was the single male heir. It did finally perpetuate and it continued the family until the mid-19th century, but Michelangelo was very, very concerned about the perpetuation of his family.

The artist was now in his 80s and he's suffering from kidney stones. He was unable to urinate without suffering excruciating pain. Michelangelo lamented that he was "groaning day and night, unable to sleep or to get any rest whatsoever." For more than a year, Michelangelo suffered from kidney stones—what he called "the stone"—which, as he wrote, was "the cruelest thing."

Michelangelo was grateful to be in the care of a good doctor, but he added, not surprisingly, "I believe more in prayers than in medicine." This was probably wise considering the nature of Renaissance

medicine, which employed a frightening array of pills, poultices, confections, and concoctions. One doctor, for example, recommended a most unappealing brew made from anise, mallow root, and a fistful of mallow leaves mixed and boiled in water. Michelangelo was supposed to drink some of this, at a tepid temperature, every hour.

His ailment prompted some facetious verses about bodily functions. I'll read you a selection here: "I myself have gotten to know urine and the little tube it comes out of." He faced his discomfort with humor and characteristic resignation. "I'm putting up with my malady as best as I can and in comparison with other old men I've no cause for complaint, thank God."

The maladies of old age and thoughts of death were Michelangelo's constant companions in the final two decades of his life. He wrote frequently of his age in his last 20 years, mentioning it more than 70 times in 60 extant letters: "I am old and every hour may be my last," he wrote. In 1555 he wrote that he was in the "twenty-fourth hour" of his life, and yet he lived almost another whole decade.

He lived in expectation of death; the inexorable creep of age was his constant companion. "No thought is born which does not have death within it," he wrote. In his poetry, death is even more ubiquitous—first a frequent presence, then an expectation, and finally a longing: "Certain of death, though not yet of its hour, life is short and little of it is left to me."

Michelangelo was still extremely active, going to oversee work at St. Peter's as often as possible. When he was younger, it took him approximately 40 minutes, walking briskly, to get from his house at the Forum of Trajan to St. Peter's, or about half as long if he traveled by horse or mule. But by 1560, the artist's age—then 85—made daily attendance increasingly difficult. Moreover, he was now responsible for multiple building sites scattered all across Rome. The Campidoglio, Santa Maria degli Angeli, Porta Pia, and St. Peter's were all still "works in progress."

On the days he rode to St. Peter's, Michelangelo could have seen his early sculpture of the *Pietà*, a masterpiece finished more than a half century previously. Now how many artists are forced to confront in so obvious a manner their youth and their brash early self-confidence? That youthful work, with its boastful—his only—

signature right across the chest of Mary, may have been a source of justifiable pride as he looked upon it, but just as likely it helped stimulate the melancholic thoughts that permeate his poetry:

> The springtime, fresh and green, can never guess
> how, at life's end, my dearest Lord, we change.
> [We change] our taste, desire, love, longing—years' debris.
> The soul means more, the more the world means less;
> art and impending death don't go together,
> so what are You still expecting, Lord, of me?

"The soul means more, the more the world means less." Michelangelo is clearly withdrawing, or is desirous of withdrawing, from this world. And more, he's withdrawing from his art. "Art and death do not go well together," he wrote. It seems now that Michelangelo prefers death to art.

Just months before he died, Michelangelo wrote a letter to his nephew thanking him for sending the 12 "most excellent and delicious cheeses," which the faithful Leonardo continued to send him every year, along with flasks of Trebbiano wine, and batches of new linen shirts. He used to share the cheeses and the wine with the pope, especially Pope Paul III, but all these friends were now dead. In that same letter, Michelangelo, thanking Leonardo, continued:

> I am delighted at your well-being; the same is true of me. Having received several letters of yours recently and not having replied, I have omitted doing so, because I can't use my hand to write …I think that is all. From Rome on the 28th day of December, 1563.

Even at 88 years old, the cramped hand is still remarkably clear and steady. Michelangelo grew old but never senile. This was the last of more than 200 letters that Michelangelo wrote to his nephew. Indeed, it was the last letter he ever wrote.

Every day he could, Michelangelo continued carving on the *Rondanini Pietà*. At the same time, he was carving this small wood crucifix now in the Casa Buonarroti. It's less than 11 inches high, probably meant as a gift to send to Leonardo, his nephew. It is far more monumental and moving than its diminutive size and incomplete state would suggest. It appears so small, especially alongside so many other works that we've looked at in this course. It's hard *not* to think of Michelangelo as the artist of monumentality,

of titanic expression. And yet this is so small, so quiet, so private—an aged artist preparing to die. It's like some of his Crucifixion drawings, the physical act of carving a Christ, of touching his Lord's flesh, must have been a private comfort to the aged artist.

On Saturday, February 12, 1564, Michelangelo worked all day on his feet, carving on the *Rondanini Pietà*, the subject of our last lecture. He was just three weeks shy of turning 89. But suddenly he was struck by fever and visibly began to fail. Just two days later, Michelangelo's friend and assistant, Tiberio Calcagni wrote to Michelangelo's nephew, Leonardo:

> I wanted to inform you that as I was going about Rome today, I heard from many persons that Michelangelo was ill. I went immediately to visit him and although it was raining he was out walking. When I saw him I said I don't think it's a good idea to be out in such weather. [To which he testily replied:] "What do you want me to do? I am not well and I cannot find peace and quiet anywhere."

Michelangelo, in fact, soon after fell sick, and quickly began to decline. He was attended by two doctors who prescribed a fantastic array of medicines—mainly purgatives and expectorants. Some were benign, such as the carafe of sweetened water with sage, and the lozenges to suppress coughing. Others sound much less helpful, such as the crushed pearl in sugared rosewater. This was an expensive and special remedy prescribed only to important persons, including Lorenzo de' Medici on his deathbed. But the pearl concoction and daily syrups did little for the failing artist.

The world was watching as Michelangelo grew old and approached death. Fully conscious of his hero's place in history, Giorgio Vasari wrote to Duke Cosimo de' Medici in 1560, "the ancients are surpassed by the beauty and grace of what his divine genius has been able to achieve." Vasari claimed that Michelangelo was the equal of the ancients. In the Renaissance there could be no higher praise.

In February 1564, Michelangelo's friend and pupil, Tiberio Calcagni, wrote to advise the artist's nephew, Leonardo, to hurry to Rome. That same day, another friend and pupil, Daniele da Volterra, also wrote to inform Leonardo that his uncle was asking for him, begging him to come to Rome hurriedly. Weakly, Michelangelo signed the letter after Daniele's name. On February 17, the urgent

appeal to hasten to Rome was repeated, but it was too late. Michelangelo died the following evening between 4 and 5 pm. Leonardo was informed that, "He died without making a will, but in the attitude of a perfect Christian." Michelangelo died just two weeks shy of turning 89. That same year—1564—William Shakespeare and the great scientist Galileo Galilei were born.

As a gift for Michelangelo's nephew, Daniele da Volterra cast this portrait in bronze, which is the best-known likeness of the great artist. We see Michelangelo as a well-dressed gentleman, as he wished to be remembered and for which recognition he had labored all of his life—not as "Michelangelo *scultore*," as he signed so many letters early in life, but as Michelangelo patrician, as Condivi and Michelangelo himself emphasized.

On the morning after Michelangelo's death, a judge and notary arrived to make an inventory of the house and its contents. The first item noted on the inventory was Michelangelo's bed with its mattress and coverlet, because beds oftentimes were the most valuable items in a household. The notaries were much more interested in the furniture than in the works of art, for example. They also inventoried a large wooden credenza packed with the master's clothes and linens, and I'd like to give you a sense of what they found in Michelangelo's house.

> Two fur coats, a lined mantle of fine black Florentine wool, another mantle of black wool, a black lamb's wool tunic, two black hats, undershirts, stockings, nineteen old shirts, five new ones, fifteen handkerchiefs, a pair of slippers, five hand towels, three face towels, seven white sheets, and eight tablecloths.

And so it continues, at great length, an inventory of some five pages long—the detritus of a great man's life. Michelangelo, the Florentine, always preferred Florentine goods, as they were, in his opinion, of the best quality. And you may have noticed that he preferred black; not of melancholy, but black was the color of current fashion of the nobility and of the political elite with whom Michelangelo associated.

In the workshop towards the back of the house, the notary recorded several unfinished works including the *Rondanini Pietà*. There was a walnut box with drawings, and another contained a huge sum of

money: Roman gold scudi, Venetian gold ducats, and an assortment of Hungarian, German, and Spanish coins. The total was more than 8,000 scudi, that is, enough cash to construct a small building or to pay 10 skilled workmen their annual salaries for more than 15 years.

Now in the Renaissance wealth was the most visible measure of status. At the time of his death, Michelangelo was extremely rich, but despite his affluence he lived modestly. He was, like most of his contemporaries, extremely wary of gossip. So Michelangelo told Condivi once, "Ascanio, however rich I have been, I have always lived as a poor man," which was largely true even if it deflects attention from the artist's unprecedented wealth and from his favoring of very expensive Florentine clothes. Michelangelo, however, left his only heir, Leonardo, financially secure, essentially the equivalent of a multimillionaire.

Now although Michelangelo died in Rome, he was far too important to the Florentines. The Florentines made immediate arrangements to steal his body and return it to Florence, packed in straw and smuggled along with other bales of goods. Michelangelo the artist had achieved, in his lifetime, the status of a saint, and he was stolen like one by the Florentines.

Michelangelo's body was brought back to Florence where it was given a magnificent funeral, and there began the apotheosis of Michelangelo. Vasari, who devoted himself to Michelangelo's deification, stated it best: "If Florence could not enjoy his presence when alive, she may possess his body and preserve his memory, and keep alive the fame of his noble house."

According to Vasari, neither popes, emperors, nor kings, nor even saints Peter or Paul could have been shown greater honor. Thus like Venice with Saint Mark, Rome with Saint Peter, Florence now possessed a saint-like figure whose name and art would be indelibly associated with the city in which he was born but had not lived for the last 30 years of his life.

Duke Cosimo de' Medici authorized an elaborate funeral celebration, and helped sponsor the creation of the artist's tomb in Santa Croce, created by members of the newly founded Artists' Academy (the *Accademia del Disegno*). It's a final irony of Michelangelo's life that he's buried in his own marble, in a tomb partly fashioned from blocks taken from his Florentine studio in Via Mozza.

Finally Duke Cosimo de' Medici had realized his longstanding dream of bringing Michelangelo "home" to Florence. Michelangelo, who began his education and his career in the bosom of the Medici, was finally in the end returned to them. While he gained immeasurably from the Medici early in his life, so in turn did the Medici subsequently reap the benefits of the artist's worldwide fame.

Vasari's revised edition of his best-selling *Lives of the Artists,* published in 1568, just four years after the artist's death, brilliantly served to celebrate the entwined heroes—Michelangelo and his Medici benefactors. In the end, the glory of the Medici is greater for having assimilated Michelangelo's history to their own. Ever since, the fame of one has contributed to the other, and vice versa. Indeed, I think in our minds the Renaissance, the Medici, and Michelangelo are all practically synonymous.

Directly opposite Michelangelo's tomb in Santa Croce is the tomb of the great scientist and astronomer Galileo Galilei. The location of this tomb was no accident, for Galileo claimed to have been born, not only in the same year but on the very same day that Michelangelo died. In the Renaissance, there was a firm belief that the spirit of genius could and did pass from one generation to the next through such coincidences. Thus even in death Galileo continues to receive some reflected glory as he rests opposite his hero. Indeed Michelangelo's tomb is the first stop on many a tourist visit to Santa Croce, just as Galileo's is the last tomb to which we pay homage before exiting the church. Michelangelo and Galileo— the alpha and omega of Florentine genius.

From early in his career Michelangelo insisted on his special status. He believed firmly in his aristocratic origins, and he acted and dressed the part, as is evident in these two portraits. These are just two of the many portraits celebrating Michelangelo, not as an artist and craftsman but as a Florentine patrician, as is made explicitly clear in the inscription on the engraving that served as the frontispiece for Condivi's *Lives of the Artists*. Michelangelo was no ordinary craftsman; rather, his art was a coveted commodity made for a privileged few.

Condivi says it very well. He notes, "When Michelangelo was asked by growing numbers of lords and rich people for something from his own hand, and they gave lavish promises, he rarely did it, and when he did, it was rather from friendship and benevolence than from hope

for reward." Now Condivi may have been exaggerating, but not much. Michelangelo's relations with his patrons were extensions of social bonds founded on favor, friendship, and family.

Michelangelo was an aristocrat who made art. It is little wonder that he styled himself a nobleman whose humble origins in Settignano and his slow beginnings as a sculptor are obscured by myth and by his many great accomplishments. Few artists have achieved as much as Michelangelo in so many diverse endeavors. Few so completely embody our very notion of genius.

However, his legacy is even greater than the sum of his works. More than any of his contemporaries, Michelangelo significantly raised the stature of the profession, from craftsman to genius, from artisan to gentleman. He demanded respect from his patrons and he earned tremendous prestige as an artist. The era of the superstar artist is born.

It may be that one of Michelangelo's greatest legacies was his collaboration with Ascanio Condivi and Giorgio Vasari in fashioning his biography. Alongside his many other accomplishments, the written word offers us the master's most finished, the longest-enduring, and the best-loved self-portrait. There we learn, for example, that Michelangelo was self-trained, that his genius was first recognized by the greatest patron of the Renaissance, Lorenzo de' Medici, and that Pope Julius II threatened Michelangelo on the Sistine scaffolding.

This is the stuff of legend, and it's the central ingredients of many a popular book on Michelangelo, including that best known—Irving Stone's *The Agony and the Ecstasy*. The legends are probably mostly true, or at least they contain kernels of an embellished past. But like most memory, Michelangelo's was selective and artistic. Through his biographers he's left us an enduring legend, and through his art he has left us enduring monuments. Both are remarkable accomplishments.

Except during the 17th and early 18th centuries, when Raphael was considered the supreme genius of Renaissance art, Michelangelo's reputation has steadily grown. Sir Joshua Reynolds, whom we see here in his self-portrait, standing alongside a bust of Michelangelo, was a great English painter and the first president of the English Royal Academy of Artists. Between 1769 and 1790, in his capacity

as president, Reynolds delivered 15 discourses on art that were intended as instructions and guidelines for young artists to achieve greatness. In the very last of these lectures, delivered shortly before his death, Reynolds expressed his distress at the decline of art from Michelangelo's time to his own. But there was hope, and there was a model to follow to achieve perfection—Michelangelo. Reynolds concluded his final speech in this manner:

> That ART has been in a gradual state of decline, from the age of Michelangelo to the present, must be acknowledged. To recover this lost taste, I would recommend young artists to study the works of Michelangelo, as he himself did the works of ancient sculptors. He began, when a child, a copy of a mutilated Satyr's head, and finished in this model what was wanting in the original. In the same manner, the first exercise that I would recommend to any young artist when he first attempts invention, is to select every figure, if possible, from the inventions of Michelangelo. …I reflect not without vanity, that these Discourses bear testimony of my admiration of that truly divine man, and I should desire that the last words I should pronounce in this Academy, and from this place, might be the name MICHEL ANGELO.

Oscar Wilde once remarked, "I think a man should invent his own myth." Now although he was not the primary author, Michelangelo certainly helped to shape his own myth. Ironically fiction and fact, myth and truth, have become inextricably intertwined. What Michelangelo believed was family history, we now question and dismiss as pure fancy, while certain embellished or invented episodes in the artist's life are defended with a surprising tenacity by historians who should normally be more skeptical.

Perhaps we cannot help ourselves, for as Oscar Wilde further noted:

> What is true in a man's life is not what he does, but the legend which grows up around him. …You must never destroy legends. Through them we are given an inkling of the true physiognomy of a man.

Both the truth and the legend of Michelangelo are fascinating. Together they give us much more than just the inkling of the man.

And so Michelangelo's life continues to fascinate us. His sculpture, painting, and architecture continue to astonish. We cannot help but

wonder at the humanity, tenacity, and awe-inspiring accomplishments of such a man.

Yet at the summit of his illustrious career, Michelangelo was paid to gild eight knobs on two of the pope's beds. To the unknown Vatican functionary who paid the artist for this silly task, this 75-year-old man was merely "Michelangelo the painter." And so, such is the everyday world even of great persons … such is the fleetingness of fame. Although he was sometimes forced to undertake such humble tasks, and although deeply human and sometimes vulnerable, Michelangelo rose above mundane circumstances; and he employed his incomparable gifts and a transcendent genius to create sublime works of art, for the world and for all time.

Timeline

1475March 6. Born in Caprese.

1481Death of his mother, Francesca Neri di Miniato del Sera.

c. 1485..........................Attends the grammar school of the humanist Francesco di Urbino (1485–88?). Father remarries.

1487Michelangelo documented in workshop of Domenico Ghirlandaio (1449–1494).

c. 1490..........................In the Medici household through 1492. The probable years of the *Madonna of the Steps* and *Battle of the Centaurs*.

1492Death of Lorenzo de' Medici.

1494Expulsion of the Medici from Florence.

1494–95Michelangelo in Bologna. Carves figures for the Tomb of Saint Dominic.

1495Returns to Florence, under the sway of the Dominican preacher Girolamo Savonarola. Michelangelo carves *St. John the Baptist* and the *Sleeping Cupid*.

1496First trip to Rome (arrives June 25).

1496–1501In Rome. Carves *Bacchus*, Rome *Pietà*.

1501Returns to Florence. Contracts to carve figures for the Piccolomini altar in the Duomo in Siena, and receives commission to carve the *David*.

1503Commission for the twelve Apostles, including *St. Matthew* for the Florentine Cathedral.

c. 1503–06....................Completes the *Doni Tondo*, *Taddei Tondo*, *Pitti Tondo* and the *Bruges Madonna*.

1504Completes *David*. Receives commission to paint the *Battle of Cascina*.

1505	Summoned to Rome by Pope Julius II (1503–13); commissioned to create the tomb for the pope. Spends eight months in the quarries of Carrara selecting marble for the tomb.
1505–45	Michelangelo works on the Tomb of Julius II on and off, in both Rome and Florence, carving *Moses*, *Rebellious Slave*, *Dying Slave*, *Accademia Slaves*, *Rachel* and *Leah*.
1506	Returns to Florence in April. Michelangelo and Pope Julius II reconciled in Bologna in November. Commissioned to execute bronze statue of Pope Julius II in Bologna (destroyed).
1507	In Bologna working on bronze statue of Julius II.
1508	Returns to Florence in February. Summoned to Rome by Pope Julius II and asked to paint the ceiling of the Sistine Chapel in May.
1508–12	In Rome painting the ceiling of the Sistine Chapel (unveiled 31 October 1512).
1513	Death of Pope Julius II. Election of Giovanni de' Medici as Pope Leo X (1513–21). Signs new contract for the Tomb of Pope Julius II.
1514	Commissions for the *Risen Christ* and the Chapel of Pope Leo X in Castel Sant'Angelo, Rome.
1516	Returns to Florence in July. Commission to erect the façade of the Medici church of San Lorenzo in Florence. Signs new contract for the Tomb of Pope Julius II.
1516–19	Numerous trips to the marble quarries at Carrara and Pietrasanta for the San Lorenzo façade project, eventually cancelled in 1520.

1520	Commission to design the New Sacristy or Medici Chapel for San Lorenzo.
1521	Death of Pope Leo X. Begins work on the tombs for the Medici Chapel.
1523	Election of Giulio de' Medici as Pope Clement VII (1523–34).
1524	Commission to design the Laurentian Library at San Lorenzo.
1527	Sack of Rome occurs May 6. Exile of the Medici from Florence on May 17.
1527–30	The Last Republic in Florence. Commission to carve a *Hercules* (never executed). Michelangelo designs and builds fortifications.
1529–30	Siege of Florence by the combined forces of Pope Clement VII and the Holy Roman Emperor Charles V. Paints *Leda and the Swan* for Alfonso d'Este, which is subsequently sent to France with Michelangelo's pupil Antonio Mini.
c. 1530	Carves *David* (*Apollo*), designs the *Noli me Tangere* and the *Venus and Cupid*, painted by Pontormo (1494–1556/7).
1532	Visits Rome, meets Tommaso de' Cavalieri. Presents Cavalieri with gifts of drawings and poems. Signs new contract for the Tomb of Pope Julius II.
1533	Reliquary Tribune balcony in San Lorenzo completed.
1534	Death of Pope Clement VII. Election of Alessandro Farnese as Pope Paul III (1534–49). Michelangelo departs Florence, never to return. Medici *Madonna and Child* and *Victory* left incomplete in Florentine workshop. Spends remaining thirty years of his life in Rome.

1536Begins painting the *Last Judgment* in the Sistine Chapel. Meets Vittoria Colonna.

1538Begins work on the Capitoline Hill (*Campidoglio*).

1540s?Carves bust of *Brutus*.

1541*Last Judgment* completed and unveiled.

1542In August contracts with Pope Julius' heirs for the final version of the pope's tomb. Begins work on the Pauline Chapel.

1545Tomb of Julius II completed and installed in San Pietro in Vincoli, Rome. Still working on the Pauline Chapel frescos, continues through 1550.

1546Death of Antonio da Sangallo.

1547Michelangelo appointed chief architect of St. Peter's and the Farnese Palace. Death of Vittoria Colonna. Begins work on the *Florentine Pietà* for his own tomb, abandoned 1555.

1550Publication of the first edition of Giorgio Vasari's *Lives of the Artists*. Completion of the frescos in Pauline Chapel.

1553Publication of Ascanio Condivi's *Life of Michelangelo*.

1555Death of Urbino, Michelangelo's favorite servant/assistant.

1556Begins work on the *Rondanini Pietà*.

1559–60Designs for San Giovanni dei Fiorentini, Rome.

c. 1560..........................Commission for the Cappella Sforza in Santa Maria Maggiore, Rome.

1561Commissions for Porta Pia and Santa Maria degli Angeli in Rome.

1564February 18. Dies at home in Macel de'
Corvi, Rome.

Glossary

arca: A sarcophagus, especially as part of a large funerary monument, such as that in Bologna which houses the remains of St. Dominic.

arriccio: A rough plaster layer applied to a wall below the *intonaco* on which an artist paints in fresco.

bottega: An artisan's workshop, both the place and the people associated with it.

calcagnuoli: Coarse two-toothed chisels used by Michelangelo for the majority of his marble carving.

Campidoglio: The "Capital" Hill; one of the seven hills of Rome, the original location of the temple of Jupiter, and the area redesigned by Michelangelo from the 1530s.

cangiante: Italian for "changing" or "shot" color. A technique of painting that juxtaposes complementary colors for heightened visual effect, as Michelangelo did especially in the Sistine Chapel lunettes.

cartoon: From the Italian *cartone*, "large paper," referring to full-scale drawings often made in preparation for painting in fresco, as Michelangelo made for the commission for the *Battle of Cascina*.

contrapposto: Italian term used also in English to describe human posture in which the shift of weight to one or the other leg causes one part of the body to be twisted in the opposite direction from the other.

corbel: A projecting block, usually of stone, supporting a beam or other horizontal member.

Dioscuri: *The Horse Tamers*, a pair of ancient, giant Roman statues on the Quirinale Hill, much admired by Michelangelo.

disabitato: Italian for "uninhabited," referring especially to large areas of Rome within the ancient circuit of walls.

di sotto in su: "From below to above." A foreshortened angle of vision, especially when one looks up at painting or sculpture placed above eye level. Donatello was a pioneer in adjusting the proportions of his sculptures accordingly, as did Michelangelo in the *Moses*.

fantasia: Italian for "fantasy," whimsy, and inventively original, often applied to Michelangelo's art, especially his architecture.

fresco: Literally "fresh" in Italian. The preferred means of decorating large wall surfaces—by painting on damp plaster—perfected in Italy between the 13th and 16th centuries.

giornati: Italian for "days." Refers to the patches of plaster on which an artist can work for one day in fresco painting. Up close, it is easy to see the joins between one plaster section and the next and, thus, to determine the order of painting and the number of days required to paint a surface.

gonfaloniere di giustizia: "Flagbearer of justice," the supreme head of Florentine government. Piero Soderini was the first *gonfaloniere* to be elected "for life" in 1502, although he was deposed when the Medici returned in 1512.

gradina: A fine-tooth chisel used in carving the penultimate layer of marble before polishing with rasps, pumice, and grit.

guttae: Small drop-like projections carved under a triglyph (q.v.).

ignudi: Nude youths, referring to those painted by Michelangelo on the ceiling of the Sistine Chapel.

intonaco: The fine plaster layer applied over the *arriccio* on which the artist paints in fresco. If the *intonaco* is damp, the technique is referred to as "true fresco" (*buon fresco*), and if dry, the technique is referred to as *a secco* ("dry").

manu fortis: Italian for "strong of hand." The biblical characterization of David, also applicable to Michelangelo's representation of David.

nave: The central aisle of a church, often flanked by aisles.

non-finito: "Unfinished," the characteristic of many of Michelangelo's works, sometimes purposeful, sometimes not.

pietra serena: A fine-grained, durable sandstone, quarried in the hills all around Florence and much used in Florentine architecture and decoration, including Michelangelo's Laurentian Library.

pilaster: A shallow pier or rectangular column projecting slightly from a wall.

podestà: The resident governor, often of a small town.

rilievo schiacciato: Italian phrase for "squashed relief." A technique of low-relief carving perfected by Donatello and in evidence in Michelangelo's *Madonna of the Stairs*.

Ringhiera: The elevated platform in front of Palazzo della Signoria in Florence where the *David* was originally placed.

signoria: Chief governing council of Florence.

spandrel: The curved, triangular spaces at the four corners of the Sistine Chapel connecting the chapel walls and ceiling.

spolvero: A technique by which the lines on a full-scale cartoon are pricked through and pounced with charcoal dust to transfer the outlines of the cartoon drawing to another surface.

subbia: A single-point chisel used for rough and rapid carving work.

tepidarium: The warm-water pool of an ancient bath complex, such as the one transformed by Michelangelo at Santa Maria degli Angeli into a church entrance.

terribilità: Italian word for "terribleness." A term often used to characterize Michelangelo's volatile temperament.

tondo: A round design and a particularly popular Florentine type of painting, although Michelangelo created marble *tondi* (the plural form) when he carved examples for the Pitti and Taddei families.

transept: The transverse arms of a cross-shaped church.

triglyph: Blocks that form part of a Doric frieze; used inventively and decoratively by Michelangelo, especially in the windows of the Farnese Palace courtyard. Each triglyph is decorated with vertical grooves of glyphs.

Bibliography

Essential Reading:

Ackerman, James S. *The Architecture of Michelangelo*, 2 vols. London: Zwemmer, 1961. Classic overview and catalogue of Michelangelo's architecture. A one-volume paperback edition is still in print.

Argan, Giulio Carlo, and Bruno Contardi. *Michelangelo Architect.* Translated by Marion L. Grayson. New York: Harry Abrams, 1993. Survey of Michelangelo's architectural projects, with excellent photographs, plans, drawings, and an up-to-date bibliography.

Buonarroti, Michelangelo. *Il Carteggio di Michelangelo*, 5 vols. Edited by Giovanni Poggi, Paola Barocchi, and Renzo Ristori. Florence: Sansoni, 1965–83. Critical edition of all letters to and from Michelangelo. Michelangelo's letters have been translated in *The Letters of Michelangelo*, 2 vols. Edited by E. H. Ramsden. Stanford: Stanford University Press, 1963.

———. *Complete Poems and Selected Letters of Michelangelo.* Translated by Creighton Gilbert and edited by Robert N. Linscott. Princeton: Princeton University Press, 1963. With a useful forward and critical notes by one of the leading Renaissance art historians of his era.

———. *The Poetry of Michelangelo: An Annotated Translation.* Edited by James M. Saslow. New Haven and London: Yale University Press, 1991. Based on the classic Enzo Girardi edition (Rime, 1960), presenting the original Italian alongside the English translations.

———. *The Complete Poetry of Michelangelo.* Translated by Sidney Alexander. Columbus: Ohio University Press, 1991. English translation of the artist's poetry.

———. *Michelangelo: The Poems.* Edited and translated by Christopher Ryan. London: J. M. Dent, 1996. English translation of Michelangelo's poetry.

———. *The Complete Poems of Michelangelo.* Translated by John Frederick Nims. Chicago: University of Chicago Press, 1998. English translation of Michelangelo's poetry by a noted poet.

Condivi, Ascanio. *Michelangelo: Life, Letters, and Poetry.* Translated by George Bull; poems translated by George Bull and

Peter Porter. Oxford and New York: Oxford University Press, 1987. Includes the *Life of Michelangelo* by Condivi, as well as a selection of letters and poems in English translation.

———. *The Life of Michelangelo*, 2nd ed. Translated by Alice S. Wohl and edited by Helmutt Wohl. University Park: Pennsylvania State University Press, 1999. English translation of an important contemporary biography of Michelangelo, with useful notes regarding persons, places, and events.

Hibbard, Howard. *Michelangelo*. New York: Harper & Row, 1974. Still the best one-volume introduction to the artist, his life, and works.

Symonds, John Addington. *The Life of Michelangelo Buonarroti*, 2 vols. London, 1893. Classic biography, recently reprinted with an introduction by Creighton C. Gilbert (Philadelphia: University of Pennsylvania Press, 2002).

Vasari, Giorgio. *The Lives of the Artists*. Translated by George Bull. Harmondsworth and Baltimore: Penguin Books, 1965. English translation of an important contemporary biography.

Supplementary Reading:

Barnes, Bernadine. *Michelangelo's Last Judgment: The Renaissance Response*. Berkeley: University of California Press, 1998. A worthwhile examination of the contemporary artistic response to Michelangelo's masterpiece, including paintings and prints, and letters and documents of the late 16th century.

Barolsky, Paul. *Michelangelo's Nose: A Myth and Its Maker*. University Park: Penn State University Press, 1990. Innovative examination of myth and artistic identity.

———. *The Faun in the Garden: Michelangelo and the Poetic Origins of Italian Renaissance Art*. University Park: Penn State University Press, 1994. A brilliant inquiry into the literary and poetic beginnings of High Renaissance art in central Italy.

———. *Michelangelo and the Finger of God*. Athens, GA: Georgia Museum of Art, 2003. A beautifully written narrative by one of the leading experts on the relationship between Italian Renaissance literature and the visual arts.

Beck, James. *Three Worlds of Michelangelo*. New York and London: Norton, 1999. Biographical overview, focusing on the most dominant male figures in the artist's life.

Berenson, Bernard. *The Drawings of the Florentine Painters*, 3 vols. Chicago: University of Chicago Press, 1938; reprinted, 1970. Fundamental critical catalogue of drawings by Michelangelo, his pupils, and his followers in the context of drawings by the Florentine painters.

Brandt, Kathleen Weil-Garris, et al., eds. *Giovinezza di Michelangelo*. Florence and Milan: Artificio Skira, 1999. Catalogue of an international loan exhibition focused on the youth and early works of Michelangelo.

Bull, George. *Michelangelo: A Biography*. New York and London: Viking, 1995. Good, reliable modern biography.

Cadogan, Jean, K. *Domenico Ghirlandaio: Artist and Artisan*. New Haven and London: Yale University Press, 2000. Excellent modern monograph on this important 15th-century painter, Michelangelo's first teacher.

Chapman, Hugo. *Michelangelo Drawings: Closer to the Master*. London and New Haven: Yale University Press, 2005. A catalogue published in conjunction with an exhibition at the British Museum that also serves as a good introduction to the artist, especially from the perspective of his draftsmanship.

Clements, Robert J. *Michelangelo's Theory of Art*. New York: New York University Press, 1961; London: Routledge and Kegan Paul, 1962. Still one of the best introductions to Michelangelo as a writer and theorist of art.

Colonna, Vittoria. *Sonnets for Michelangelo: A Bilingual Edition*. Edited and translated by Abigail Brundin. Chicago: University of Chicago Press, 2005. The book of poems that Colonna presented to Michelangelo, with facing pages in Italian and English.

Dussler, Luitpold. *Michelangelo-Bibliographie, 1927–1970*. Wiesbaden: O. Harrassowitz, 1974. A bibliography of Michelangelo literature published in all languages between 1927 and 1970.

Einem, Herbert von. *Michelangelo*, rev. ed. Translated by Ronald Taylor. London: Methuen, 1973. Excellent general study originally published in German.

Ferino-Pagden, Siliva, ed. *Vittoria Colonna: Dichterin und Muse Michelangelos*. Vienna: Kunsthistorisches Museum, Skira editore, 1997. Catalogue of an important exhibition exploring the relations between Colonna and Michelangelo.

Franklin, David. *Painting in Renaissance Florence, 1500–1550*. New Haven and London: Yale University Press, 1991. Good overview of the artistic scene of Florence during the years that Michelangelo was working in the city.

Gilbert, Creighton. *Michelangelo On and Off the Sistine Ceiling: Selected Essays*. New York: Braziller, 1994. A collection of essays by one of the premier scholars of Michelangelo.

Gill, Meredith J. *Augustine in the Italian Renaissance: Art and Philosophy from Petrarch to Michelangelo*. New York: Cambridge University Press, 2005. Important new research into the significant religious textural sources for Michelangelo's Sistine Chapel ceiling.

Goffen, Rona. *Renaissance Rivals: Michelangelo, Leonardo, Raphael, Titian*. New Haven and London: Yale University Press, 2002. A study of the rivalry among four of the most important figures of the Italian Renaissance.

Guicciardini, Francesco. *The History of Italy*. Translated by Sydney Alexander. Princeton: Princeton University Press, 1984. A history by Michelangelo's contemporary and an eyewitness to most of the important political events of his time.

Hall, Marcia B., ed. *Michelangelo's Last Judgment* (Masterpieces of Western Painting). Cambridge and New York: Cambridge University Press, 2005. Good introduction and contributions by a number of scholars.

———, ed. *Rome* (Artistic Centers of the Italian Renaissance). Cambridge and New York: Cambridge University Press, 2005. Includes essays by prominent scholars surveying the art of Rome from the 14th through the 16th centuries.

Hartt, Frederick. *Michelangelo* (The Library of Great Painters). New York: Harry Abrams, 1964; London: Thames and Hudson, 1965. Commentaries by one of the great scholars of Michelangelo.

———. *Michelangelo. The Complete Sculpture*. New York: Harry N. Abrams, 1968; London: Thames and Hudson, 1969. Commentaries by one of the great scholars of Michelangelo.

———. *Michelangelo Drawings*. New York: Harry N. Abrams, 1970. A critical catalogue of Michelangelo drawings.

———. *Michelangelo's Three Pietàs: A Photographic Study by David Finn*. New York: Abrams, n.d. (1978). Written and photographic essays on a subject of central importance to Michelangelo's life and art.

Hatfield, Rab. *The Wealth of Michelangelo* (Studi e testi del Rinascimento Europeo 16). Rome: Edizioni di storia e letteratura, 2002. A detailed study of Michelangelo's financial history based on archival documents.

Hirst, Michael. *Michelangelo and His Drawings*. New Haven and London: Yale University Press, 1988. A handy introduction to the artist's drawings.

———, and Jill Dunkerton. *The Young Michelangelo: The Artist in Rome, 1496–1501* (Making and Meaning Series). London: National Gallery Publications, 1994. A good introduction to the early Roman works of the artist.

Istituto Geografico de Agostini. *Michelangelo: La Cappella Sistina*. Novara: Istituto Geografico de Agostini, 1994. Three-volume report on the conservation of the ceiling of the Sistine Chapel, with many scholarly essays, conservation details, and beautiful reproductions.

Kent, F. W. *Lorenzo de' Medici and the Art of Magnificence*. Baltimore and London: Johns Hopkins University Press, 2004. Excellent overview of the art and patronage of Michelangelo's first patron.

King, Ross. *Michelangelo and the Pope's Ceiling*. New York: Walker and Co., 2003. Highly readable and engaging history of Michelangelo's most significant painting commission.

Levey, Michael. *Florence: A Portrait*. Cambridge, MA: Harvard University Press, 1996. An accessible history of Michelangelo's native city.

Liebert, Robert S. *Michelangelo: A Psychoanalytic Study of His Life and Images*. New Haven and London: Yale University Press, 1983. The artist and his creations from a psychoanalytic perspective.

McHam, Sarah Blake, ed. *Looking at Renaissance Sculpture*. Cambridge and New York: Cambridge University Press, 1998. A collection of essays by leading scholars on various aspects of Renaissance sculpture.

Milanesi, Gaetano. *Le Lettere di Michelangelo Buonarroti coi ricordi ed I contratti artistici*. Florence: Le Monnier, 1875. Publication of Michelangelo's letters, contracts, and records.

Montreal Museum of Fine Arts. *Michelangelo: The Genius of the Sculptor in Michelangelo's Work*. Montreal: Montreal Museum of Fine Arts, 1992. An exhibition catalogue with scholarly essays.

Murray, Linda. *Michelangelo: His Life, Work and Times*. New York: Thames and Hudson, 1984. A life and times with extensive quotation from Michelangelo's correspondence.

Nagel, Alexander. *Michelangelo and the Reform of Art*. Cambridge and New York: Cambridge University Press, 2000. A study of Michelangelo's art in relation to the reform movements in the Catholic Church to which the artist was sympathetic.

d'Ossat, Guglielmo, and Carlo Pietrangeli. *Il Campidoglio di Michelangelo*. Rome: Silvana, 1965. Folio volume with superb photographs, plans, and drawings of one of Michelangelo's most important architectural projects.

Papini, Giovanni. *Michelangelo: His Life and His Era*. Translated by Loretta Murname. New York: E. P. Dutton, 1952. Biographical sketches of the hundreds of persons known to Michelangelo—patrons, family, friends, and enemies.

Partner, Peter. *Renaissance Rome, 1500–1559: A Portrait of a Society*. Berkeley: University of California Press, 1976. Excellent single-volume introduction to the city of Rome during the years that Michelangelo lived and worked there.

Partridge, Loren, Fabrizio Mancinelli, Gianluigi Colalucci, and Takashi Okamura. *Michelangelo, The Last Judgment: A Glorious Restoration*. New York: Abrams, 1997. Beautiful photographs and essays related to the conservation campaign of the *Last Judgment*.

Pastor, Ludwig von. *The History of the Popes*, 40 vols. Edited by R. F. Kerr. London: Routledge and Kegan Paul, 1891–1963. A comprehensive history of the papacy.

Pietrangeli, Carlo, et al. *The Sistine Chapel: The Art, the History, and the Restoration*. New York: Harmony Books, 1986. Good photographs and essays prompted by the conservation campaign of 1980–1990.

————, et al. *The Sistine Chapel: A Glorious Restoration*. New York: Abrams, 1994. Photographs and essays prompted by the conservation campaign of 1980–1990.

Poeschke, Joachim. *Michelangelo and His World*. Translated by Russell Stockman. New York: Harry Abrams, 1996. Comprehensive survey of the sculpture of Michelangelo and his contemporaries.

Pope-Hennessy, John. *Italian High Renaissance and Baroque Sculpture*. London: Phaidon, 1963. Best introduction in English to the sculpture of Michelangelo and his contemporaries.

Rocke, Michael. *Forbidden Friendships: Homosexuality and Male Culture in Renaissance Florence*. New York and Oxford: Oxford University Press, 1996. A serious, archive-based account of homosexual culture in Michelangelo's Florence.

Roth, Cecil. *The Last Florentine Republic*. London: Methuen and Co., 1925. The best single-volume history of Florence before, during, and after the tumultuous period of the last republic (1527–30).

Scigliano, Eric. *Michelangelo's Mountain: The Quest for Perfection in the Marble Quarries of Carrara*. New York: Free Press, 2005. A compelling narrative of Michelangelo's relationship with Carrara, the workers, and the culture of marble from the Renaissance to the present.

Seymour, Charles Jr. *Michelangelo's David: A Search for Identity*. New York: Norton, 1974. The history, sources, and interpretation of this major sculpture.

————. *Michelangelo: The Sistine Ceiling* (Norton Critical Studies in Art History). New York: Norton, 1972. A volume of original documentation, history, and interpretive essays, with an excellent introduction by Seymour.

Steinberg, Leo. *Michelangelo's Last Paintings*. New York, Oxford University Press, 1975. An analysis of Michelangelo's Pauline Chapel frescos.

Steinmann, Ernst. *Die Porträtdarstellungen des Michelangelo*. Leipzig: Klinkhardt & Biermann, 1913. A collection of more than 100 portraits of Michelangelo.

Stinger, Charles L. *The Renaissance in Rome*. Bloomington and Indianapolis: Indiana University Press, 1985. Excellent single-

volume introduction to the city of Rome during the years that Michelangelo lived and worked there.

Summers, David. *Michelangelo and the Language of Art*. Princeton: Princeton University Press, 1981. Renaissance artistic theory as revealed in the language used by Michelangelo and his contemporaries.

Tolnay, Charles de. *Michelangelo*, 5 vols. Princeton: Princeton University Press, 1969–1971 (reprint). A comprehensive examination of the artist and his work, including: *The Youth of Michelangelo, The Sistine Chapel, The Medici Chapel, The Tomb of Julius II*, and *The Final Period*.

―――. *The Art and Thought of Michelangelo*. Translated by Nan Buranelli. New York: Pantheon Books, 1964. Four excellent essays on Michelangelo's political opinions, "philosophy," religious outlook, and artistic convictions.

―――. *Corpus dei disegni di Michelangelo*, 4 vols. Novara: Istituto Geografico de Agostini, 1975–1980. Complete catalogue of the artist's drawings, reproduced in color and full-size, both recto and verso.

Wallace, William E. *Michelangelo at San Lorenzo: The Genius as Entrepreneur*. Cambridge and New York: Cambridge University Press, 1994. Documentary study of Michelangelo's Medici commissions at San Lorenzo.

―――. *Michelangelo: The Complete Sculpture, Painting, Architecture*. Hugh Lauter Levin Associates, 1998. A beautifully illustrated volume by the course professor.

―――. "Michelangelo Buonarroti." In *Europe, 1450 to 1789: Encyclopedia of the Early Modern World*, 6 vols. (vol. 4, pp. 110–113). Edited by J. Dewald, New York: Charles Scribner's Sons, 2004. A brief overview of Michelangelo's career and significance by the course professor.

―――, ed. *Michelangelo: Selected Scholarship in English*, 5 vols. Hamden, CT: Garland, 1995. Collection of 100 articles in English on all aspects of Michelangelo's art and life.

―――, ed. *Michelangelo: Selected Readings*. New York and London: Garland Press, 1999. Affordable, one-volume paperback edition that collects 35 articles in English on all aspects of Michelangelo's art and life.

Wasserman, Jack, ed. *Michelangelo's Florence Pietà*. Princeton and Oxford: Princeton University Press, 2003. Includes essays by Jack Wasserman, Franca Trinchieri Camiz, Peter Rockwell, and Tim Verdon; new photographs by Aurelio Amendola; and technical studies of the sculpture.

Weinberger, Martin. *Michelangelo the Sculptor*, 2 vols. New York: Columbia University Press, 1967. A survey of Michelangelo's sculptures.

Wilde, Johannes. *Michelangelo: Six Lectures by Johannes Wilde*. Edited by John Shearman and Michael Hirst. Oxford: Clarendon Press, 1978. Six lectures turned into readable essays on various facets of Michelangelo's art and life.

Wind, Edgar. *The Religious Symbolism of Michelangelo: The Sistine Ceiling*. Edited by Elizabeth Sears. Oxford: Oxford University Press, 2000. Reprints a number of classic papers by an important scholar, in addition to several unpublished papers and notes.

Wittkower, Rudolf. *Sculpture: Processes and Principles*. New York: Harper and Row, 1977. A good general introduction to the subject with a chapter on Michelangelo.

————, and Margot Wittkower. *The Divine Michelangelo: The Florentine Academy's Homage on His Death in 1564. A facsimile edition of "Esequie del Divino Michelangelo Buonarroti," Florence, 1564*. London: Phaidon, 1964. A facsimile edition of obsequies printed as part of Michelangelo's Florentine funeral.

Notes

Notes